Canon® EOS
Rebel T3/1100D
Digital Field Guide

10659988

Canon® EOS
Rebel T3/1100D
Digital Field Guide

Charlotte K. Lowrie

Wiley Publishing, Inc.

Canon® EOS Rebel T3/1100D Digital Field Guide

Published by
Wiley Publishing, Inc.
10475 Crosspoint Boulevard
Indianapolis, IN 46256
www.wiley.com

Copyright © 2011 by Wiley Publishing, Inc., Indianapolis, Indiana

Unless credited otherwise, all photographs Copyright © Charlotte Lowrie

Published simultaneously in Canada

ISBN: 978-1-118-09320-7

Manufactured in the United States of America

10 9 8 7 6 5 4 3 2 1

No part of this publication may be reproduced, stored in a retrieval system or transmitted in any form or by any means, electronic, mechanical, photocopying, recording, scanning or otherwise, except as permitted under Sections 107 or 108 of the 1976 United States Copyright Act, without either the prior written permission of the Publisher, or authorization through payment of the appropriate per-copy fee to the Copyright Clearance Center, 222 Rosewood Drive, Danvers, MA 01923, (978) 750-8400, fax (978) 646-8600. Requests to the Publisher for permission should be addressed to the Permissions Department, John Wiley & Sons, Inc., 111 River Street, Hoboken, NJ 07030, 201-748-6011, fax 201-748-6008, or online at http://www.wiley.com/go/permissions.

LIMIT OF LIABILITY/DISCLAIMER OF WARRANTY: THE PUBLISHER AND THE AUTHOR MAKE NO REPRESENTATIONS OR WARRANTIES WITH RESPECT TO THE ACCURACY OR COMPLETENESS OF THE CONTENTS OF THIS WORK AND SPECIFICALLY DISCLAIM ALL WARRANTIES, INCLUDING WITHOUT LIMITATION WARRANTIES OF FITNESS FOR A PARTICULAR PURPOSE. NO WARRANTY MAY BE CREATED OR EXTENDED BY SALES OR PROMOTIONAL MATERIALS. THE ADVICE AND STRATEGIES CONTAINED HEREIN MAY NOT BE SUITABLE FOR EVERY SITUATION. THIS WORK IS SOLD WITH THE UNDERSTANDING THAT THE PUBLISHER IS NOT ENGAGED IN RENDERING LEGAL, ACCOUNTING, OR OTHER PROFESSIONAL SERVICES. IF PROFESSIONAL ASSISTANCE IS REQUIRED, THE SERVICES OF A COMPETENT PROFESSIONAL PERSON SHOULD BE SOUGHT. NEITHER THE PUBLISHER NOR THE AUTHOR SHALL BE LIABLE FOR DAMAGES ARISING HEREFROM. THE FACT THAT AN ORGANIZATION OR WEB SITE IS REFERRED TO IN THIS WORK AS A CITATION AND/OR A POTENTIAL SOURCE OF FURTHER INFORMATION DOES NOT MEAN THAT THE AUTHOR OR THE PUBLISHER ENDORSES THE INFORMATION THE ORGANIZATION OR WEB SITE MAY PROVIDE OR RECOMMENDATIONS IT MAY MAKE. FURTHER, READERS SHOULD BE AWARE THAT INTERNET WEB SITES LISTED IN THIS WORK MAY HAVE CHANGED OR DISAPPEARED BETWEEN WHEN THIS WORK WAS WRITTEN AND WHEN IT IS READ.

For general information on our other products and services or to obtain technical support, please contact our Customer Care Department within the U.S. at (877) 762-2974, outside the U.S. at (317) 572-3993 or fax (317) 572-4002.

Wiley also publishes its books in a variety of electronic formats and by print-on-demand. Some content that appears in standard print versions of this book may not be available in other formats. For more information about Wiley products, visit us at www.wiley.com.

Library of Congress Control Number: 2011930290

Trademarks: Wiley and the Wiley Publishing logo are trademarks or registered trademarks of John Wiley & Sons, Inc. and/or its affiliates. Canon is a registered trademark of Canon, Inc. All other trademarks are the property of their respective owners. Wiley Publishing, Inc. is not associated with any product or vendor mentioned in this book.

WILEY

About the Author

Charlotte K. Lowrie is an award-winning photographer and writer based in the Seattle, Washington, area. She has more than 25 years of photography experience, ranging from photojournalism and editorial photography to nature and portraits. Her images have appeared in national magazines and newspapers, and on a variety of websites, including MSN.com, www.takegreatpictures.com, and the Canon Digital Learning Center.

Charlotte divides her time among maintaining an active photography business, teaching photography, and writing books and magazine articles. She is the author of 15 books, including the bestselling *Canon EOS 7D Digital Field Guide* and 13 other Digital Field Guides. In addition, she teaches monthly online photography courses at BetterPhoto.com. Visit her website at wordsandphotos.org.

Credits

Acquisitions Editor
Courtney Allen

Project Editor
Kristin Vorce

Technical Editor
Jon Canfield

Copy Editor
Lauren Kennedy

Editorial Director
Robyn Siesky

Business Manager
Amy Knies

Senior Marketing Manager
Sandy Smith

Vice President and Executive Group Publisher
Richard Swadley

Vice President and Executive Publisher
Barry Pruett

Project Coordinator
Patrick Redmond

Graphics and Production Specialists
Andrea Hornberger
Christin Swinford

Quality Control Technician
Rebecca Denoncour

Proofreading and Indexing
Susan Hobbs
BIM Indexing & Proofreading Services

I dedicate this book to my children who endure book deadlines with the utmost grace and with great support for me. And this book is dedicated to God, my constant source of inspiration.

Acknowledgments

Taking on a book is a big task, and it can't be accomplished alone. I have the distinct privilege of working with my favorite editors at Wiley for this book. Kristin Vorce is a rock. She is a top-notch editor, a huge support to me, and she makes impossible deadlines seem possible. And Lauren Kennedy is a savvy, accomplished copyeditor who not only copyedits beautifully, but also asks smart questions about the content. Thanks are in order for Jon Canfield, technical editor, long-time friend, and fellow photographer. He brings years of experience and a watchful eye to this project. Thank you Kristin, Lauren, and Jon for your excellent editing and for your encouragement through this project. Thanks also to Courtney Allen, acquisitions editor, for her support.

You'll see pictures in this book that were made by my son, Bryan Lowrie, and my daughter, Sandy Ripple. Thanks so much, Bryan and Sandy for your help and for allowing me to use your lovely images. I am blessed to have you as children.

Contents

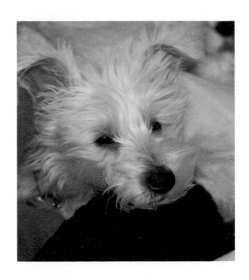

CHAPTER 2
Controlling Exposure and Focus 49

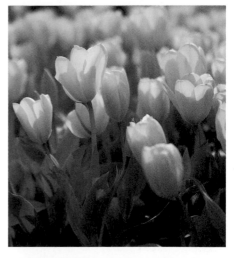

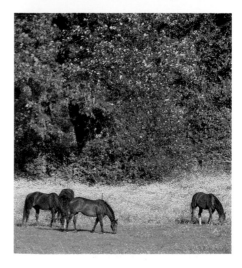

CHAPTER 3
Getting Great Color and Adding Creative Looks to Images 107

CHAPTER 4
Customizing the EOS Rebel T3/1100D 137

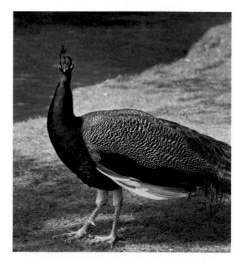

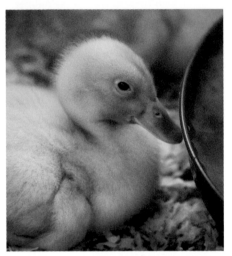

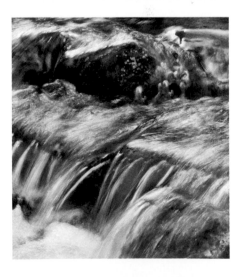

APPENDIX A

APPENDIX B

Introduction

If you're reading this, then chances are good that you are the proud owner of a Canon EOS Rebel T3/1100D. You probably already know that the camera delivers excellent images right out of the box. Just attach the lens, charge the battery, set the camera to one of the automatic shooting modes, and start shooting. But if you've spent any time exploring the camera controls and the camera menus, then you know that there is a lot of creative opportunity with the camera that you may be missing. This book is written to help you discover and understand all the creative power that the T3/1100D offers. The editors at Wiley and I hope that this book becomes your one-source guide for getting the best images that you can get with the T3/1100D.

As you read this book and use the camera, you're encouraged to explore the creative options that are available at every turn with this camera. If you're moving up from a point-and-shoot camera to the T3/1100D, you'll find some controls and features that are immediately familiar to you. Even if you're currently using only the automatic modes, the T3/1100D offers you some creative control over your images. As you read this book, you can transition from the automatic modes to the semiautomatic modes and Manual mode, where you have full creative control. The main goal of students in my Rebel photography courses is to move from shooting in the automatic modes to shooting with control over the exposure. This book is written to help you make and enjoy making that transition.

Given that the T3/1100D is a great camera to grow your photography skills, it's also good to know that the camera sports some of the newest technologies in Canon's stable — technologies that help deliver excellent image quality. For example, the image sensor offers 12 megapixels that produce images that make beautiful prints at 11 × 17 inches and larger. The color out of the camera is pleasing and exposures are consistent thanks in large part to Canon's latest metering system. This system uses a dual-layer metering sensor that reads both illumination and color from 63 zones and combines it with information from the autofocus system. You also get the latest iteration of Canon's venerable DIGIC processor, which has 14-bit processing for smooth tonal gradations, rich color, Live View shooting, and a number of customization options.

The camera offers good performance at 3 frames per second during continuous shooting to record up to 830 large JPEGs in a shooting burst. That makes it a capable camera for photographing everything from school football games to skiing competitions. With its high-resolution 1280 × 720 HD video, the T3/1100D is a great tool for multimedia storytelling, opening new doors of creative expression.

With that short introduction to some of the features of the T3/1100D, this book is written to help you learn not only what the camera features and options are, but also when and how to use them — with step-by-step instructions. And if you are new to digital photography or are returning after a long hiatus, be sure to check out the introduction to photographic exposure in Chapter 9.

I believe that any book about a camera should have staying power; in other words, it should be useful to you for as long as you use the T3/1100D. With that in mind, the book includes both basic and advanced shooting techniques so that as you progress, you'll have more advanced techniques to explore.

You may be wondering if this is the type of book where you can skip around reading chapters in random order. You can, of course, read in any order you want, but be sure to read Chapters 1 through 3 early. These chapters provide the foundation for learning the camera, getting the best image quality, and getting great color. From there you can explore customizing the camera, using Live View shooting, video, flash, and lenses in any order you want.

Before you begin reading, know that the best way to learn the T3/1100D and photography is to shoot, evaluate, and then shoot some more. Rinse and repeat. Carry the camera with you everywhere and use it. Be curious. Be fearless. Be passionate. And always look for the light.

The team at Wiley and I hope that you enjoy reading and using this book as much as we enjoyed creating it for you.

Charlotte

Postscript: Thanks to the many readers who have contacted me over the years. Your questions, suggestions, and ideas for previous books continue to influence the content of the books that I write today. I learn as much from you, I believe, as I hope that you have learned from me. Thank you, and keep the questions and ideas coming.

Quick Tour

Whether you just got your EOS T3/1100D or you've been using it for a while, it's important to set up the camera to get the best image quality and to suit your shooting preferences. This Quick Tour gives you a brief look at key camera controls and provides the basics for setting up and using the camera. Many of the topics here are discussed in more detail later in the book, but this tour helps get you off to a good start.

Some people worry about changing camera settings for fear that they will "mess up" the camera. You don't need to worry because you can easily reset the camera to the factory default settings. The Canon EOS T3/1100D is versatile and fun to use. You can begin making pictures at your

For this image of a sunset over the Cascade Mountains, I relied on the T3/1100D to give me a great overall exposure, and I was not disappointed. Exposure: ISO 100, f/2.8, 1/60 second.

current skill level and get excellent images. Then as you gain experience, you have all the power you need to take full creative control.

A Quick Look at Key T3/1100D Camera Controls

The camera controls you use most often are within reach. The following main controls can be used together or separately to control key functions on the T3/1100D:

▶ **Mode dial.** This dial enables you to choose a shooting mode. Shooting modes determine how much control you have over your images and over camera settings. To select a shooting mode, turn the Mode dial until the mode you want is lined up with the line on the camera body.

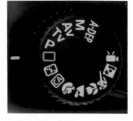

QT.1 The Mode dial

▶ **Cross keys and Set button.** When you are shooting images, you can press these keys to make adjustments to the ISO, AF (Autofocus mode), WB (White Balance), or Drive mode that is displayed as an icon in P, Tv, Av, M, an A-DEP shooting modes. When you are using the camera menus, you can press the left or right cross key to select a menu tab and the up or down cross key to move to menu options and make other menu selections. After you make a menu choice, press the Set button to confirm your choice. The Set button functions like an OK button for many actions.

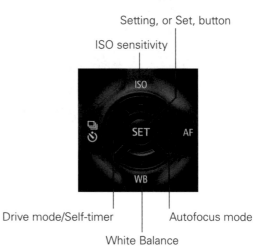

Setting, or Set, button

ISO sensitivity

Drive mode/Self-timer Autofocus mode

White Balance

QT.2 The cross keys and Set button. The surrounding camera controls are screened out to isolate the cross keys and Set button.

▶ **Main dial and shutter button.** Use the Main dial to move among camera menu tabs, to make selections on the Quick Control screen, to change the aperture in Av shooting mode, and to change the shutter speed in Manual shooting mode. Half-press the shutter button to set the focus. Then fully press the shutter button to make the picture.

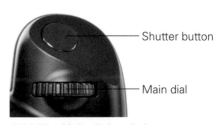

Shutter button

Main dial

QT.3 The Main dial and shutter button

▶ **Quick Control button.** The Q on the back of the camera is very handy for quick access to the camera settings you change most often as you're shooting. Press the Q button, press one of the cross keys to select the setting you want to change, and then turn the Main dial to adjust the setting. The number of settings you can adjust depends on the shooting mode that you choose. In P, Tv, Av, M, and A-DEP shooting modes, you can adjust more camera settings than when you use the automated shooting modes such as Flash Off, Portrait, and Landscape.

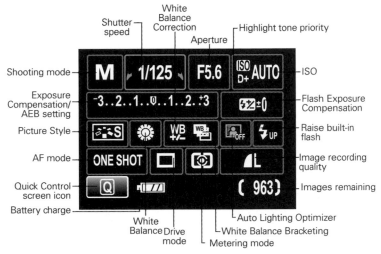

QT.4 The Quick Control screen

Setting up the T3/1100D

Much of the setup for the camera is done using the camera menus. To help you navigate the menus, similar settings are grouped and color-coded. For example, settings that affect shooting are located on the Shooting (red) menu tabs while setup and playback settings are grouped on other menu tabs.

It's important to know that the items on the camera menus change according to the shooting mode that you chose. In the automatic, or Basic Zone shooting modes, there are fewer options on camera menus than there are in the semiautomatic and Manual, or Creative Zone, modes. Also, the menus change when you're in Movie and Live View shooting modes. So if you can't find one of the options mentioned in this book, first check to see what shooting mode the camera is in, and then switch to P, Tv, Av, M, or A-DEP shooting mode and check the menu again.

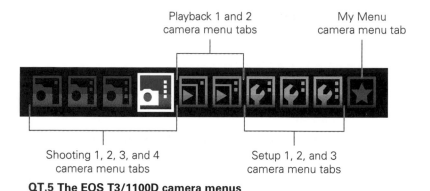

Playback 1 and 2
camera menu tabs

My Menu
camera menu tab

Shooting 1, 2, 3, and 4
camera menu tabs

Setup 1, 2, and 3
camera menu tabs

QT.5 The EOS T3/1100D camera menus

To use the camera menus, follow these steps:

1. **Press the Menu button on the back of the camera.**

2. **Turn the Main dial to move to the camera menu tab that you want.** You can also press the left or right cross key to move among camera menu tabs.

3. **Press the up or down cross key to choose an option.**

4. **Press the Set button to display suboptions, or to open additional screens.**

5. **Press a cross key to choose the option you want.**

6. **Press the Set button to confirm your choice.**

Setting the date and time

Setting the date and time is the first thing that the camera asks you to do. Once you set it, the date and time are included into EXIF (Exchangeable Image File Format) data for every image that you make. The EXIF data contains all the information about a picture, including the exposure information, camera settings, and the date and time you made the picture. You can see this information when you view your images in ImageBrowser, a program on the EOS Solution Disk that comes with the camera. The date and time provides a handy record that you can use to recall when you took pictures, and it can help

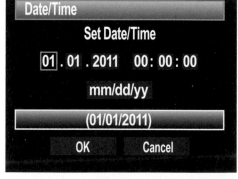

QT.6 Date/Time screen

you organize images on your computer. You may need to reset the date and time if the battery runs completely out of power.

To set the date and time, follow these steps:

1. **On the Setup 2 camera menu tab, select Date/Time, and then press the Set button.** The Date/Time screen appears with the month control selected.

2. **Press the Set button to activate the month control.** The camera adds up and down arrows to the month control.

3. **Press the up or down cross key until the number of the current month appears, and then press the Set button.**

4. **Press the right cross key to move to the next control, and then repeat Steps 2 and 3 to set the day, year, hour, minute, and second.**

5. **Press the left or right cross key to select OK, and then press the Set button.**

Setting the image quality

Choosing the image-recording quality is an important decision because it affects the following:

▶ **The maximum size at which you can print your images.** The higher the image quality, the larger the print that you can make.

▶ **The number of images that you can store on the memory card.** The higher the image quality, the fewer images you can store on the card. But with memory card prices being much more affordable in recent years, it's worth getting a large memory card and taking advantage of the highest quality images that the T3/1100D can deliver.

▶ **The *burst rate* — the maximum number of images captured when you shoot a series of images in rapid succession.** The higher the image quality, the lower the burst rate. But even at the Large/Fine quality, the burst rate is a healthy 830 images.

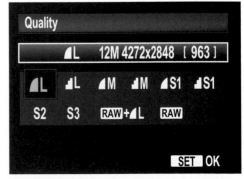

QT.7 Quality screen

I recommend choosing the Large/Fine recording quality to get the highest quality JPEG images. Also, if you're an

experienced photographer, then shooting RAW capture is an excellent option for getting the best image quality.

Here is how to set the image quality:

1. **Press the Q button on the back of the camera.** The Quick Control screen appears.

2. **Press the cross keys to select the Image-recording quality control located at the lower right of the screen, and then press the Set button.** This control displays the currently selected image-recording quality as an icon; for example, a quarter circle icon with the letter L appears if the camera is set to Large/Fine JPEG recording. The Quality screen appears after you press the Set button.

3. **Press the left or right cross key to select the recording quality you want, and then press the Set button.** As you move through the settings, the screen displays the image dimensions in pixels and the number of images that you can store on the memory card. The icons next to the letters on the Quality screen indicate the amount of compression. A quarter circle with a smooth edge indicates low compression for high image quality while a jagged icon edge indicates high compression for low image quality.

You can learn more about image-recording quality in Chapter 1.

Choosing a Shooting Mode

While Chapter 2 is the best place to learn all about the Rebel's shooting modes, here is a high-level summary to help you choose a shooting mode:

▶ **When you want to shoot quickly without worrying about changing camera settings, choose a shooting mode such as Portrait, Landscape, or Sports mode to have the camera take control of almost all the camera settings.** You can choose the image-quality settings and a few other options. Just press the Q button to display the Quick Control screen that shows the adjustments you can make.

▶ **When you want more control with minimal adjustments, set the Mode dial to Creative Auto (CA) shooting mode.** Then press the Q button on the back of the camera to display the Quick Control screen. On this screen, you can choose an Ambience setting that changes the overall contrast and color saturation of your images. You can set the level of background blur, which is the same as changing the f-stop. Just press the left or right cross key to increase or decrease the level of blur. Then press the down cross key to select either of the last two settings, Drive mode and Flash firing, and then press the Set button. Press the left or right cross key to select the option you want, and then press the Set button.

▶ **When you want a lot of control or complete control of the exposure and the camera settings, select P, Tv, Av, M, or A-DEP shooting mode.** In P mode, you can use the camera's suggested settings, or you can temporarily change the f-stop and shutter speed for one picture simply by turning the Main dial. In Av and Tv modes, you can control the f-stop and the shutter speed respectively. In Manual mode, you can set the f-stop and shutter speed yourself. And in A-DEP mode, the camera sets the best depth of field (by setting the f-stop automatically) and it sets the focus automatically. In these shooting modes, you can control all the features of the camera including the White Balance, Drive mode, focus (except in A-DEP mode), and autofocus mode, as well as other settings.

With the shooting mode set on the Mode dial, you can begin shooting. If you set the camera to P, Tv, Av, or M shooting mode, be sure to read the next section on focusing.

Getting Sharp Focus

When you're shooting in P, Tv, Av, and M shooting modes, you can control the focus — where the sharp focus is set in the image. In other shooting modes, the camera automatically decides what and where the subject is, and it decides which autofocus (AF) point or points to use. This is called automatic AF-point selection. Sometimes the camera correctly identifies the subject, and other times, it does not. Because one aspect of getting a successful image is getting sharp focus, it's important to know how to control the focus.

To ensure that the sharp focus is where it should be in the image, the best option is to use P, Tv, Av, or M shooting mode and to manually select the AF point yourself.

Here is how to manually select an AF point:

1. **In P, Tv, Av, or M shooting mode, press the AF-point Selection/Magnify button on the top right back of the camera.** This button has an icon of a magnifying glass with a plus sign under it.

QT.8 The Autofocus points are also displayed on the LCD. Here the center AF point is manually selected.

2. **Watch in the viewfinder as you turn the Main dial until the AF point you want is highlighted.** Choose an AF point that is on top of the place in the scene that should have sharp focus. For example, in a portrait, choose the AF point that is on top of the person's eye. As you move through the AF points, eventually all the AF points are highlighted. This is the option where the camera automatically chooses the AF point or points to use. Do not choose this option if you want to control the focus yourself. Instead select an option where only the one AF point you want to use is highlighted.

3. **Half-press the shutter button to focus, and then press it completely to make the picture.** When you half-press the shutter button, the AF point you selected will be highlighted.

Why Are My Pictures Blurry?

The most common reasons for blurry pictures are

▶ **Handholding the camera at a slow shutter speed and/or at a shutter speed that is too slow for the lens being used.** This is the number one reason for blurry pictures. If everything in the image is blurry, then handshake is the problem. Chapter 2 gives guidelines for minimum shutter speeds at which you can hold the camera without getting blur from handshake. To avoid handshake at slow shutter speeds, you can use tripod in interior and low-light scenes. Alternatively, you can use the built-in or an accessory flash. Or you can increase the ISO sensitivity setting to get a faster shutter speed.

▶ **The subject moves during a slow shutter speed.** If only the subject is blurry and the rest of the image is sharp, then subject movement during the exposure caused the blur. Check the shutter speed in the viewfinder, and if it is roughly 1/60 second or slower, then chances are good that if the child, pet, or subject you're photographing moves during the exposure, it will cause blur.

▶ **Automatic AF-point selection.** When the camera automatically selects the AF point or points, it is guessing where the subject is in the scene. Watch in the viewfinder to see which AF points the camera is using, and if the AF points are not on the subject, then move the camera, refocus, and see if you can force the camera to choose AF points where you want the sharp focus.

▶ **The camera back- or front-focuses.** Occasionally, the camera will focus in front of or behind the subject. Make it a habit to check images on the LCD after shooting to verify that the focus is precisely where you want it. Just press the AF-point Selection/Magnify button to zoom in the image. Press the cross keys to move to the place where you focused, and verify that focus is sharp. If the focus is not in the right place, reshoot.

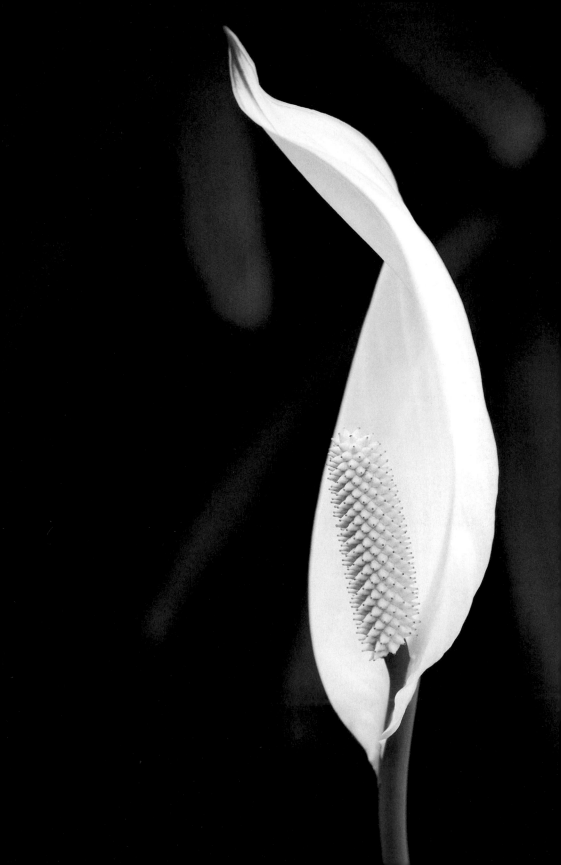

Setting up the EOS Rebel T3/1100D

One of the best ways to ensure that you never miss a picture is to know your T3/1100D like the back of your hand. With continued practice, you can learn the camera controls so well that you use them without hesitation. This chapter helps you become familiar with the T3/1100D and provides ways to make your everyday shooting easier and faster. As you read, have the camera nearby so that you can locate the controls. And also know that the shortest path to gaining mastery of the camera is by using it every day. This chapter also helps you set up the camera so that you can get the best images from it, and it provides a look at some camera options that can make shooting more enjoyable.

For this image of antique baby shoes, I wanted to keep the shutter speed fast enough for me to handhold the camera and not get blur from hand shake. I used the widest aperture on the lens, f/2.8, and I increased the ISO to 800, a combination which gave me a 1/50 second shutter speed — fast enough to handhold the camera and get a sharp image. Exposure: ISO 800, f/2.8, 1/50 second.

Overview of the T3/1100D Camera Controls

There are several key camera controls that you will use often. The following sections provide methods for using the controls efficiently.

▶ **Cross keys and Setting (Set) button.** These controls (shown in Figure 1.1) enable you to make adjustments to key camera settings in P, Tv, Av, M, or A-DEP shooting modes. Just press the AF (Autofocus mode); Drive (drive mode), which is displayed as an icon; WB (White Balance); or ISO sensitivity button to display a screen with options for changing the current settings, and then turn the Main dial to adjust the setting. When you're shooting in P, Tv, Av, M, or A-DEP shooting mode, you can

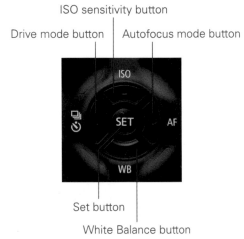

ISO sensitivity button

Drive mode button | Autofocus mode button

Set button

White Balance button

1.1 The cross keys and Set button

change the settings using all of these keys, but in automatic shooting modes such as Portrait, Landscape, and Sports, only some of the settings can be changed. The Set button, located in the center of the cross keys, is used to confirm changes to the options on the camera menus, and to open some submenus. Also, when you are using the Quick Control screen, you can select a setting, such as White Balance, and then press the Set button to display all the options for the setting.

▶ **Main dial.** On some camera menu screens, such as the Quality screen, you can turn the Main dial (shown in Figure 1.2) to select different options. You can also turn the Main dial to move among the camera menu tabs, and then press a cross key to select to a menu option.

1.2 The Main dial

▶ **Quick Control button.** This button with a Q on it gives you access to the Quick Control screen where you can change settings ranging from the ISO and Exposure Compensation to the White Balance and image quality. Just press the Q button, and then press

one of the cross keys to select a setting on the Quick Control screen (shown in Figure 1.3). Then turn the Main dial to change the setting. For some settings, you can press the Set button to display a screen with all the options. For example, if you select the White Balance and then press the Set button, the White Balance screen appears. Then just turn the Main dial to choose a different White Balance setting. The Quick Control screen is the easiest way to adjust settings when you are shooting in Program (P), Shutter-priority AE (Tv), Aperture-priority AE (Av), Manual (M), and Automatic Depth of Field (A-DEP) shooting modes.

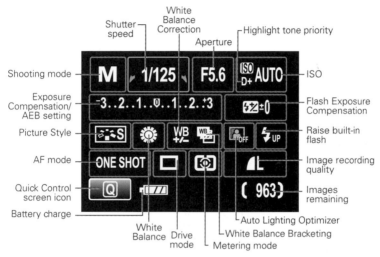

1.3 The Quick Control screen. If you have the Feature guide turned on, then some of the feature explanations cover up part of the Quick Control screen. You can turn off the Feature guide on the Setup 2 menu.

Roadmap to the Rebel T3/1100D

With the clean design of the T3/1100D, you can use your right thumb to quickly adjust the key controls on the back of the camera. If you are upgrading from a point-and-shoot camera, you'll find that the weight of the T3/1100D helps you stabilize your hands during shooting. The 2.7-inch LCD monitor is bright and detailed. You can adjust the LCD brightness up to seven levels. The LP-E10 battery gives you approximately 700 still images, 220 images Live View images, and approximately 1 hour and 50 minutes of movie shooting per charge.

The T3/1100D's most frequently accessed camera controls are easily accessible for quick adjustments as you're shooting. Less frequently used functions are accessible

from the camera menus. The following sections help you get acquainted with the camera's buttons and controls. It's a good idea to familiarize yourself with the names of the controls because the names are used throughout the book.

Front of the camera

On the front of the camera (shown in Figure 1.4), the control that you'll use most often is the Lens Release button. And, of course, you'll use the lens mount each time you change lenses.

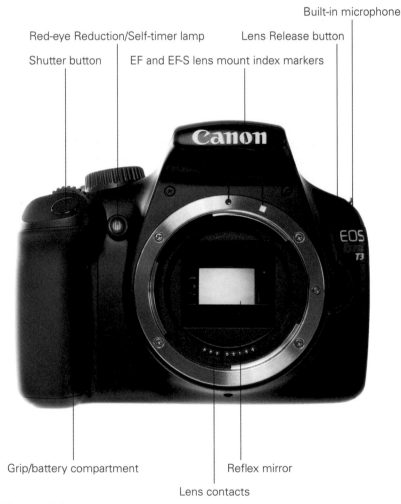

Built-in microphone

Red-eye Reduction/Self-timer lamp Lens Release button

Shutter button EF and EF-S lens mount index markers

Grip/battery compartment Reflex mirror

Lens contacts

1.4 Rebel T3/1100D front camera controls

Here is a look at the front of the camera:

▶ **Red-eye Reduction/Self-timer lamp.** When you have Red-eye Reduction turned on, this lamp lights to help reduce the size of the subject's pupils, which minimizes the appearance of red-eye in the final image.

▶ **Shutter button.** Press this button halfway down to focus on the subject, and then press it completely to make the picture. You'll learn more about focusing and exposure in Chapter 2. In addition, when you half-press the shutter button, the camera measures, or *meters*, the light and calculates the aperture and shutter speed based on the current ISO needed to make a well exposed picture.

▶ **Grip/battery compartment.** This is the molded area where your hand grips the camera, and it serves as the battery and memory card compartment as well.

▶ **Lens contacts.** These contacts provide communication between the lens and the camera.

▶ **Reflex mirror.** This mirror provides a view of the scene when you're composing the image in the viewfinder, and when you press the shutter button completely, it flips up and out of the optical path to expose the image sensor to make the picture. In Live View and Movie shooting, the mirror also flips up to give you a live view of the scene.

▶ **Built-in microphone.** The built-in monaural microphone records sound when you're shooting movies. See Chapter 6 for more details on the microphone.

▶ **Lens Release button.** Press this button to release the lens from the lens mount, and then turn the lens to remove it.

▶ **EF and EF-S lens mount index markers.** The lens mount has a white and a red mark for two types of lenses. The white mark on the lens mount is for Canon EF-S lenses that have a white mark on the lens barrel. EF-S lenses are designed for the smaller sensor size of the T3/1100D. The red mark on the lens mount is for Canon EF lenses. EF lenses can be used on any Canon EOS camera. Just set the lens on the lens mount and line up the white or red mark on the lens barrel with the same color mark on the lens mount, and then turn the lens to attach it.

Top of the camera

Controls on the top of the camera, shown in Figure 1.5, enable you to use your thumb and index finger to control common adjustments quickly. Here is a look at the top of the camera:

▶ **Focal plane mark.** This is the point from which the lens's minimum, or closest, focusing distance is measured.

▶ **Built-in flash.** The flash pops up automatically in automatic shooting modes. In semiautomatic and Manual shooting modes, you must press the Flash button to pop up and use the flash.

▶ **Hot shoe.** You can mount an accessory Speedlite or third-party flash unit here. The contacts provide communication between the flash and the T3/1100D.

▶ **Mode dial.** Turning this dial changes the shooting mode. Just line up the shooting mode you want to use with the white mark beside the dial. Shooting modes are detailed in Chapter 2.

▶ **Power switch.** This button switches the camera on and off.

 Custom Functions are detailed in Chapter 4.

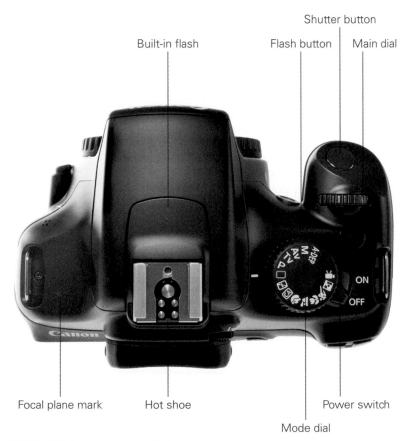

Shutter button

Built-in flash Flash button Main dial

Focal plane mark Hot shoe Power switch

Mode dial

1.5 Rebel T3/1100D top camera controls

▶ **Shutter button.** Described in the previous section.

▶ **Main dial.** Described earlier in the chapter.

▶ **Flash button.** In P, Tv, Av, M, and A-DEP shooting modes, press this button to pop up and use the built-in flash. In Basic Zone shooting modes, such as Full Auto and Portrait, the flash fires automatically.

Rear of the camera

The controls on the back of the Rebel T3/1100D, shown in Figure 1.6, enable you to make quick adjustments while you're shooting. Some of the rear camera controls can be used only in P, Tv, Av, M, and A-DEP shooting modes. In automatic camera modes such as Portrait, Landscape, and Sports, the camera sets the majority of the camera settings for you, so pressing the AF mode, WB, and ISO buttons has no effect. But in P, Tv, Av, or M, and A-DEP shooting modes, these buttons function as described in this section.

Here is a look at the back of the camera. The four cross keys and the Setting button on the back of the camera are detailed separately following this list.

▶ **LCD monitor.** The LCD monitor displays camera menus, pictures, and movies that are stored on the memory card, and it displays the Quick Control screen where you can change camera settings. The LCD monitor also displays a live view of the scene when you're shooting in Live View mode or in Movie mode.

▶ **Aperture/Exposure Compensation/Erase button.** Press and hold this button and turn the Main dial to set Exposure Compensation in P, Tv, Av, and A-DEP shooting modes. In Manual mode, press and hold this button and turn the Main dial to set the aperture. During image playback, press this button to delete the currently displayed image. Or you can press the left or right cross key to move to another picture to delete.

▶ **Live View/Movie shooting button.** Pressing this button enables you to begin shooting in Live View mode, or to shoot movies when the Mode dial is set to Movie shooting mode. During movie recording, a red dot appears on the LCD screen to indicate that recording is underway.

▶ **Quick Control (Q) button.** Press this button to display the Quick Control screen on the LCD when you're shooting still images, and when you're using Live View and Movie shooting. From the Quick Control screen, you can change exposure and other camera settings for still images, and in Live View and Movie shooting, you can change select camera settings. During image playback, pressing the

Q button displays controls for you to protect images, rotate them, rate images, or set a method for jumping among images. During printing, press this button to print one or more images from the memory card when the camera is connected to a compatible printer.

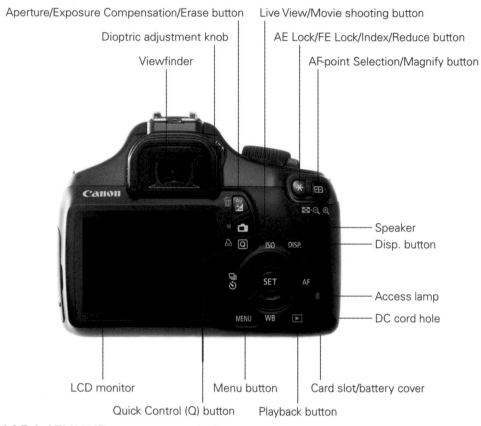

1.6 Rebel T3/1100D rear camera controls

▶ **Menu button.** Press the Menu button to display camera menus on the LCD. To move among menu tabs, turn the Main dial or press the left or right cross keys on the back of the camera. (The cross keys are the keys surrounding the Set button.)

▶ **Playback button.** Press this button to display the last image or movie captured on the LCD. To show more or less information during playback, press the Disp. button one or more times. Pressing the Index/Reduce button on the top-right back of the camera during playback displays a grid of 2 × 2 or 3 × 3 images that you can scroll through using the Main dial. Press the AF-point Selection/Magnify button once or twice to return to single-image display.

▶ **Card slot/battery cover.** The card slot/battery cover conceals the housing for the SD, SDHC (SD High Capacity), or SDXC (SD Extended Capacity) memory card and for the battery. Do not open this cover while images are being recorded or erased from the memory card, and do not turn off the camera.

▶ **DC cord hole.** Use this connection with the accessory AC Adapter Kit ACK-E8 to power the camera by plugging it into a household electrical outlet.

▶ **Access lamp.** This lamp lights when images are being written to the memory card. Do not open the card slot cover or turn off the camera when this lamp is lit.

▶ **Disp. button.** You can press this button to turn on and off the LCD. Each time you press this button during image playback, the information displayed on the LCD changes to show more or less information. If the camera menu is displayed, pressing the Disp. button shows the current camera settings. Press the Disp. button again to return to the camera menu.

▶ **Speaker.** Plays the audio recorded when you shoot a movie clip. You can adjust the playback volume by turning the Main dial.

▶ **AF-point Selection/Magnify button.** Press this button to activate the AF points displayed in the viewfinder so that you can manually select an AF point in P, Tv, Av, and M shooting modes. As you hold the button and turn the Main dial, you can select one AF point, or you can select all the AF points to have the camera automatically select the AF point or points used to focus. Or you can press the Set button to select the center AF point, or press again to switch to Automatic AF-point selection. During image playback, you can press this button to enlarge the preview image to check focus. With the image enlarged, just press a cross key to scroll around the image.

▶ **AE Lock/FE Lock/Index/Reduce button.** Pressing this button after pressing the shutter button halfway enables you to lock the exposure on a specific point in the scene. Then you can focus on another part of the scene. If you're using the built-in flash, pressing this button locks the flash exposure in the same way. During image playback, you can press this button to display multiple images as an index or four or nine images, or to reduce the size of an image you've enlarged during image playback.

▶ **Dioptric adjustment knob.** Turn this knob to adjust the sharpness for your vision by −2.5 to +0.5 diopters. If you wear eyeglasses or contact lenses for shooting, be sure to wear them as you adjust the dioptric adjustment knob. To make the adjustment, point the lens to a light-colored surface such as a white wall, and then turn the control until the AF points in the viewfinder are perfectly sharp for your vision.

▶ **Viewfinder.** On the Rebel T3/1100D, the viewfinder offers an approximately 95 percent view of the scene. The viewfinder uses a noninterchangeable Precision Matte focusing screen that displays the nine autofocus (AF) points.

The four buttons grouped around the Set button are collectively referred to as cross keys. The functionality of the keys or buttons change(s) depending on whether you're playing back images, navigating camera menus, or changing exposure settings. Also you can adjust most of the settings designated by the keys only in P, Tv, Av, M, and A-DEP modes. In automatic modes such as Portrait and Landscape, only some of the keys are available. For example, in Portrait shooting mode, you can press the Drive mode key to select some of the drive modes, but you cannot change the ISO setting when you press the ISO button.

During image playback, the left and right cross keys move backward and forward through the images stored on the memory card. On the camera menus, press the up and down cross keys move among menu options.

Here is a summary of the cross key and Set button functions:

▶ **ISO sensitivity button.** In P, Tv, Av, M, and A-DEP shooting modes, you can Press this button to change the ISO setting. ISO settings include Auto, where the camera automatically selects the setting based on the light in the scene, or settings from 100 to 6400 that you select.

▶ **Drive mode button.** Press this button to set the drive mode in P, Tv, Av, M, and A-DEP shooting modes and in some automatic modes. Depending on the shooting mode, you can choose to shoot one picture at a time, to shoot continuously at 3 frames per second (fps), or to shoot in one of the Self-timer modes. The maximum burst during continuous shooting is approximately 830 Large/Fine JPEG images or 5 RAW images. During image playback, press this button to move to a previous image.

▶ **White Balance button.** Press this button to display the White Balance screen where you can choose among seven preset White Balance options, or choose Custom White Balance in P, Tv, Av, M, and A-DEP shooting modes. (In automatic modes such as Portrait and Landscape, you can choose an adjustment similar to White Balance, but called Lighting or Scene type by using the Quick Control screen.)

▶ **AF mode button.** In P, Tv, Av, M, and A-DEP shooting modes, press this button to choose one of three autofocus modes: One-shot AF (also known as AI Focus) for still subjects; AI Focus AF for subjects that may start to move or move unpredictably, such as children and wildlife; or AI Servo AF for tracking focus of moving subjects.

▶ **Set button.** Press this button to confirm changes you make on the camera menus, and to display submenus.

Side of the camera

On the side of the T3/1100D is a set of terminals under a cover and embossed with icons that identify the terminals, which include the following:

▶ **Remote control terminal.** This terminal enables the connection of an accessory Remote Switch RS-60E3. You can use a remote control to press the shutter button both halfway and completely. A remote control is very nice to prevent the motion of having your finger press the shutter button at the beginning of long exposures.

▶ **Digital terminal.** Use this terminal to connect the camera to the computer or to a compatible printer using the cable supplied in the camera box.

▶ **HDMI mini OUT terminal.** The HDMI (High-Definition Multimedia Interface) mini OUT terminal is used to connect the camera to an HD television using an accessory HDMI cable to play back still images and movies on the TV.

Lens controls

Depending on the lens you are using, the number and type of controls offered vary. For example, if you are using an Image Stabilized lens, such as the lens in Figure 1.7, the lens barrel has a switch to turn on Image Stabilization, which helps counteract the motion of your hands as you hold the camera and lens. Some lenses offer a switch on the side that enables you to switch from autofocus to manual focusing.

Depending on the lens, additional controls may include the following:

▶ **Focusing distance range selection switch.** Although not offered on the lens in Figure 1.7, this switch determines and limits the range that the lens uses when seeking focus to speed up autofocusing. The focusing distance range options vary by lens.

▶ **Image Stabilizer switch.** This switch turns Optical Image Stabilization on or off. Optical Image Stabilization (IS) corrects vibrations at any angle when handholding the camera and lens. IS lenses typically allow sharp handheld images of two or more f-stops over the lens's maximum aperture.

▶ **Focus mode switch.** Many Canon lenses offer the Focus mode switch that enables you to switch between Autofocus (AF) and Manual Focus (MF).

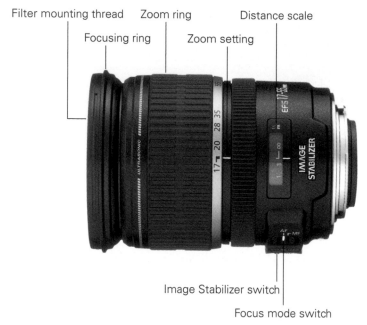

Filter mounting thread Zoom ring Distance scale

Focusing ring Zoom setting

Image Stabilizer switch

Focus mode switch

1.7 Controls on an Image Stabilized lens

▶ **Stabilizer mode switch.** Although not offered on the lens in Figure 1.7, this switch is offered on some telephoto lenses, and it has two modes: one mode for standard shooting and one mode for vibration correction when panning at right angles to the camera's panning movement.

▶ **Distance scale and infinity compensation mark.** This shows the lens's minimum focusing distance to infinity, denoted as an "8" on its side. The infinity compensation mark compensates for the shifting of the infinity focus point that results from changes in temperature. You can set the distance scale slightly past the infinity mark to compensate.

▶ **Zoom setting.** The focal length at which a zoom lens is set.

▶ **Zoom ring.** The zoom ring adjusts the lens in or out to the focal lengths marked on the ring.

▶ **Focusing ring.** For lenses that have a Focus mode switch, the lens-focusing ring can be used at any time regardless of focusing mode by switching to Manual Focus (MF) on the side of the lens, and then turning this ring to focus.

The LCD

With the T3/1100D, the 2.7-inch LCD not only displays captured images and current camera settings, but it also provides a live view of the scene when you're shooting in

Live View and Movie modes. The LCD displays 100 percent coverage of the scene. Figure 1.8 provides LCD details.

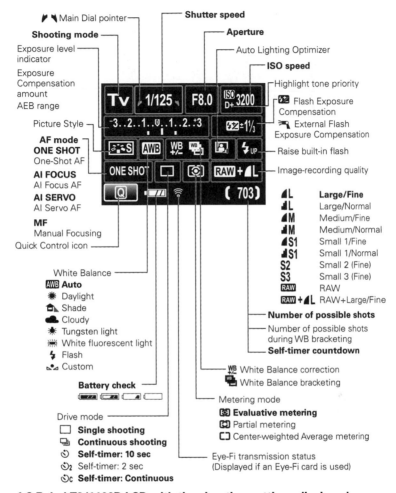

1.8 Rebel T3/1100D LCD with the shooting settings displayed

Viewfinder display

On the Rebel T3/1100D, the optical, eye-level pentamirror viewfinder displays approximately 95 percent of the scene that the sensor captures. In addition, the viewfinder displays the AF points, as well as information at the bottom that displays the current shooting settings, a focus confirmation light, and other settings. Figure 1.9 provides viewfinder display details.

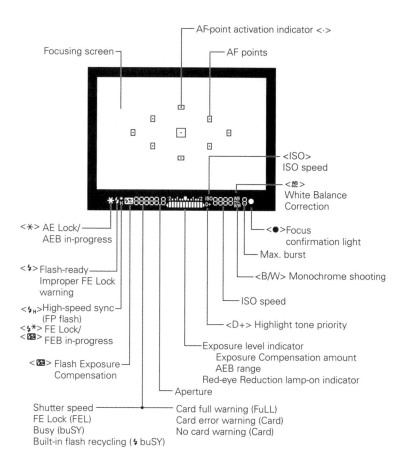

AF-point activation indicator <·>

Focusing screen

AF points

<ISO>
ISO speed

<WB> White Balance Correction

<✶> AE Lock/
AEB in-progress

<●>Focus confirmation light

Max. burst

<✦>Flash-ready
Improper FE Lock warning

<B/W> Monochrome shooting

<✦H>High-speed sync
(FP flash)

ISO speed

<✦✶> FE Lock/
<FEB> FEB in-progress

<D+> Highlight tone priority

<FEC> Flash Exposure Compensation

Exposure level indicator
Exposure Compensation amount
AEB range
Red-eye Reduction lamp-on indicator
Aperture

Shutter speed
FE Lock (FEL)
Busy (buSY)
Built-in flash recycling (✦ buSY)

Card full warning (FuLL)
Card error warning (Card)
No card warning (Card)

The display will show only the settings currently applied.

1.9 Rebel T3/1100D viewfinder display

Nine AF points are displayed in the viewfinder. You can manually select an AF point by pressing the AF-point Selection/Magnify button and turning the Main dial until the AF point you want is selected. If the camera automatically selects the AF point or points, the selected AF point or points are highlighted in the viewfinder when you press down the shutter button halfway.

You can verify exposure settings, focus, and more in the viewfinder before making a picture. The display changes depending on the shooting mode you're using.

Resetting the Rebel T3/1100D

Many people are afraid that changing camera settings will "mess up" the pictures that they're getting, and that they won't know how to reset the camera if they don't like the changes they've made. But there is no reason to worry because Canon provides a reset option so that you can always go back to the original settings on the Rebel T3/1100D and start fresh.

To reset the camera to the original settings, follow these steps:

1. **In P, Tv, M, or A-DEP shooting mode, press the Menu button, and then press the right cross key to select the Setup 3 menu.**

2. **Press the down cross key to select Clear settings, and then press the Set button.** The Clear settings screen appears.

3. **To reset the camera to factory settings, press the up or down cross key to select Clear all camera settings, and then press the Set button.** The Clear all camera settings confirmation screen appears.

4. **Press the right cross key to select OK.**

Memory Cards

One of the important choices you make is deciding which memory card you use in the camera. You can use SD and SDHC, SDXC, and Eye-Fi SD memory cards. Not all memory cards are created equal, and the type and speed of the card that you use affects the Rebel T3/1100D's performance, including how quickly images are written to the memory card, and your ability to continue shooting during the image-writing process. Memory card speed also affects the speed at which images display on the LCD and the recording of your movies. And with the high-definition video capability of the Rebel, Canon recommends using a Class 6 or higher memory card.

In addition, the T3/1100D accepts SDXC memory cards that have a greater storage capacity than SD cards. Eye-Fi SD cards have a built-in Wi-Fi transmitter and internal antenna for wireless, high-speed transfer of images and video from the camera to the computer or to online websites from Wi-Fi-enabled locations or your home network. Eye-Fi also supports geotagging, where geographical information is recorded with the image metadata.

At the time of this writing, SDXC cards are not supported by all computer operating systems. If you insert the card into a computer or card reader and receive a message

asking you to format the card, choose Cancel to avoid overwriting the SDXC format. For more information, visit www.sdcard.org/developers/tech/sdxc/using_sdxc.

The type of image file that you choose for shooting also affects the speed of certain tasks. For example, JPEG image files write to the memory card faster than RAW or RAW+Large JPEG files. JPEG and RAW file formats are discussed in detail later in this chapter.

As you take pictures, the LCD on the Rebel T3/1100D shows the approximate number of images that will fit on the memory card. The number is approximate because each image varies slightly, depending on the ISO setting, the file format and resolution, the Picture Style, and the image itself (different images compress differently). And for shooting video, recording shuts off automatically when the size of the movie file reaches 4GB. For still and video shooting, an 8GB or 16GB card is a good size to consider.

When you buy a new memory card, be sure to always format the card in the camera and never on your computer. Always off-load all images and movies to the computer before formatting because formatting erases images and movies even if you've protected them. Also be sure to format cards that you've used in other cameras when you begin using them in the Rebel T3/1100D. Formatting a memory card in the camera also cleans any image-related data, freeing up space on the card, and it manages the file structure on the card so the Rebel T3/1100D and memory card work properly together.

 For step-by-step tasks in this chapter that involve the camera menus, just press the Menu button, turn the Main dial to move to the camera menu tab you want, and then press the up or down cross key to select an option.

To format a card in the camera, be sure that you download all images and movies to your computer first, and then follow these steps:

1. **On the Setup 1 camera menu tab, select Format, and then press the Set button.** The Format screen appears asking you to confirm that you want to format the card and lose all data on the card.

 You can optionally choose the Low level format option that takes longer but completely erases all data and the recordable sectors on the card. The Low level format can improve the performance of the card.

2. **Select OK, or to do a Low level format, press the Erase button to place a check mark next to Low level format, and then select OK.**

3. **Press the Set button.** The camera formats the card, and then displays the Setup 1 menu.

It is a good idea to format memory cards every few weeks in the camera.

NOTE Here's how to avoid taking pictures when no memory card is in the camera. On the Shooting 1 menu, select Release shutter without card. Press the Set button, select Disable, and then press the Set button again.

Avoid Losing Images

When the camera's red access light — located on the back of the camera — is blinking, it means that the camera is recording or erasing image data. When the access light is blinking, do not open the card slot/battery cover, do not attempt to remove the memory card, do not turn off the camera, and do not remove the camera battery. Any of these actions can result in lost images and damage to the memory card. There is a beep to let you know that images are being written to the card, but make it a habit to use the access light as the indicator to not to open the memory card slot cover or turn off the camera.

Choosing the Image Quality

One of the first decisions you make when setting up the camera is the quality or resolution of the images you record and whether to shoot JPEG or RAW images, or both. You need to choose whether to shoot JPEG or RAW images, and then you choose the quality or resolution of the files. These decisions are important because they determine not only the number of images that you can store on the memory card, but also the size at which you can print images from the Rebel T3/1100D.

Many people choose JPEG images at a lower quality level so that they can store more images on the memory card. But it's as important or more important to get the best image quality from the camera if you want high-quality prints, especially if you want high-quality prints at large sizes. Another consideration is that the prices of memory cards have decreased over the years, so it's much more affordable to buy a large-capacity memory card and shoot at the highest quality settings. At the highest quality settings, you can make beautiful prints at approximately 11.7 × 16.5 inches on inkjet printers. Even if you don't foresee printing images any larger than 4 × 5 inches, you may get a once-in-a-lifetime shot that you want to print as large as possible. For this reason, and to take advantage of the Rebel T3/1100D's fine image detail and high resolution, consider setting a highest-quality setting for all your shooting.

You can choose the type of images you shoot and the quality level on the Quality screen, which can be accessed on the Shooting 1 camera menu. On the Quality screen, the JPEG quality options are displayed with icons that indicate the compression level of the files and the recording size, as shown in Figure 1.10. For example, the letter "L" indicates the largest JPEG file size, whereas the solid quarter circle indicates the lowest level of file compression that translates into the highest image quality. A jagged quarter circle indicates higher compression levels and lower image quality, whereas the "M" designation indicates medium quality. And "S" indicates small, or the lowest, image quality setting. To help you decide the image quality setting to use, file formats and compression levels are detailed next.

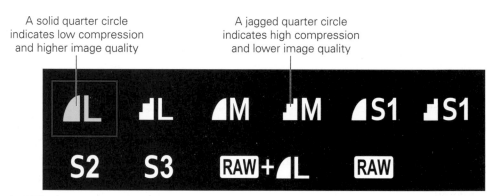

1.10 The icons on the Quality screen indicate the level of compression by the type of quarter circle shown with the letter designations.

JPEG format

JPEG, an acronym for Joint Photographic Experts Group, is a popular file format for digital images that provides not only smaller file sizes than the RAW files, but also enables you to display your images straight from the camera on any computer, on the web, and in e-mail messages. To achieve the small file size, JPEG compresses images, and, in the process, discards some data from the image — typically data that you would not easily see. This characteristic of discarding image data during compression is why JPEG has a *lossy* moniker. The amount of data discarded depends on the level of JPEG compression. High compression levels discard more image data than low levels. The higher the compression level, the smaller the file size and the more images that you can store on the memory card, and vice versa.

As the compression level increases to make the file size smaller, more of the original image data is discarded, and the image quality degrades. Compression also introduces defects, referred to as *artifacts*, which can create a blocky, jagged look, blurring, and

diminished color fidelity in the image. At low compression levels, artifacts are minimal, but as the level increases, they become more noticeable and objectionable. You'll see the effects of high compression ratios when you enlarge the image to 100 percent in an image-editing program on the computer. To get the highest-quality images, use the lowest compression and the highest quality settings, such as Large/Fine. The Fine setting is indicated by a solid edge on the quarter circle icon. If space on the card is tight, then use the next lower setting, Large/Normal. You can, of course, use the lower Medium and Small quality settings, but be aware that the image quality diminishes accordingly.

 If you edit JPEG images in an editing program, image data continues to be discarded each time you save the file. I recommend downloading JPEG files to the computer, and then saving them as TIFF (Tagged Image File Format) or PSD (Photoshop's file format) files. TIFF and PSD, available in Adobe's Photoshop or Photoshop Elements image-editing program, are lossless file formats.

When you shoot JPEG images, the camera's internal software processes, or edits, the images before storing them on the memory card. This image processing is an advantage if you routinely print images directly from the SD card, and if you prefer not to edit images on the computer. And because the T3/1100D offers a variety of Picture Styles that change the way that image contrast, saturation, sharpness, and color are rendered, you can get very nice prints with no editing on the computer.

Picture Styles are detailed in Chapter 3.

Should You Use the S2 and S3 JPEG Options?

On the T3/1100D you have two additional JPEG options: S2 and S3. Both options create images that are saved at very small sizes. The S2 option produces images at a diminutive 3.9 × 5.8 inches with a 2.5 megapixel recording size, but the image is a size that fits into a digital photo frame with no resizing needed in an editing program. The S3 option produces even smaller images that are ready for you to send in e-mail or to post on the web, and it records only 0.35 megapixels. These are convenient options, but because you cannot shoot these small files in combination with a larger file size, you have to be certain that you will never want larger versions of your S2 and S3 images. In short, I do not recommend shooting at the S2 and S3 quality settings.

The JPEG quality options reflect the megapixels recorded for the image. At the Large settings, images are recorded at 12.2 megapixels. The Medium quality options record 6.3 megapixels, while Small quality options record 2.5 megapixels.

RAW format

RAW files store image data directly from the camera's sensor to the memory card with minimal in-camera processing. Unlike JPEG images, which you can view in any image-editing program, you must view RAW files using the Canon Image Browser or Digital Photo Professional (shown in Figure 1.11), which are programs included on the EOS Digital Solution Disk. Or you can use another RAW-compatible program such as Adobe Bridge, Lightroom, Camera Raw, or Apple Aperture. Most operating systems, such as the Mac OS, provide regular updates so that you can view RAW images on your computer without first opening them in a RAW conversion program. To print and share RAW images, you must first convert them by using a program that supports the T3/1100D's RAW file format, and then save them as a TIFF or JPEG file. You can use Canon's Digital Photo Professional program or a third-party RAW-conversion program to both view and convert RAW images to TIFF or JPEG format.

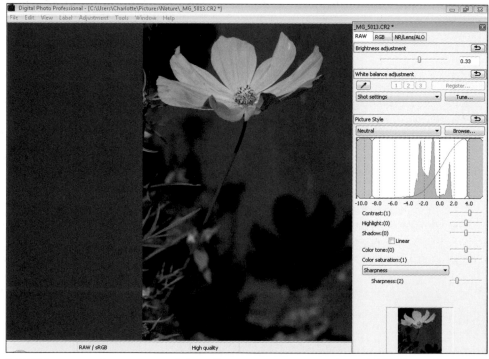

1.11 This screen shows some of the adjustments you can make to RAW files using Digital Photo Professional.

With all these caveats, you may wonder why you'd choose RAW shooting. The answer is simple and compelling — RAW files offer the highest image quality and the ultimate flexibility in correcting and perfecting your images. With RAW images, you can adjust key camera settings after you take the picture. For example, if you didn't set the correct white balance or exposure, you can change it when you convert the RAW image on the computer.

In addition, you can adjust the image brightness, contrast, and color saturation — in effect, you have a second chance to correct underexposed or overexposed images, and to correct the color balance, contrast, and saturation after you take the picture. The only camera settings that the Rebel T3/1100D applies to RAW files are aperture, ISO, and shutter speed. Other settings, such as White Balance, and Picture Style, are "noted," but not applied to the file. As a result, you have a great deal of control over how image data looks when you convert a RAW image.

Because RAW is a *lossless* format (no loss of image data), image quality is not degraded by compression. However, RAW files are larger, so you can store fewer RAW images on the memory card than JPEG images.

RAW files are denoted with a .CR2 file name extension. RAW conversion is a simple process that gives you the highest level of control over the final image. Appendix A provides an overview of how to convert and save a RAW file as a TIFF or JPEG.

RAW+JPEG

On the Rebel T3/1100D, you can also choose to capture both RAW and Large/Fine JPEG images simultaneously. The RAW+JPEG option on the image Quality screen is handy when you want the advantages that RAW files offer, and you also want a JPEG image to quickly post on a website or to send in e-mail. If you choose RAW+JPEG, both images are saved in the same folder with the same file number but with different file extensions. RAW files have a .CR2 extension, and JPEG files have a .JPG extension.

Table 1.1 shows the choices you have for image quality on the T3/1100D and how each affects the number of images you can capture when you're using Continuous drive mode and shooting a series of images, called a *burst*. You'll also see the maximum number of images that you can shoot in a burst on the right side of the viewfinder. This display only goes up to 9, so if the maximum number is greater than 9, it is displayed as "9."

Table 1.1 Image Quality, Size Options, and Burst Rates

Image quality		Approximate size in megapixels (MP)	File size (MB)	Maximum burst rate (4GB card)
JPEG	Large/Fine	12.2	4.4	830
	Large/Normal		2.2	1600
	Medium/Fine	6.3	2.6	1400
	Medium/Normal		1.4	2630
	Small1 (Fine)	3.4	1.7	2130
	Small1 (Normal)		0.9	4060
	S2	2.5	1.2	2880
	S3	0.35	0.3	11280
RAW	RAW	12.2	16.7	5
RAW +JPEG	RAW+Large/ Fine JPEG	12.2 each	21.1	1

To set the image quality, follow these steps:

1. **On the Shooting 1 camera menu select Quality, and then press the Set button.** The Quality screen appears. The currently selected quality setting is highlighted along with the image dimensions in pixels and the approximate number of images you can store on the current memory card in the camera.

2. **Press the right or left cross key to select the size and quality that you want, and then press the Set button.**

Working with Folders

The T3/1100D automatically creates a folder in which to store images. However, you can set up additional folders. This is a handy option that you can use to keep images separate for different scenes and subjects. Plus using folders can help you organize images as you download them to the computer. On the T3/1100D, each folder can contain up to 9,999 images, and when that number is reached, the camera automatically creates a new folder.

The folder numbering sequence is straightforward. It starts with the default 100CANON folder and goes up to 999CANON. You can create new folders either in the camera or on the computer.

When image 9999 is recorded within a folder on the memory card, the camera displays an error message, and you cannot continue shooting until you replace the

memory card, regardless of whether the card contains additional free space. This may sound innocuous, but it can cause missed shots. So if the camera stops shooting, try replacing the card. Here are the folder guidelines using either option:

▶ **Creating folders in the camera.** Folders created in the camera are numbered sequentially and begin with one number higher than the last number in the existing folder. The camera automatically creates folder 100CANON; therefore, if you create a new folder, the next folder name is 101CANON. When you create folders in the camera, the folder naming structure is preset and cannot be changed. If you insert a memory card from another Canon EOS dSLR, the folder retains the folder naming from the other EOS camera until you format the card in the T3/1100D.

▶ **Creating folders on the computer.** You can also create folders on the computer where you have more flexibility in folder naming, as shown in Figure 1.12. However, you must follow naming conventions. Each folder must be labeled with a unique three-digit number from 101 to 999. Then a combination of up to five letters (upper- and/or lowercase) and/or numbers can be added with an underscore after the number. No spaces are allowed and the same three-digit number can't be repeated. So, you can create a folder named 102CKL_1, but not one named 102SKL_1.

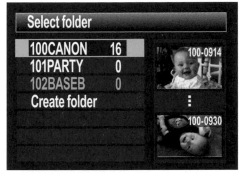

1.12 The Select Folder screen with two folders created on the computer.

If you format the memory card, the folders you created either in the camera or on the computer are erased along with all images. The only folder that isn't erased is the default 100CANON folder.

When you format the memory card, all existing folders except 100CANON are deleted. Thus you need to create new folders after you format the card.

To view an existing folder or create a new folder, follow these steps:

1. **On the Setup 1 camera menu tab, highlight Select Folder, and then press the Set button.** The Select folder screen appears showing existing folders and the number of images in each folder.

2. **Highlight Create folder, and then press the Set button.** The camera displays the Select folder screen with a confirmation message to create a folder with the next incremented number.

3. **Press the right cross key to select OK, and then press the Set button.** The Select folder screen appears with the newly created folder selected. The next images you take will be stored in the new folder. If you want to use a different folder, repeat Step 1, and then choose another folder.

Choosing a File Numbering Method

The Rebel T3/1100D automatically numbers images, but you can change the numbering sequence to suit your work.

At the default settings, the Rebel numbers images sequentially and assigns prefixes and file extensions. Both JPEG and RAW files begin with the prefix IMG. Movie files begin with MVI_ and have a .mov file extension. File numbering flexibility comes in handy because you can choose the type of file numbering method that the camera uses, and your choice can help you manage images on your

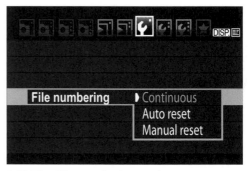

1.13 The File numbering options screen

computer. The file numbering options are Continuous, Auto reset, and Manual reset (shown in Figure 1.13).

Continuous file numbering

When you begin using the T3/1100D, the camera automatically numbers images sequentially. When you replace the memory card or switch to another folder, the camera remembers the last highest image number and continues numbering from the last file number. Images are numbered sequentially using a unique, four-digit number from 0001 to 9999. The camera continues sequential numbering until you shoot image number 9999. At that point, the camera creates a new folder, and new images that you shoot restart with number 0001.

This file-numbering sequence continues uninterrupted until you insert a memory card that already has images on it. At that point, the T3/1100D notes the highest file number on the memory card, and then uses the next highest number when you take the

next image — provided that the number is higher than the highest image number stored in the camera's memory. Stated another way, the camera uses the highest number that is either on the memory card or that is stored in the camera's internal memory. Then the camera uses that number to continue file numbering. If it is important to you that files be numbered consecutively, then be sure to insert formatted/empty memory cards into the camera.

An advantage of Continuous file numbering is that, to a point, this file-numbering option ensures unique file names, making managing and organizing images on the computer easier because there is less chance that images will have duplicate file names.

Auto reset

With this file-numbering option, you can have the file number restart with 0001 each time you insert a different memory card. If the memory card has images stored on it, then numbering continues from the highest image number stored on the card. So if you want the image numbering to always begin at 0001, then be sure to insert a freshly formatted memory card each time you replace the card.

If you like to organize images by memory card, Auto reset is a good option. However, be aware that multiple images that you store on the computer will have the same file name. This means that you should create separate folders on the computer and follow scrupulous folder organization to avoid file name conflicts and potentially overwriting images that have the same file name.

 Now is a good time to create a system for storing images in folders on your computer. I know from experience that the time spent creating a solid file system for storing images pays big dividends over time.

Manual reset

If you choose Manual reset, the camera automatically creates a new folder on the memory card, and then it saves images to the new folder starting with file number 0001. Then the file numbering returns to Continuous or Auto reset — whichever option you used previously.

The Manual reset option is handy if you want the camera to create separate folders for images that you take over a span of several days.

To change the file-numbering method on the T3/1100D, follow these steps:

1. **On the Setup 1 menu, select File numbering, and then press the Set button.** Three file-numbering options appear with the current setting highlighted.

2. **Press the down or up cross key to select Continuous, Auto reset, or Manual reset, and then press the Set button.** The option you choose remains in effect until you change it with the exception of Manual reset, as noted previously.

Additional Setup Options

The T3/1100D has a number of handy setup options can make your shooting easier and more efficient. You may have already set some of these options, but in case you missed some, you can check Table 1.2 and see which ones you want to set or change.

The additional setup options are typically those that you set up only once, although some you may revisit in specific shooting scenarios. For example, I prefer to turn on the autofocus confirmation beep in most shooting situations. But at a wedding or an event where the sound of the beep is intrusive, I turn it off.

Also, you may prefer to have vertical images automatically rotate on the LCD to the correct orientation. However, this rotation makes the LCD image smaller, so you may prefer to rotate vertical images only for computer display.

Table 1.2 provides a guide for these additional setup options. If you don't see an option listed in the table, check to see which shooting mode you've set on the Mode dial. Some options are not available in the automatic shooting modes such as Portrait, Landscape, and Sports. If an option isn't available, just change the Mode dial to P, Tv, Av, M, or A-DEP to access the option. In other instances, the options are detailed in later chapters of this book.

To change these options, press the Menu button, and then follow the instructions in the subheadings in Table 1.2. Options for shooting movies are detailed in Chapter 6.

Table 1.2 Additional Setup Options

Turn the Main dial to choose this Menu tab.	Press the up or down cross key to select this Menu option.	Press the Set button to display these Menu suboptions.	Press a cross key to select the option you want, and then press the Set button.
Shooting 1	Beep	Enable, Disable	Choose On for audible confirmation that the camera achieved sharp focus. Choose Off for shooting scenarios where noise is intrusive or unwanted. The beep is also used for the Self-timer drive mode.
	Release shutter without card	Enable, Disable	Choose Disable to prevent inadvertently shooting when no memory card is inserted. The Enable option is marginally useful, and then only when gathering Dust Delete Data.
	Image review	Off, 2 sec., 4 sec., 8 sec., Hold	Longer durations of 4 or 8 seconds to review LCD images have a negligible impact on battery life except during travel, when battery power is at a premium. I use 4 sec. unless I'm reviewing images with a subject; then I choose 8 sec.
Playback 1	Rotate		Choose this option to rotate vertical images to the correct orientation on the LCD only, albeit at a smaller size. You can rotate by 90, 270, or 0 degrees. You can use this option for thumbnail Index view as well. Movies cannot be rotated. If you set the Auto rotate option, you do not need to use this option.
Setup 1	Auto power off	30 sec., 1 min., 2 min., 4 min., 8 min., 15 min., Off	This setting determines when the camera turns off after you haven't used it. Shorter times conserve battery power. To turn the camera back on, lightly press the shutter button or press the Menu or Disp. button; a cross key; and so on. Even if you choose the Off option, the LCD turns off automatically after 30 minutes.
	Auto rotate	On the LCD and computer, On the computer only, or Off	Two On options let you choose to automatically rotate vertical images to the correct orientation on the LCD and computer monitors, or only on the computer monitor. If you choose the first option, the LCD preview image is displayed at a reduced size. Choose Off for no rotation on the camera or computer.

continued

Table 1.2 Additional Setup Options *(continued)*

Turn the Main dial to choose this Menu tab.	Press the up or down cross key to select this Menu option.	Press the Set button to display these Menu suboptions.	Press a cross key to select the option you want, and then press the Set button.
Setup 1 *(continued)*	Screen Color	1, 2, 3, or 4	Each option changes the background color: 1. The default black background with white text. 2. Gray background with black text. 3. Dark gray background with white text. 4. Dark gray background with green text.
	Eye-Fi settings	Eye-Fi Trans (Enable/ Disable), and Connection info.	This menu option is available only when you're using an Eye-Fi SD card in the camera. Choose the Enable option to allow automatic wireless image or movie file transmission. Connection info. displays the access point and MAC address information as well as other error messages.
Setup 2	LCD brightness	Seven levels of brightness	Choose this menu option to display a screen on which you can select from one to seven levels of LCD brightness.
	LCD off/on btn	Shutter btn, Shutter/ Disp., Remains on	This option determines how you dismiss or display the LCD. The Shutter btn option is the default where half-pressing the shutter button dismisses the display. The Shutter/Disp. option dismisses the display with a half-press of the shutter button, and redisplays it with a press of the Disp. button. The Remains on option does what it says it will do by leaving the LCD on, although you can dismiss it by pressing the Disp. button.
	Feature guide	Enable, Disable	The default Enable option displays brief descriptions of camera functions and options.
Setup 3	Clear settings	Clear all camera settings, Clear all Custom Func. (C.Fn.), Cancel	Choose the Clear all camera settings option to reset the camera settings back to the manufacturer's default settings. Choose Clear all Custom Func. (C.Fn.) to reset all Custom Function settings to the manufacturer's original settings.
	Firmware Ver.		Displays the current firmware version. Choose this option to install a newer firmware version.

Adding a Copyright to Images

In broad terms, a copyright identifies your ownership of images. On the T3/1100D, you can add your copyright information to the metadata so that your name and other information is embedded into the data that is included for each image that you make. This copyright information can be a first step in proving your ownership of images that are used without your permission. For this and other reasons, I encourage you to enter your copyright information. You only have to enter it once for it to be used on all your images. Also, the copyright information appears only in the image metadata, and not on printed images.

 To complete the copyright process, register your images with the United States Copyright Office. For more information, visit www.copyright.gov.

To enter your copyright and name on your images, follow these steps:

1. **On the Setup 3 camera menu tab, highlight Copyright information, and then press the Set button.** The Copyright information screen appears.

2. **Highlight the option you want, such as Enter author's name or Enter copyright details (shown in Figure 1.14), and then press the Set button.** A screen appears where you can enter the name or details (shown in Figure 1.15).

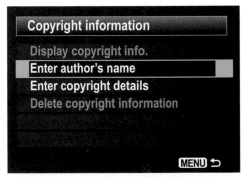

1.14 The copyright options include entering your name and your copyright details.

3. **Press the Q button to activate the keyboard portion of the screen, and then press the left or right cross key or turn the Main dial to move the cursor to the letter you want to enter.** You can enter up to 63 letters, symbols, and numbers.

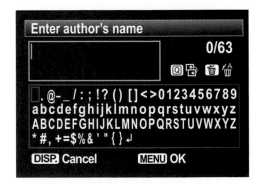

1.15 The author name entry screen

4. **Press the Set button to insert the letter in the top portion of the screen.** If you make a mistake and want to delete a character, press the Erase (trash can) button.

5. **When you're finished press the Menu button to return to the previous screen where you can choose the to enter copyright details or the author name, whichever one you didn't choose in Step 3.** You can cancel entering text by pressing the Disp. button. To display the copyright, repeat Steps 1 and 2, and in Step 3, choose Display copyright info.

If you need to delete the copyright information, choose Delete copyright information on the Copyright information screen.

Viewing and Finding Images and Movies

On the Rebel T3/1100D, you can view images and movies immediately after you take them. For still images, you can also magnify images to verify that the focus is sharp, display and page through multiple images that you have stored on the memory card, check the histogram and exposure information, or watch images as a slide show. The following sections describe viewing options and suggestions for using each one.

You can also play back movies on the LCD, as detailed in Chapter 6.

Single-image or movie playback

Single-image or movie playback is the default playback mode. In Single-image play-back the camera displays one image or movie at a time on the LCD. Canon sets the initial display time to 2 seconds to maximize battery life, but a longer display time of 4 seconds is more useful. And, if you are reviewing images with a friend or the subject of the picture, the 8-second option may be best. Alternatively, you can choose the Hold option that displays the image until you dismiss it by lightly pressing the shutter button.

To turn on image review, press the Playback button on the back of the camera. If you have multiple pictures on the memory card, you can use the left and right cross keys to move forward and backward through the images.

In Single-image playback, you can cycle through four different displays. Each display includes more or less information about the image. In the default display, only the preview image is displayed with a small ribbon of information at the top. Just press

the Disp. button to show the image with the exposure settings, folder and file number, and images on the memory card overlaid. Press the Disp. button once or twice more to display a small preview image with shooting information and one or more histograms.

Index display

Index display shows thumbnails of four or nine images at a time. This display is handy when you need to ensure that you have a picture of everyone at a party or event, or to quickly select a particular image on a card that is full of images.

To turn on the Index display, follow these steps:

1. **Press the Playback button on the back of the camera, and then press the AE/FE Lock button once to display an index of four images, or press it twice to display nine images.** The AE/FE Lock button has an icon asterisk on the button. The LCD displays an index of images stored on the memory card. If you don't have four or nine images on the card, it displays as many images as are stored on the card.

2. **Press the cross keys to select an image.** The selected image has a border around it.

3. **To move to the next page, turn the Main dial.**

4. **Press the AF-point Selection/Magnify button one or more times to return to single-image display, or press the Set button to display the selected image in Single-image playback mode.**

Rating images and movies

Every photographer can quickly identify the best images or movies in a series, and can as quickly identify those that are second and third picks. With the T3/1100D, you can assign one to five star ratings to images and movies, not only to simply identify the best ones, but also to help you quickly find your favorite images on the memory card using the image jump technique detailed next. In addition, you can use the star ratings when you create a slide show, and to sort images and movies in the ImageBrowser, a program provided on the EOS Digital Solution Disk that comes in the box.

To rate images or movies, follow these steps.

1. **On the Playback 2 camera menu tab, highlight Rating, and then press the Set button.** The last image on the memory card appears on the LCD with a ribbon of rating options overlaid on the top.

2. **If necessary, press the left or right cross key to select the image or movie to rate, and then press the up or down cross key one or more times to select a rating.** Stars appear on the left of the ribbon to reflect the rating.

3. **To continue rating images, repeat Step 2, and then press the Menu button to exit the rating display.** The Playback 2 menu appears.

Image jump

When you have a lot of images on the memory card or you want to find only the movies or only the still images on the card, you can use Image jump on the Playback 2 menu. Then you can choose to move through images by 1, 10, or 100 images at a time, or find images by date, folder, movies, stills (still images), or by image rating.

Here is how to choose the jump method to move through images:

1. **On the Playback 2 camera menu tab, highlight Image jump w/[Main dial], and then press the Set button.** The Image jump w/[Main dial] screen appears, as shown in Figure 1.16. You can choose among icons that represent 1, 10, 100 images, or date, folder, movies, stills (still images), or image rating.

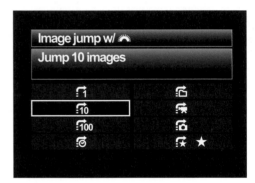

1.16 The Image jump options

2. **Press the up or down cross key to select the jump method, and then press the Set button.** If you chose image rating (represented with a star icon), just turn the Main dial to select the rating number you want to jump by.

3. **To jump through images, press the Playback button on the back of the camera.** The most recent image is displayed on the LCD.

4. **Turn the Main dial to jump through images by the option you selected in Step 2.** The LCD displays the jump method and relative progress through the images on the card at the lower right of the LCD.

Slide show

When you want to sit back and enjoy all the pictures or movies on the memory card, you can create a slide show. This is a nice option to use when you want to share

pictures with one or two of the people you're photographing, or to verify that you've taken all the shots that you intended to take during a shooting session.

During the slide show, the camera does not go to sleep, which would interrupt the image or movie playback.

You can set up and start a slide show by following these steps:

1. **On the Playback 2 camera menu tab, select Slide show, and then press the Set button.** The Slide show screen appears, as shown in Figure 1.17.

2. **Press the up or down cross key to highlight All images, and then press the Set button. Scroll arrows are added to the right of the All images box.**

 1.17 The Slide show screen

3. **Press the up or down cross key to select from the options: All images, Rating, Stills, Movies, Folder, or Date.** And then:

 • If you select All images, Stills, or Movies, press the Set button.

 • If you select Date, Folder, or Rating, press the Disp. button to select the date from the Select date screen. Then press the Set button. If you select All images, Date, Folder, or Rating, both still images and movies are played in the slide show. To see only movies or only still images, choose the Stills or Movies option.

4. **Select Set up, and then press the Set button.** The Slide show screen appears with options to set the Display time, Repeat, and Transition effect.

5. **Select Display time, and then press the Set button.** The Display time options appear and are 1, 2, 3, 5, 10, or 20 seconds.

6. **Select the Display time duration you want, and then press the Set button.**

7. **Repeat Steps 5 and 6 to set the Repeat and Transition effect options you want.** If you want a continuously playing slide show, select Enable for the Repeat option. And for Transition effect, you can choose one of two Slide-in options and one of three Fade options.

8. **Press the Menu button, and then select Start.**

9. **Press the Set button to begin the slide show.** You can pause and restart the slide show by pressing the Set button. Press the Disp. button to change the display to single image, or images with histograms and shooting information. If you're playing back movies, turn the Main dial to adjust the volume. Press the Menu button to stop the slide show and return to the Slide show screen.

You can also play the slide show on a TV. Connecting the camera to an HD TV is detailed in the next section.

Displaying images on an HD TV

Viewing images stored on the memory card on a TV is a convenient way to review images at a large size whether you're at home or traveling. If you want to view images on an HD TV, you need to buy an HDMI Cable HTC-100, and the TV must have an HDMI terminal.

1. **Turn off the TV and the camera.**

2. **Attach the HDMI cable to the camera's HDMI OUT terminal with the plug's HDMI MINI logo facing the front of the camera, and connect the other end to the TV's HDMI IN port.**

3. **Turn on the TV, and then switch the TV's video input to the connected port.**

4. **Turn on the camera.**

5. **Press the Playback button.** Images are displayed on the TV but not on the camera's LCD monitor. When you finish viewing images, turn off the TV and the camera before disconnecting the cables. If your TV is HDMI CEC (Consumer Electronics Control) compatible, you can use the TV remote to control the slide show. On the Playback 2 menu, select Ctrl over HDMI, select Enable, and then press the Set button.

> **TIP** You can use the previous steps not only to display images stored on the memory card on the TV, but also to use the TV to display what would appear on the LCD during both general shooting and when you're shooting in Live View.

Erasing and Protecting Images and Movies

For those of you who keep multiple images on memory cards for prolonged periods of time, it's important to protect images you want to keep from being deleted. The following sections detail how to erase and protect one or multiple images.

Erasing images and movies

Erasing images is useful provided that you are certain that you don't want the images. From experience, I know that some images that appear to be mediocre on the LCD can very often be salvaged with judicious image editing on the computer. For that reason, I recommend erasing images with caution.

With the Rebel T3/1100D, you can choose to erase images one at a time, select individual images to erase, erase all images in a folder, or can erase all images on the memory card. If you want to delete one image at a time, follow these steps:

1. **Press the Playback button, and then press the left and right cross keys to select the picture that you want to delete.**

2. **Press the Erase button, and then press the right cross key to select Erase.** The Erase button is also the AV (Aperture/Exposure Compensation) button to the right of the LCD.

3. **Press the Set button to erase the image.**

To select and erase a group of images that you select, follow these steps:

1. **On the Playback 1 camera menu tab, highlight Erase images, and then press the Set button.** The Erase images screen appears, as shown in Figure 1.18.

2. **Highlight Select and erase images, and then press the Set button.** The last captured image appears on the LCD with an erase icon and a box at the upper left of the screen.

3. **Press the left or right cross key to move to the first image you want to delete, and then press the up cross key to place a check mark in the box at the top left of the screen.** This marks the image for deletion, as shown in Figure 1.19.

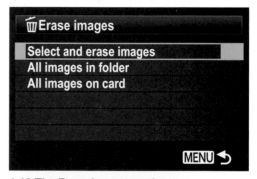

1.18 The Erase images options

1.19 An image on the playback screen that is ready to be marked for deletion.

4. **Repeat Step 3 to move to and mark additional images.**

5. **Press the Erase button on the back of the camera.** The Erase images screen appears with a confirmation message asking if you want to erase the selected images.

6. **Select OK, and then press the Set button.** All check-marked images are erased.

Alternatively, in Step 1 you can choose to erase all images in a folder or all images on the memory card. If you choose the folder option, then the Select folder screen appears where you can select the folder from which you want to delete images. Press the Set button, and then select OK to delete images in the folder.

Protecting images and movies

To ensure that important images are not accidentally deleted, you can add protection to them. Setting protection means that no one can erase the image when using the Erase images options. I know from personal experience that it takes only a minute to accidentally delete images. In that second, important images are lost forever. This can be prevented if you go through your images and apply protection to them. And if several people use the T3/1100D, and they need more space on the memory card, you can avoid having your important images deleted by adding protection.

 Even protected images are erased if you or someone else formats the
CAUTION memory card.

You can protect an image by following these steps:

1. **On the Playback 1 camera menu tab, highlight Protect images, and then press the Set button.** The Protect images screen appears, as shown in Figure 1.20.

2. **Select the Select images, All images in the folder, or All images on the card option.** If you choose the Select images option, the last image taken

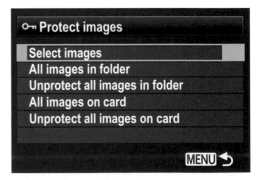

1.20 The Protect images screen

appears on the LCD with a protection icon, denoted by a key, and a SET icon in the upper-left corner. If this isn't the image you want to protect, press the left or right cross key to display the image you want to protect.

3. **Press the Set button to add protection to the image.** A key icon appears at the top of the preview image, as shown in Figure 1.21.

4. **Press the left or right cross key to move to another image, and then press the Set button.** If you want to remove protection, navigate to a protected image, and then press the Set button. Protection is removed

1.21 An image with protection applied as indicated by the key icon in the upper ribbon above the image.

and is indicated by the protection icon being removed.

Alternatively, in Step 2 you can choose to protect all images in a folder or all images on the memory card. If you choose the folder option, then the Select folder screen appears where you can select the folder in which you want to protect images. Press the Set button, and then select OK to protect images in the folder. If you opt to protect all images on the memory card, a confirmation screen appears. Simply select OK to protect all images on the memory card. To unprotect images on the card or on the folder, select the appropriate option on the Protect images screen.

Working with Eye-Fi Cards

A handy way to transfer images and movies to the computer is to use an Eye-Fi card that wirelessly transmits images to an online service or to your computer using a wireless local area network (LAN). The card looks just like an SD/SDHC card but adds the wireless transfer capability as well as other features that work with the T3/1100D.

 The T3/1100D can use Eye-Fi cards, although Canon does not guarantee support for all functions on the card.

Depending on the Eye-Fi card, you can upload to your favorite networks with the proper ID and passwords. You first set up the Eye-Fi card on your computer to choose the network you want to use, and then you set up a folder for transferring images and movies to the computer. Then when you insert the Eye-Fi card into the T3/1100D, media is automatically transferred as you shoot. In addition, the card controls the T3/1100D's Auto power-off function so that the camera's power remains on until the transfers are complete.

Newer Eye-Fi cards offer *endless memory*, a function that deletes the oldest images and movies that have been successfully transferred to the computer or network service to free up space on the card. You can set the card capacity point at which older images will be deleted to make space available. The concept of endless memory applies to the card, and it is endless only insofar as the amount of the space you have on the computer or network service. Newer cards also include geotags, hotspot locations, RAW file transfer, and more. Card sizes range from 4GB to 8GB.

You need to verify that wireless transmissions are permitted in certain regions and locations. Airports, hospitals, and some businesses do not permit wireless transmissions. In such areas, you can prevent the card from emitting a signal, even when no images are being transmitted, by removing the card from the camera.

To use an Eye-Fi card in the T3/1100D, set up the card in the computer according to the manufacturer's instructions and insert it in the camera. Then follow these steps:

1. **On the Setup 1 camera menu tab, highlight Eye-Fi settings, and then press the Set button.** The Eye-Fi settings screen appears.

2. **Select Eye-Fi trans. (transmission), and then press the Set button.** The Enable and Disable options appear.

3. **Select Enable, and then press the Set button.**

4. **On the Eye-Fi settings screen, select Connection info., and then press the Set button.** The Connection info. screen appears.

5. **Verify that an Access point Service Set Identifier (SSID) is being used, and you can also verify the Media Access Control (MAC) address.**

6. **Press the Menu button three times to exit.**

7. **Take the first picture.** The preview image is displayed. Thereafter, a transfer icon is displayed for images that have already been transferred. The T3/1100D has four self-explanatory icons that indicate connection status; or you can press the Info. button to see the status on the shooting settings display screen.

Controlling Exposure and Focus

Part of the beauty of the T3/1100D is that you don't have to be an experienced photographer to make beautiful images. If you previously had a point-and-shoot camera, some of the features of your point-and-shoot camera carry over to the T3/1100D. More important, the Rebel T3/1100D's full complement of features opens the door to a wonderful creative photography experience.

If you're like many new EOS Rebel photographers, you likely want to graduate from using the automatic camera modes and move into the creative modes. This chapter helps you do that. In addition, you learn about how to get great image exposures and how to adjust the exposure when you face challenging scenes and subjects. You also learn in this chapter how to get tack-sharp focus.

For this image, I used negative Exposure Compensation to tone down the highlights in the water surrounding the water lily. Exposure: ISO 200, f/6.3, 1/320 second with –1/3-stop of Exposure Compensation.

Exploring Exposure on the T3/1100D

If you are new to photography, then I encourage you to read Chapter 9, which details all the elements that go into making an exposure. With that chapter as background, you will be ready for the next step: defining what makes a "good exposure."

From a creative point of view, a good exposure captures and expresses the scene as you saw it or envisioned it. Technically, a good exposure maintains image detail within the brightest highlights (or the highlights within the subject) and in the shadows, displays a full and rich range of tones with smooth transitions, has visually inviting color, pleasing contrast, and, of course, tack-sharp focus. With that in mind, your goal is to capture the best exposure possible *in the camera* rather than relying on using image editing to fix problems.

The first step in getting a technically good exposure happens when the camera measures, or *meters*, the amount of light in the scene. The T3/1100D meters light every time you half-press the shutter button. Then based on the meter reading, the camera quickly calculates the ISO if you're using Auto ISO, aperture (f-stop), and shutter speed needed to make a good exposure. This calculation is the camera's suggested, or ideal, exposure. You may use the suggested exposure as is, or you may want to change elements of the exposure such as changing the aperture to get more or less blur in the background. Alternately, if you're shooting a sports event, you may want to use a faster shutter speed than what the camera suggests.

Let's say that you decide to change the f-stop (aperture) without changing the ISO setting. When you change the f-stop, the shutter speed must also change proportionally to get a good exposure. You have a good deal of latitude when making changes to the aperture (or shutter speed) simply because many different combinations of apertures and shutter speeds produce an equivalent and correct exposure.

For example, at the same ISO setting, f/11 at 1/125 second is equivalent to f/2.8 at 1/2000 second. In other words, both of these exposures let the same amount of light into the camera. While the amount of light is the same, the resulting pictures look very different. With a narrow aperture, or large f-stop number, such as f/11, the scene will have sharper detail from front to back than it will if you use a wide aperture, or small f-stop number of f/2.8. An f/8 to f/22 or narrower aperture provides an extensive depth of field where detail is rendered in acceptably sharp focus from back to front in the image (see Figure 2.1). By contrast, f/5.6 to f/2.8 creates a shallow depth of field where detail behind and in front of the plane of sharp focus appears as a soft blur (see Figure 2.2).

 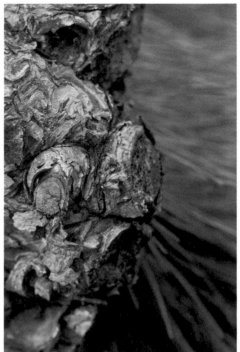

2.1 In this image, a narrow f/14 aperture shows much more detail in the background tree branch than in Figure 2.2. Exposure: ISO 200, f/14, 1/25 second.

2.2 In this image, the details of the background tree branch are blurred thanks to a wide aperture that provides shallow depth of field. Exposure: ISO 200, f/5.6, 1/200 second.

Although it's helpful to know about exposure settings, you don't have to master them to use the Creative Zone modes, except perhaps M (Manual) mode. In Program AE (P), Shutter-priority AE (Tv), and Aperture-priority AE (Av) shooting modes, when you set one exposure setting, the Rebel automatically sets the other exposure element for you. For example, if you choose Av mode, you can set the f-stop, and the camera automatically sets the correct shutter speed. This makes it easy to use the Rebel's creative controls immediately, and it helps you learn how different settings change the image.

Keep this exposure summary in mind as you read about shooting modes. It will help you understand the exposure settings you can control in each shooting mode. Later in this chapter, I go into more detail about the specifics of exposure and how the T3/1100D meters the light to determine its suggested exposure settings. In addition, I discuss how the focus system ties in with exposure.

As you read about all the different aspects of exposure, metering, and focusing, it might seem overwhelming, especially if this is your first experience with a dSLR. Give yourself time to absorb the information and to practice each element of photographic exposure as you go through this chapter. Over time and with experience, everything will come together and become second nature.

How shooting modes relate to exposure

When you choose a shooting mode on the camera's Mode dial, you have four choices that affect the amount of control that you have over exposure. You can choose to

▶ **Use one of the automatic, or *Scene*, modes, such as Portrait, Landscape, or Sports, where the camera makes all the metering, exposure, focus decisions and whether to use the flash.** There are only a few settings that you can change in these automatic modes.

▶ **Use Creative Auto (CA) shooting, which enables you to set the amount of background blur or sharpness (the aperture), and control the flash firing and drive mode.** This mode gives you more control than the automatic modes, but less control than the semiautomatic modes and Manual mode.

▶ **Control part of the exposure by setting either the aperture or shutter speed.** You can get this type of control by choosing a semiautomatic shooting mode such as P, Tv, and Av. If you choose one of these shooting modes, you can also set the ISO, metering mode, and focus yourself, or let the camera do it.

▶ **Control everything.** You get full control over the camera by choosing M mode. You can set the aperture, shutter speed, the ISO, metering mode, and the focus yourself.

To choose a shooting mode, turn the Mode dial to line up the shooting mode you want with the white line on the camera body. I describe each shooting mode in the following sections.

Canon divides the Mode dial (see Figure 2.3) roughly into two sections: (1) the automatic, or *Basic Zone*, shooting modes, and (2) the semiautomatic and Manual mode, collectively dubbed the *Creative Zone* modes. And although Movie shooting mode is mentioned in this chapter, it is discussed extensively in Chapter 6.

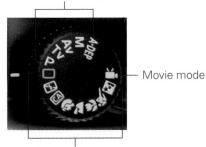

Creative Zone shooting modes

Movie mode

Basic Zone shooting modes

2.3 The Rebel T3/1100D Mode dial and shooting zones

In most of the Basic Zone modes, the camera sets almost everything automatically so that you can concentrate on capturing the moment.

The semiautomatic and Manual, or Creative Zone, shooting modes are designated by letter abbreviations: P for Program AE (Auto Exposure), Tv for Shutter-priority AE, Av for Aperture-priority AE, M for Manual, and A-DEP for Automatic Depth of Field. If you are an experienced photographer, or if you're anxious to move beyond the automated modes to have more creative control, then the Creative Zone modes are the ticket.

The following sections give a more detailed description of these shooting modes.

Basic Zone shooting modes

The automatic, or Basic Zone, shooting modes are grouped together on one side of the Mode dial, as shown in Figure 2.4.

In the scene shooting modes such as Landscape and Portrait, you simply choose the shooting mode that matches the type of scene you're shooting and begin shooting. For example, if you're photographing a landscape, then you can use the shooting mode with the mountain icon.

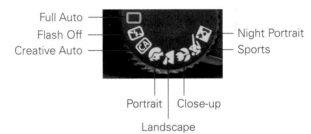

2.4 The Basic Zone shooting modes on the Mode dial

Landscape images traditionally show the scene with all or almost all areas of the image in acceptably sharp focus, called extensive depth of field. In this mode, the T3/1100D sets as narrow of an aperture (large f-stop number such as f/8, f/11, or f/16) as it can given the amount of light in the scene. Each of the other Basic Zone modes except Creative Auto (CA) and Full Auto make similar adjustments to give you a classic photographic result for each type of scene or subject.

In Basic Zone modes except CA mode, the camera automatically sets all the exposure settings — ISO, aperture, and shutter speed — as well as the focus mode and the autofocus point or points. However, you can change some settings, and the settings you can change vary by shooting mode. To see what settings you can change, just set the Mode dial to the scene mode you want, and then press the Q button to display the Quick Control screen. The Quick Control screen shows the changes you can make. For example, in Portrait mode, you can set an Ambience type (initially displayed as

Standard setting), change the Lighting or Scene type (initially displayed as Default setting) to match the type of light in the scene, and change the default drive mode to Continuous Self-timer. A drive mode determines how many images you capture when you press the shutter button once or when you press and hold the shutter button.

Basic Zone modes can be a good choice for getting started using the T3/1100D and for quick shots. For example, if you are shooting a football game and you want the motion of the players to be frozen without blur, then choose Sports mode, which sets as fast a shutter speed as possible given the light in the scene.

There are two primary disadvantages to using Basic Zone modes. First, you cannot control where the sharp focus is set in the image. In a portrait, the camera may decide to focus on the subject's nose or teeth rather than on the subject's eyes. In portraits, the subject's eyes should have the sharp focus. Second, you can't control the flash — it fires automatically in the automatic modes except for the Flash Off, CA, Landscape, and Sports modes. While the T3/1100D flash output is well controlled for natural-looking results, if you prefer to not use the flash, you have to switch to CA mode or to a Creative Zone mode.

In addition to setting the ISO, f-stop, and shutter speed, in Basic Zone shooting modes, the Rebel T3/1100D also automatically sets the following:

▶ **Auto Lighting Optimizer.** This is an automatic adjustment that lightens images that are too dark and increases the contrast in low-contrast images.

▶ **High ISO speed noise reduction.** This is used to reduce digital noise in images made at high ISO settings. The automatic modes use Auto ISO, where the camera can set the ISO from 100 to 3200. Having this Custom Function automatically turned on is good for images where the camera sets ISO 800 and higher. In Creative Zone modes, you can set the highest ISO that the camera can use with Auto ISO, but even if you set a limit, it is not used in the Basic Zone shooting modes.

▶ **The AF point or points.**

▶ **Evaluative metering mode.**

▶ **The drive mode.** This mode determines how many images the Rebel T3/1100D takes when you press and hold the shutter button. The drive mode changes depending on the shooting mode you choose. In Full Auto, Flash Off, Landscape, Close-up, and Night Portrait modes, the drive mode is set to Single shooting. In Portrait, and Sports mode, the drive mode is set to Continuous shooting. In CA mode, you can choose Single or Continuous. And in all Basic Zone modes, you can choose to use the 10-second or the Continuous Self-timer mode on the Quick Control screen.

▶ **The use of the built-in flash in some Basic Zone modes.** The flash fires auto-
matically in Full Auto, Portrait, Close-up, and Night Portrait modes. The flash
never fires in Flash Off, Landscape, or Sports shooting modes.

▶ **The sRGB (standard Red, Green, Blue) color space.** Color spaces are detailed
in Chapter 3.

In all except Full Auto and Flash Off Basic Zone shooting modes, you can press the Q
button and choose the following:

▶ **Ambience selection.** Ambience options change the look of the image, and they
range from Vivid and Soft to Monochrome. On the Quick Control screen,
Ambience is shown as "Standard setting." Just select this text, and then turn
the Main dial to change the setting.

▶ **Lighting or Scene type.** These options enable you to match the setting to the
type of light in the scene to get the best color. On the Quick Control screen, this
is shown as "Default setting." Just select this text, and then turn the Main dial
to change the setting. This option cannot be selected in Full Auto, Flash Off, CA,
or Night Portrait shooting modes.

CROSS REF For more detail on Ambience selections and Lighting or Scene types, go to
Chapter 3.

To make changes to Basic Zone shooting mode settings, follow these general steps:

1. **Turn the Mode dial to the Basic Zone mode you want, and then press the
 Q button.** The Quick Control screen appears.

2. **Press a cross key to select a setting, and then turn the Main dial to adjust
 the setting.** Alternatively, you can select the setting, and then press the Set but-
 ton to display a screen that shows all the options you can select.

Each of the automatic shooting modes is discussed in the sections that follow.

Full Auto mode

In Full Auto shooting mode, the Rebel T3/1100D evaluates the scene and makes its
best guess in applying settings that are appropriate for the scene or subject.

In Full Auto mode, the Rebel automatically selects all exposure settings and the use of
the flash. This shooting mode can be good for quick snapshots, and you can enhance
your creative options with the lens you choose. However, keep in mind that the cam-
era defaults to using the built-in flash in low-light scenes, although you may not want

or need to use the flash. And be aware that the camera may set a very high ISO that produces digital noise in your images.

In Full Auto mode, the camera uses a focusing mode called AI Focus AF mode so that if the subject begins moving, the camera automatically switches from One-shot auto-focus mode to AI Servo AF mode — a mode that maintains focus on the subject even as the subject moves. Autofocus modes are detailed later in this chapter.

The camera also automatically selects the AF point or points. It may choose one or multiple AF points. Typically the camera focuses on what is closest to the lens and/or that has the most readable contrast in the scene.

> **TIP** If the camera doesn't set the point of sharpest focus where you want, you can try to force it to choose a different AF point by moving the camera position slightly. If you want to control where the point of sharpest focus is set in the image, then it is better to switch to P, Av, or Tv shooting mode and set the AF point manually (which is explained later in this chapter).

In Full Auto mode, the camera automatically sets the following:

▶ **Single-shot drive mode.** This drive mode means that one picture is taken with each press of the shutter button, rather than a burst of images when you press and hold the shutter button. You have the option to set the 10-second or Continuous Self-timer drive mode. You can turn on Red-eye Reduction on the Shooting 1 menu.

▶ **Automatic flash with the option to turn on Red-eye Reduction mode on the Shooting 1 menu.**

Flash Off mode

In Flash Off mode, the Rebel T3/1100D does not fire the built-in flash or an external Canon Speedlite, regardless of how low the scene light is. If you use Flash Off shoot-ing mode in low-light scenes, be sure to use a tripod and ensure that the subject remains completely still.

In Flash Off mode, the camera automatically sets the following:

▶ **AI Focus AF autofocus mode with automatic AF-point selection.** This means that the camera uses One-shot AF designed for still subjects, but it automatically switches to the focus-tracking mode AI Servo AF if the subject begins to move. The camera automatically selects the AF point.

▶ **Single-shot drive mode.** This means that one picture is taken with each press of the shutter button. You can switch to one of the Self-timer modes using the Quick Control screen.

Creative Auto (CA) mode

This shooting mode only loosely falls within the automatic shooting mode category is Creative Auto, denoted as CA on the camera Mode dial. The Creative Auto screen is shown in Figure 2.5. If you're new to using a dSLR, and you want to get the creative effects that are commonly associated with dSLR shooting, then CA mode is a good shooting mode to choose. This shooting mode offers more control than the other automatic modes, but less control than the Creative Zone shooting modes (detailed later in this chapter).

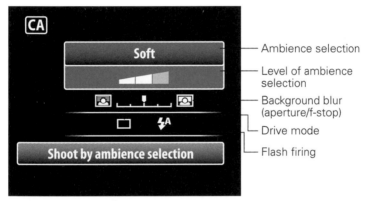

2.5 The Creative Auto screen gives you control over how the background is rendered — either as sharp or blurred. On this Quick Control screen, I've selected Soft as the Ambience selection. The camera then displays the level control to select the degree of softness used for the image. You can also control the drive mode and flash firing on the Quick Control screen.

In CA shooting mode, you can adjust the following settings:

▶ **Ambience selection.** Ambience selection changes the look of the image to make color and contrast more expressive. Details on Ambience selection and sample images are provided in Chapter 3.

▶ **Background blur.** You can adjust this control to blur the background or render it with more sharpness. Just adjust the marker to the left to increase background blur or to the right to increase background sharpness. As discussed earlier, the relative blurring or sharpening of the background is referred to as depth of field,

and it's controlled in large part by the f-stop. Thus this control enables you to change the f-stop, or aperture.

▶ **Drive mode and Flash firing.** The drive mode determines the speed, or number of images the camera takes with each press of the shutter button. This control enables you to choose Single or Continuous shooting mode at 3 frames per second (fps). Or you can choose Self-timer/Remote control mode with a 10-second delay before the image is made or Self-timer Continuous mode, which takes the number of images that you choose, from two to ten, at 10-second intervals.

The Flash firing determines when the built-in flash fires, and you can choose to have it fire automatically when the light is too low to handhold the camera and get a sharp image; choose to have the flash fire with every image; or choose to turn off the flash completely. If you choose to turn off the flash in low-light scenes, be sure to stabilize the camera on a tripod or on a solid surface.

If you're taking a portrait in CA mode, move the Background blur control to the left to keep the background elements from distracting from the subject. If you're shooting a landscape, move the control to the right to keep as much of the scene from back to front in sharp focus.

To use CA mode, follow these steps:

1. **Turn the Mode dial to CA, and then press the Q button.** The Quick Control screen appears.

2. **Press the up or down cross key to choose a setting, and then turn the Main dial to change the setting:**

 - **Ambience selection is initially displayed as "Standard setting" or the last Ambience setting you selected is displayed.** For all except the Standard setting, a scale appears below the name of the Ambience selection. To change the level of the selection, press the down cross key to select the level control, and then turn the Main dial to change it.

 - **Background blur.** Press the left or right cross key or turn the Main dial to change the setting. Moving to the left increases background blur and vice versa. You cannot change the Background blur if the built-in flash is raised. This control changes the aperture (f-stop) that's used for the image. And if you set this control and then use the flash, the setting you applied is not used.

 - **Drive mode.** Press the down cross key to select the last line of options on the Quick Control screen. Then press the left or right cross key to select the

drive mode, and then press the Set button. The options are Single shooting, Continuous shooting, 10-sec/Remote control, or Self-timer Continuous. Press a cross key to make a selection, and then press the Set button.

- **Flash firing.** Press the left or right cross key to select the Flash icon, and then the Set button to display the options: Auto, Flash on, or Flash off. Turn the Main dial to change the setting, and then press the Set button.

 You can also choose to turn on Red-eye Reduction on the Shooting 1 menu.

Portrait mode

In Portrait mode, the T3/1100D sets a wide aperture (small f-stop number) to provide a shallow depth of field that blurs background details and prevents them from distracting from the subject. Obviously, Portrait mode is great for people portraits, but it can also be used for taking pet portraits (see Figure 2.6), indoor and outdoor still-life shots, and nature shots.

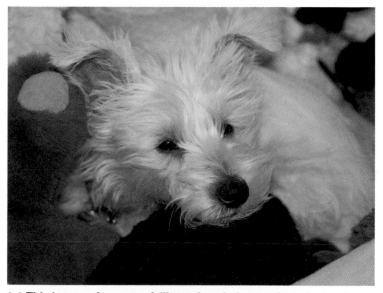

2.6 This image of a puppy falling asleep in her toy box shows the type of settings used in Portrait mode. The camera set a wide f/4 aperture, and fired the flash automatically. The wide aperture blurs the background details nicely to keep them from distracting from the subject. Exposure: ISO 200, f/4, 1/25 second.

In Portrait mode, the camera automatically sets the following:

▶ **One-shot AF mode and automatic AF-point selection.**

▶ **Continuous drive mode.** This mode enables you to shoot at 3 frames per second (fps) up to 830 Large JPEG images in a burst. Alternately, you can choose to use the 10-second Self-timer/Remote control or the Self-timer Continuous drive mode.

▶ **Automatic flash with the option to turn on Red-eye Reduction mode on the Shooting 1 menu.**

To enhance the effect that Portrait mode provides in blurring the background, use a telephoto lens and move the subject several feet away from the background.

In Portrait mode, the camera automatically selects the AF point or points. When the camera chooses the AF point, it looks for points in the scene where lines are well defined, for the object that is closest to the lens, and/or for points of strong contrast. In a portrait, the point of sharpest focus should be on the subject's eyes. But the subject's eyes may not fit the camera's criteria for setting focus. As a result, the camera often focuses on the subject's nose, mouth, or clothing. So as you shoot, watch in the viewfinder to see which AF points the camera chooses when you half-press the shutter button. If the AF point or points aren't on the eyes, then shift your shooting position slightly to try to force the camera to reset the AF point to the eyes. If you can't force the camera to refocus on the eyes, then switch to Av mode, set a wide aperture such as f/5.6, and then manually select the AF point that is over the subject's eyes. Manually selecting an AF point is detailed later in this chapter.

Landscape mode

In Landscape mode, the T3/1100D sets the exposure so that both background and foreground details are acceptably sharp for an extensive depth of field. To do this, the camera sets a narrow aperture (large f-stop number). Also in Landscape mode, the camera gives you the fastest shutter speed possible given the amount of light in the scene. The fast shutter speed helps ensure sharp handheld images.

In lower light, however, the Rebel T3/1100D tries to maintain as narrow an aperture as possible, and this can result in slower shutter speeds, or the camera increases the ISO, or both. So as the light fades, be sure to monitor the shutter speed in the viewfinder. If the shutter speed is 1/30 second or slower, or if you're using a telephoto lens, then steady the camera on a solid surface or use a tripod for shooting. As it does

in all Basic Zone modes, the camera uses Evaluative metering (described later in this chapter) to meter the light in the scene to determine the exposure settings.

In Landscape mode, the camera automatically sets the following:

▶ **One-shot autofocus mode and automatic AF-point selection.**

▶ **Single-shot drive mode with the option to set 10-second Self-timer/ Remote control or Self-timer Continuous drive mode.**

▶ **The flash never fires.**

Close-up mode

In Close-up mode, the Rebel T3/1100D allows a close focusing distance, and it sets a wide aperture (small f-stop number) to create a shallow depth of field that blurs background details. It also sets as fast a shutter speed as possible given the light. This mode produces much the same type of rendering as Portrait mode. You can further enhance the close-up effect by using a macro lens (see Figure 2.7). If you're using a zoom lens, zoom to the telephoto end of the lens.

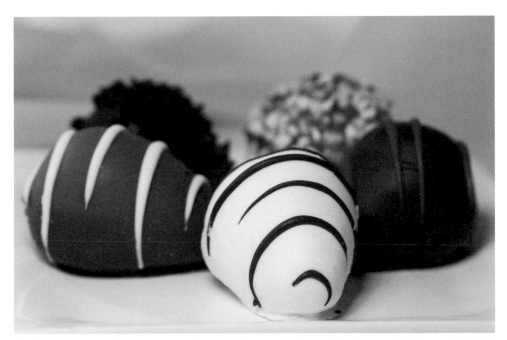

2.7 To accentuate the close-up effect for this image, I used the Canon EF 100mm f/2.8L II IS Macro USM lens. To keep the flash from firing automatically, I added extra household lamps around the chocolate-covered strawberries. Exposure: ISO 100, f/5.6, 1/8 second.

> **TIP** All lenses have a minimum focusing distance that varies by lens. This means that you can't focus at distances closer than the minimum focusing distance of the lens. You know that you're not closer than the minimum focusing distance when you hear the autofocus confirmation beep from the camera and/or when the focus indicator light in the viewfinder burns steadily.

In Close-up mode, the camera automatically sets the following:

- ▶ **One-shot autofocus mode with automatic AF-point selection.**
- ▶ **Single-shot drive mode with the option to set 10-second Self-timer/ Remote control or the Self-timer Continuous drive mode.**
- ▶ **Automatic flash with the option to turn on Red-eye Reduction mode.**

Sports mode

In Sports mode, the Rebel T3/1100D sets a fast shutter speed to freeze subject motion. This mode is good for capturing athletes and the antics of pets and children.

In this mode, when you half-press the shutter button, the camera focuses and begins tracking focus on the subject as long as the subject remains within the autofocus points. The focus is locked at the moment you fully press the shutter button.

In Sports mode, the camera automatically sets the following:

- ▶ **AI Servo AF autofocus mode with automatic AF-point selection.**
- ▶ **Continuous drive mode.** Continuous drive mode enables you to shoot at 3 fps for a maximum burst rate of 830 Large/Fine JPEG images, 5 RAW images, or 1 RAW+JPEG image. You also have the option to use the 10-second Self-timer/ Remote control or Self-timer Continuous drive mode.
- ▶ **The flash does not fire.**

Night Portrait mode

In Night Portrait mode, the Rebel T3/1100D combines flash with a slow shutter speed so that both the subject and the background are correctly exposed. This combination prevents the subject from being very bright against a very dark background. However, this mode uses a longer exposure time to properly expose a dark background, so it's important that the subject remain still during the entire exposure to avoid blur. Be sure to use a tripod or set the camera on a solid surface to take night portraits.

You should use this mode when people are in the picture, rather than for general night shots, because the camera blurs the background similar to the way it does in Portrait mode. For night scenes without people, use Landscape mode or a Creative Zone mode and a tripod.

In Night Portrait mode, the camera automatically sets the following:

▶ **One-shot autofocus mode with automatic AF-point selection.**

▶ **Single-shot drive mode with the option to set 10-second Self-timer/ Remote control or Self-timer Continuous drive mode.**

▶ **Automatic flash with the option to turn on Red-eye Reduction mode on the Shooting 1 menu.**

Movie mode

Movie mode enables you to capture full high-definition (full HD) quality video clips.

Because shooting with Movie mode differs significantly from the other Rebel shooting modes, I've devoted Chapter 6 to using Movie mode.

Creative Zone shooting modes

When you want creative control over both the exposure and the rest of the camera settings, then the semiautomatic modes and Manual mode, collectively dubbed the *Creative Zone*, put that control in your hands. You can choose a shooting mode based on the exposure element that's most important for you to control in a particular scene or with a particular subject. And when you want full exposure control, you can choose Manual (M) mode.

For example, when you want to control how blurred or sharp the background details appear, then Av shooting mode puts that control in your hands. In Av mode, you can blur the background by choosing a wide aperture of f/5.6 or wider, or you can show the background with acceptably sharp detail by choosing a narrow aperture of f/8 or narrower.

But when you want to control how the motion of the subject appears, Tv mode is the best choice. In Tv mode, you can set a fast shutter speed to freeze the motion of a player in midjump or midrun or choose a very slow shutter speed to show the motion of water as a silky blur. In M mode, you can set the aperture, shutter speed, and the ISO. And in A-DEP mode, the camera automatically calculates the optimal depth of field for you by setting the aperture (f-stop) automatically.

The following sections offer a summary of each Creative Zone shooting mode.

Program AE (P) mode

Program AE, shown as P on the Mode dial, is a semiautomatic but *shiftable* mode. Shiftable means that you can change, or shift, the camera's suggested exposure by turning the Main dial to an equivalent exposure.

Here is how shifting the exposure works. When you press the shutter button halfway, the camera displays its suggested exposure settings in the viewfinder. Let's say that the camera recommends using f/4 at 1/400 second. However, you want more sharpness in the background details (a more extensive depth of field) than f/4 provides. You can change the aperture by simply turning the Main dial to the right until you get to f/8 or f/11 for more extensive depth of field. As you adjust the aperture, the Rebel simultaneously changes the shutter speed to provide an equivalent exposure.

P mode makes it easy to shift to an equivalent exposure, but it's important to know that the shifted exposure is retained for only one picture. After that, the T3/1100D reverts to the camera's suggested exposure. Also if you don't make the picture within 2 or 3 seconds after you shift the settings, the camera reverts to its suggested exposure. Thus P mode is handy when you want to quickly change the depth of field and shutter speed for only one shot while making minimal camera adjustments.

 If you pop up the built-in flash, you can't change, or shift, from the camera's recommended exposure in P mode.

P mode is excellent to use if you're just beginning to use a dSLR. You can not only experiment by changing the exposure for one picture, but you can also have control over the other camera settings, including the focus, White Balance, drive mode, Picture Styles, and more.

If you change the exposure settings in P mode and see 30" and the maximum lens aperture, or 4000 and the minimum lens aperture, blinking in the viewfinder, it indicates the image will be underexposed and overexposed, respectively. In these instances, you can increase or decrease the ISO until the blinking stops.

To use P mode, follow these steps:

1. **Turn the Mode dial to line up P with the white mark on the camera, and then press the shutter button halfway.** The T3/1100D displays its ideal suggested exposure settings in the viewfinder.

2. **To change the camera's recommended exposure, turn the Main dial until the aperture or shutter speed that you want is displayed in the viewfinder.** As you turn the Main dial, both the aperture and shutter speed change simultaneously because the camera automatically calculates the equivalent aperture and shutter speed as you move the Main dial. Remember that the changed exposure is retained for only the current picture.

If you want to retain the exposure for a series of images, then it's best to use Av or Tv shooting modes rather than P mode.

Figures 2.8 and 2.9 show the result of shifting the exposure in P mode to make a change in the depth of field.

Why Use Program Mode Instead of Full Auto Mode?

Full Auto and Program shooting modes seem similar, but they vary greatly in the amount of control you have over the camera. In Full Auto mode, the camera sets the exposure and camera settings automatically and you can only change to using a Self-timer drive mode. However, in P mode, you can temporarily change the camera's suggested shutter speed and aperture settings, giving you creative control. And you can also change the ISO. Equally important, P mode enables you to control the autofocus point as well as all other camera functions — none of which you can control in Full Auto mode. Here is a look at the settings you can control in P mode, but that you can't control in Full Auto mode:

▶ **Shooting settings.** AF mode and AF-point selection, drive mode, metering mode, aperture, shutter speed, ISO, Exposure Compensation, Auto Exposure Bracketing, AE Lock, Custom Functions, and others.

▶ **Image settings.** White Balance, Custom White Balance, White Balance Correction, White Balance Bracketing, Color Space, and Picture Style.

2.8 In P mode, the camera originally set the aperture at f/5.6. Exposure: ISO 400, f/5.6, 1/13 second.

2.9 Given the current trend of using a very shallow depth of field for food shots, I opted to shift the exposure settings in P mode by setting the aperture to f/1.2. Exposure: ISO 400, f/1.2, 1/250 second.

Shutter-priority AE (Tv) mode

Shutter-priority AE mode, shown as Tv on the Mode dial, is a semiautomatic mode where you set the shutter speed and the camera automatically sets the aperture. In Tv mode, the shutter speed you set doesn't change until you change it. Thus, if you're shooting a sports event in moderately bright outdoor light, and you want to ensure that the shutter speed is always fast enough to stop the motion of the athletes in action, then you can set the shutter speed to 1/500 second and know that it won't change. If the light changes, the camera automatically adjusts the aperture while maintaining the shutter speed that you set. And this strategy works unless the light gets too low for the camera to provide a wide enough aperture to give you a good exposure at the current shutter speed. In that case, the aperture blinks in the view-finder, alerting you that the exposure is out of range. The blinking aperture displays the lens's maximum (widest or largest) aperture.

Choose Tv mode when you want to control how motion appears in the image, either stopped in midmotion, as shown in Figure 2.10, or as blurred motion. For example, if you want to show a skateboarder in midair with no motion blur, set a fast shutter speed of 1/500 second or faster.

When you want to show the motion of a waterfall as a silky blur, set a slow shutter speed of 1/10 second to several seconds. Figure 2.11 shows the affect that shutter speed has in showing the motion of water. This image was shot in natural light. Normally, I would use a slower shutter speed, but I was handholding the camera and didn't want to push my luck on getting an image that would be spoiled by blur from handshake.

Now is a good time to talk about how fast a shutter speed is necessary to avoid cam-era shake from handholding the camera. If you're not using an Image Stabilization (IS) lens, or a monopod or tripod, then the general rule is that you can handhold the cam-era and get a sharp image at the reciprocal of the focal length: 1/[focal length]. Thus if you're using a non-IS zoom lens zoomed to 200mm, then 1/200 second — 1 over the zoom setting of the lens at 200mm — is the slowest shutter speed at which you can handhold the lens and not get image blur from camera shake.

 For details on different types of lenses, see Chapter 8.

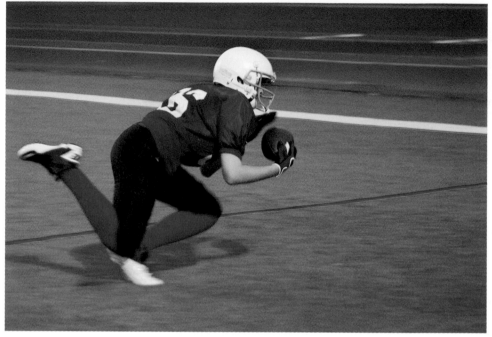

© Bryan Lowrie

2.10 This image was taken in Tv mode using 1/125 second shutter speed that stopped the motion of the player as he lunged to catch the football. Exposure: ISO 1000, f/4, 1/125 second.

In Tv mode, you have full control over camera settings, including being able to set the AF mode, AF point, metering and drive modes, and Picture Style, and use the built-in flash. The shutter speeds that you can choose depend on the light in the scene. In low-light scenes without a flash, you may not be able to get a fast enough shutter speed to stop the subject action with no motion blur.

 If you use high ISO settings and/or long exposures, I recommend using Custom Function II-3 and II-4 to reduce digital noise.

In Tv mode, the shutter speeds range from 1/4000 to 30 seconds, and Bulb. Shutter speed increments can be changed from the default 1/3-stop to 1/2-stop increments using Custom Function (C.Fn) I-1. Flash sync speed is 1/200 second to 30 seconds.

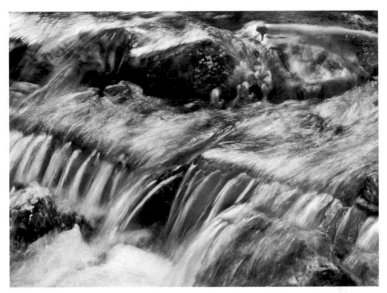

2.11 This image was taken in Tv mode using a 1/8 second shutter speed. Although there is good blur in the water, a slower shutter speed would produce a more pleasing blur. Exposure: ISO 200, f/22, 1/8 second using +1/3-stop of Exposure Compensation.

NOTE Bulb is an exposure where the shutter remains open as long as you press the shutter button. Bulb exposures are used for some fireworks and astral photography. You can set Bulb using M shooting mode. When you set the shutter speed in M mode, turn the Main dial to the left until Bulb appears as an option. Always use a tripod for Bulb exposures.

To use Tv mode, follow these steps:

1. **Turn the Mode dial to line up Tv with the white mark on the camera.**

2. **Turn the Main dial to the shutter speed that you want.** As you turn the Main dial to set the shutter speed, the camera automatically sets the aperture. At the default settings, shutter speed values display in the viewfinder and on the LCD in 1/3-stop increments. And fractional shutter speeds show only the denominator. For example, 125 indicates 1/125 second, 0"6 indicates 0.6 seconds, and 20" indicates 20.0 seconds. If the f-stop blinks in the viewfinder, it means that a suitable aperture is not available at that shutter speed in the existing light. You can switch to a higher ISO or to a slower shutter speed. Alternatively, if you set the shutter speed so slow that the exposure will be too bright, the minimum (narrowest or smallest) aperture blinks in the viewfinder. Just set a lower ISO or a faster shutter speed.

Shutter Speed Tips

Tv mode is handy when you want to set a shutter speed that is fast enough to handhold the camera and still get a sharp image, especially if you are using a long lens.

If you are shooting action scenes and want a shutter speed fast enough to stop subject motion with no motion blur, the following guidelines provide a good starting point:

▶ Use 1/250 second when action is coming toward the camera.

▶ Use 1/500 to 1/2000 second when action is moving side to side or up and down.

▶ Use 1/30 to 1/8 second when panning with the subject motion. Panning with the camera on a tripod is a really good idea.

▶ Use 1 second and slower shutter speeds at dusk and at night to show a waterfall as a silky blur, to capture the light trails of moving vehicles, to capture a city skyline, and so on.

You can also use a polarizing or neutral-density filter to capture moving water as a blur earlier in the day; both reduce the amount of light to give you a slower shutter speed. Besides reducing the light by 2 stops, a polarizer has the additional benefit of reducing reflections on the water.

Aperture-priority AE (Av) mode

Aperture-priority AE (Av) mode is also a semiautomatic shooting mode, but in Av mode you choose the aperture (f-stop) to control the depth of field, and the camera automatically sets the shutter speed. Aperture-priority AE mode is shown on the camera Mode dial as Av.

Aperture is the primary factor that controls the depth of field. A wide aperture, such as f/5.6, f/3.5, or f/2.8, creates a shallow depth of field with a softly blurred background (see Figure 2.12). A narrow aperture, such as f/8, f/11, f/16, and narrower, creates an extensive depth of field with both foreground and background elements displaying good, or "acceptable," sharpness (see Figure 2.13).

Unless you're shooting action, Av mode is a good everyday shooting mode because in many scenes, you want to control the depth of field by changing the aperture. The

apertures you can choose depend on the lens you're using. Some lenses have "variable apertures." For example, if you're using the Canon EF-S 18-55mm f/3.5-5.6 IS lens with the lens set to 18mm, then you can select f/3.5 as an aperture. But if the lens is set to 55mm, you cannot choose f/3.5. At that lens setting, or focal length, the widest aperture you can choose is f/5.6.

2.12 This image of yellow lilies was taken in Av mode. I wanted the green leaves on the sides to frame the group of flowers, particularly the center flower, without showing sharp detail in the side leaves. To achieve that goal, I used a wide f/4.5 aperture. Exposure: ISO 1200, f/4.4, 1/320 second.

In addition to providing quick control over depth of field, you may want to use Av mode to set and maintain the aperture that is the sweet spot of the lens that you're using. The sweet spot is the aperture at which the lens provides the best detail, contrast, and sharpness, and it varies by lens. In low-light scenes where you know that you need to shoot consistently at the largest (widest) aperture, Av mode maintains the aperture.

In Av mode, you have control over all the camera settings, including the AF mode, AF point, drive and metering modes, White Balance, and Picture Style. You also control use of the built-in flash.

 The T3/1100D does not have a Depth-of-Field button, but you can use Custom Function IV-8 to program the Set button as a depth-of-field preview. Then when you press the Set button, the lens diaphragm closes to the aperture that you've set so that you can see how much of the scene will be in acceptably sharp focus.

If you use Av mode, be sure to monitor the shutter speed in the viewfinder to know if you need to use a tripod. You can use the handholding rule provided earlier in the Tv section to determine when you need to use a tripod.

To change to Av mode, follow these steps:

1. **Turn the Mode dial to line up Av with the white mark on the camera.**

2. **Turn the Main dial to the aperture that you want.** The camera automatically sets the shutter speed. At the default settings, aperture values display in the viewfinder and LCD in 1/3-stop increments, such as 5.6, 6.3, and 7.1. The higher the f-number, such as f/8 and f/16, the more extensive the depth of field. The smaller the f-number, such as f/5.6 and f/4.0, the shallower the depth of field.

2.13 This image was also shot in Av mode. I used a narrow f/11 aperture to show good detail through the river and the foliage. Exposure: ISO 200, f/11, 1/160 second using –1-stop of Exposure Compensation to retain detail in the highlights in the water.

For more on setting the aperture, see Chapter 9.

Manual (M) mode

With Manual mode, indicated by an M on the Mode dial, you can set both the aperture and the shutter speed manually, and of course, the ISO. But how do you know what exposure to use? Sometimes, you know the exposure because a friend recommends the ISO, shutter speed, and aperture for shooting a specific subject or scene such as fireworks, the moon (see Figure 2.14), or star trails. But even if you don't have a

prescribed exposure, you can use M mode anytime by using the camera's onboard meter to set the exposure. Just use the Exposure level indicator displayed in the viewfinder, and adjust the aperture, shutter speed, and/or the ISO until the tick mark is at the center of the index. The advantage to using M mode is that you can provide a bit more or less exposure depending on the scene and your goals for the image.

2.14 I used M mode for this picture of the super moon, or the perigee moon, that appears every 20 years. The moon appears 14 percent larger and brighter than average as its orbit passes closer to the earth. Exposure: ISO 100, f/8, 1/40 second.

For example, M mode is helpful in difficult lighting situations when you want to override the camera's recommended exposure. If the scene has a wide difference between the highlights and shadows, the camera's suggested exposure may result in blown highlights. If you're shooting in M mode, you can simply adjust the aperture or the shutter speed to give the image less exposure (less exposure means letting less light into the camera by either using a narrower aperture or a faster shutter speed).

M mode is also an excellent choice in scenes where you want consistent exposures across a series of photos, such as for a panoramic series. And if you have studio strobes, choose M mode for setting the correct sync speed and then adjusting the aperture to get the proper exposure.

However, the classic use of M mode is to determine exposure settings by taking a meter reading on a gray card, and then setting the exposure settings from the gray-card meter reading. This is an advanced exposure technique.

In M mode, you can control all camera settings, including AF mode, AF point, drive and metering modes, White Balance, Picture Style, and use of the built-in flash.

To use Manual mode, follow these steps:

1. **With the Mode dial set to M, press down the shutter button halfway.** Watch the Exposure level indicator displayed at the bottom of the viewfinder and on the LCD. It has a tick mark that indicates how far the current exposure is from the camera's suggested exposure.

2. **To use the camera's suggested exposure, adjust the shutter speed and/or aperture until the tick mark is at the center of the Exposure level indicator by**

 - Turning the Main dial to set the shutter speed, and

 - Pressing and holding the Aperture/Exposure Compensation (Av) button on the back of the camera and turning the Main dial to adjust the aperture.

 You can also set the exposure above (to overexpose) or below (to underexpose) the metered exposure. If the amount of under- or overexposure is +/–2 Exposure Values (EV) or f-stops, left and right arrows appear on the Exposure level indicator in the viewfinder.

3. **Compose the image, press the shutter button halfway to focus, and then press the shutter button completely to make the picture.**

Optional Filters

The most useful filters, especially for outdoor photography, include the circular polarizer and graduated neutral density filter. Here is a brief overview of both:

▶ **Circular polarizers.** Polarizers deepen blue skies, reduce glare on surfaces to increase color saturation, and help remove spectral reflections from water and other reflective surfaces. A circular polarizer attaches to the lens, and you rotate it to reduce glare and increase saturation. Maximum polarization occurs when the lens is at right angles to the sun. With wide-angle lenses, uneven polarization can occur, causing part of the sky to be darker than the sky closest to the sun. If you use an ultrawide-angle lens, be sure to get the thin polarizing filter to help avoid vignetting that can happen when thicker filters are used at small apertures. Both B+W and Heliopan offer thin polarizing filters.

> ▶ **Graduated neutral density filters.** These filters allow you to hold back a bright sky from 1 to 3 f-stops to balance a darker foreground with a brighter sky. Filters are available in hard- or soft-stop types and in different densities: 0.3 (1 stop); 0.45 (1.5 stops); 0.6 (2 stops), and 0.9 (3 stops). With this filter, you can darken the sky without changing its color; its brightness is similar to that of the landscape and it appears in the image as it appears to your eye.

Automatic Depth of Field (A-DEP) mode

A-DEP, or Automatic Depth of Field, mode is a hybrid shooting mode that sets the aperture, shutter speed, and the focus automatically, but offers control over the ISO and other camera settings. The advantage of A-DEP shooting mode is that it automatically calculates the maximum depth of field between near and far subjects in the scene. The maximum depth of field means that both near and far elements will be in acceptably sharp focus. To do this, A-DEP mode uses the camera's nine AF points to detect near and far subject distances, and then calculates the aperture needed to keep the subjects in sharp focus.

Although the automatic depth-of-field calculation is handy, achieving the maximum depth of field typically means that the camera must set a narrow aperture, and that can result in slow to very slow shutter speeds. If the shutter speed is too slow for handholding the camera, then use a tripod or monopod to avoid getting a blurry picture, or increase the ISO sensitivity setting. For non-IS telephoto lenses, see the handholding guideline in the Tv shooting mode section.

Although you can use the built-in flash in this mode, the maximum depth of field is sacrificed and A-DEP mode performs more like P mode.

To change to A-DEP mode, follow these steps:

1. **Turn the Mode dial to line up A-DEP with the white mark on the camera.**

2. **Focus on the subject.** In the viewfinder, verify that the AF points displayed in red cover the subject(s), and then take the picture. If the AF points aren't on the elements in the scene that you want, shift your shooting position slightly and refocus. Also, if the aperture blinks, it means the camera can't get the maximum depth of field. Move back or switch to a wide-angle lens or zoom setting.

Different Views on Choosing Shooting Modes

There are different opinions about which shooting mode is best for everyday shooting. Here is a synopsis on when and why photographers use Tv, Av, M, and A-DEP shooting modes.

Some photographers advocate using Tv shooting mode. This school of thought argues that controlling depth of field using Av or A-DEP shooting mode is useful only so long as the image has sharp focus. And to get sharp focus when you're handholding the camera, controlling the shutter speed is often more important than controlling aperture. Thus by using Tv mode, you can lock in the shutter speed that you need for handholding the camera. But in bright to moderately bright light, Av and A-DEP shooting modes are good choices as long as you keep an eye on the shutter speed in the viewfinder and use a tripod if the shutter speed is too slow to handhold the camera and get a sharp image.

Setting the ISO Sensitivity

You have seen how you can choose a Creative Zone shooting mode to control the aperture or shutter speed, or both. The third element of exposure is the ISO setting. In general terms, the ISO setting determines the sensitivity of the image sensor to light. The higher the ISO, the less light the sensor needs to make the picture, and the faster the shutter speed you'll get in low-light scenes, and vice versa. This section explores ISO in more detail.

The Rebel T3/1100D has a wide 100 to 6400 ISO range. This broad ISO range allows you to shoot in very low light; however, as you move to higher ISO settings, the output of the sensor is also amplified and that increases the digital noise in images (see Figures 2.15 and 2.16).

Digital noise appears as unwanted colorful flecks and as grain that most commonly appears in shadow areas, but at high ISO settings, it may also appear in lighter tones within the image. So whereas you have the option of increasing the ISO sensitivity at any point during shooting, the trade-off is an increase in digital noise from the increased amplification or the accumulation of an excessive charge on the pixels. And depending on the appearance and severity, the result of digital noise is an overall loss of resolution and image quality.

In addition, some of the high ISO settings only amount to more in-camera processing of the image. If you are shooting RAW images, then you can get the same benefit of

2.15 At small image sizes, digital noise may not be objectionable, as this image shows. Given digital noise hides in the shadows, and much of this scene is in shadows, including the player in the background, digital noise is present despite having the High ISO speed noise reduction Custom Function turned on (as shown in Figure 2.16). Exposure: ISO 3200, f/4.5, 1/320 second.

2.16 This lightened section of Figure 2.15 shows the digital noise in detail: the high grain, or bumpy, appearance of the player, as well as the discoloration of his arm. Exposure: ISO 3200, f/1.8, 1/125 second.

ISO 3200 by shooting at ISO 1600 and underexposing by one f-stop, and then brightening the image during RAW conversion.

As a result, you have to weigh the ability to use high ISO settings to get shots in low-light scenes against the resulting digital noise. It is worth testing the camera by using all the ISO settings, and then comparing the images. To compare the results, view the images at 100 percent enlargement in an image-editing program, and then look at the shadow areas. If you see grain and colorful pixels where the tones should be continuous and of the same color, then you're seeing digital noise. And if you lighten the images, the digital noise becomes more visible. Also if you use Auto Lighting Optimizer, that automatically lightens images it considers to be too dark, and then the noise is also more visible. I recommend not using Auto Lighting Optimizer so that you have full control over the image exposure, and you can see the changes that different exposure settings make.

The most compelling benchmark in evaluating digital noise is the quality of the image at the final print size. And in the printed image, if the digital noise is visible and objectionable in an 8 × 10-inch or 11 × 14-inch print when viewed at a standard viewing distance, then the digital noise degraded the quality to an unacceptable level.

The Rebel T3/1100D offers two useful Custom Functions that help counteract noise: C.Fn II-3: Long exposure noise reduction, and C.Fn II-4: High ISO speed noise reduction.

 See Chapter 4 for details on each of these Custom Functions and how to set them.

The Rebel T3/1100D offers Auto ISO, a setting where the Rebel automatically sets the ISO from 100 to 3200 in all the Basic Zone shooting modes. Auto ISO is set from 100 to 6400 in P, Tv Av, M, and A-DEP shooting modes. And if you use the flash or make a Bulb exposure, the ISO is set at ISO 800 unless the flash use requires a lower ISO setting to get a good exposure. Also if the highest ISO limit is set to 400, then the Rebel uses ISO 400 with the flash. The Rebel does not hesitate to set a very high ISO setting in automatic shooting modes. I get e-mails from readers and students asking why their images have so much digital noise, and Auto ISO is inevitably the culprit.

The T3/1100D applies high ISO settings to give you fast shutter speeds so you're less likely to get blurry images from handholding the camera in low light. But the incidence of digital noise increases as the ISO settings increase. Canon must have gotten messages similar to those I received from readers because with the T3/1100D, Canon now turns on C.Fn II-4: High ISO speed noise reduction when you're shooting in Basic Zone shooting modes. Applying noise reduction helps produce better image quality. However, the downside to noise reduction is that it smooths the grainy noise, and this softens fine details in the image.

 The ISO sensitivity setting affects the effective range of the built-in flash, and the range depends on the lens that you're using. The higher the ISO speed, the greater the effective flash range.

If you're shooting in P, Tv, Av, M, and A-DEP modes, you can opt to use Auto ISO, but I recommend that you set the ISO yourself. Or at the very least, set a limit on the maximum ISO that the Rebel can use with Auto ISO. I recommend setting a limit at ISO 800.

To change the ISO sensitivity setting, follow these steps:

1. **In P, Tv, Av, M, A-DEP, or M shooting mode, press the Disp. button if the LCD is off, and then press the ISO button (the up cross key).** The ISO speed is displayed in the viewfinder and on the LCD.

2. **Turn the Main dial to the ISO setting you want.** The ISO option you select remains in effect until you change it or switch to a Basic Zone shooting mode.

 If you have Custom Function II-5, Highlight tone priority enabled, then the lowest ISO setting you can choose is 200. If Highlight tone priority is set, you'll see a D+ displayed in the viewfinder.

 For step-by-step tasks in this chapter that involve the camera menus, just press the Menu button, turn the Main dial to move to the camera menu tab you want, and then press the up or down cross key to select an option.

To set a limit on the highest ISO setting that the camera uses for Auto ISO in P, Tv, Av, M, and A-DEP shooting modes, follow these steps:

1. **In P, Tv, Av, M, or A-DEP shooting mode, select the Shooting 3 camera menu tab, and then select ISO Auto.**

2. **Press the Set button, and then select the maximum ISO setting for use with Auto ISO.** You can choose a maximum ISO setting of 400, 800, 1600, 3200, or 6400.

3. **Press the Set button.** The camera will use this setting as the highest ISO when you use Auto ISO.

If you tested the high ISO settings as suggested earlier, your test results will help you determine the maximum ISO setting to choose. Alternatively, you can opt out of using Auto ISO and set the ISO based on the scene you are shooting. This approach gives you much more control over the final image quality.

 If you don't have a good tripod, now is a great time to buy one. Using a tripod in low light and keeping the ISO setting low gives you high-quality images with tack-sharp focus and minimal digital noise.

Because the lowest ISO provides the best image quality, my philosophy for selecting an ISO setting is to always use the lowest possible setting for the conditions in which I'm shooting. If that means that I have to use a tripod, then that's what I do. With that as background, here are my general recommendations for selecting ISO settings:

▶ **In bright to moderately bright daylight, set the ISO to 100 to 200.** ISO 100 and 200 give you the least amount of digital noise, as well as the best color and contrast, and the highest level of fine image detail.

▶ **At sunset and dusk and in overcast light, set the ISO from 100 to 400.** At this time of day, shadows are deep, and keeping the ISO as low as possible helps minimize digital noise that is inherent in shadow areas. You may need to use a tripod or monopod as the light fades, especially if you're not using an Image-stabilized (IS) lens.

▶ **Indoors (including gymnasiums, recital halls, and night concerts), and for night shooting, set the ISO from 400 to 1600.** If the ISO is at a high setting, and if you're not shooting action, then consider using C.Fn II-4: High ISO speed noise reduction, and set it to Option 2: Strong if you're shooting at ISO 3200 or 6400. I would use ISO 6400 only if there is no other way to get the image.

Metering Light to Determine Exposure Settings

All photographic exposures are based on the amount or intensity of light in the scene. Before the camera can give you its suggested exposure, it must first measure the amount of light in the scene. The Rebel T3/1100D features Canon's latest Intelligent Focus Color Luminosity metering, or IFCL for short. Normally, camera light meters are colorblind. But with IFCL, the T3/1100D has a color-sensitive exposure sensor inside the camera that has two separate layers: one sensitive to Blue/Green light, and the other sensitive to Green/Red light. When calculating exposure, the camera compares the level of each layer, and then adjusts the meter reading. This color information improves exposure accuracy for all exposures, and in particular for exposures where the subject color is predominantly on one end of the color spectrum.

The exposure system segments the viewfinder into 63 zones that align with autofocus zones so that the camera can evaluate information such as the subject distance — provided by the active autofocus point — as well as the areas surrounding it. Thus the T3/1100D can bias exposure for the subject and for surrounding areas at approximately the same distance. The final result is that the T3/1100D delivers consistently excellent exposures that are based upon more information than with previous models of the camera.

Because the light in various scenes differs, there are times when you want the camera to measure the light and base the exposure settings on the entire scene, with emphasis on the main subject. But in other scenes, such as when the background

light is much brighter than the light on the subject, you want the camera to bias the exposure settings toward the subject to ensure that the subject is exposed properly. In the final image, the background may be very bright, but the subject will be exposed properly, and ultimately that is what you care about most — proper subject exposure. So as you can see, there are times when you want more or less of the overall scene light to be factored into the image exposure settings.

Metering modes enable you to control light metering for a variety of scenes and subjects. With these different modes, you have the flexibility to choose the metering mode that best suits your needs. To use the metering modes successfully, it's helpful to first understand more about how light meters work and what you can expect from the Rebel's onboard light meter.

How the Rebel T3/1100D meters light

When you half-press the shutter button, it triggers the Rebel's built-in reflective light meter that measures the light in the scene. The reflective light meter measures the amount of light that reflects from the subject back to the camera. Some subjects reflect more light and other subjects reflect less light. For example, a light-toned element such as a white wedding gown reflects much more light back to the camera than a dark element such as a black tuxedo. Despite these and other differences in reflectivity, the camera needs a standard value, and that standard assumes that all elements in the scene will reflect the same luminance as a middle gray object, or approximately 18 percent reflectance.

Knowing that 18 percent reflectance is the camera's standard, you can then predict when the camera's calculated exposure — its *metered exposure* — will be less than perfect. For example, a snow scene has predominantly light/white tones, while a scene where a black train engine fills most of the frame has predominantly dark/black tones. Left to its own devices, the camera assumes that the snow and the train engine both have 18 percent reflectance, and the result is that you get pictures with gray snow and a gray train engine. In these situations, you can use various controls on the Rebel to override the camera's suggested exposure to get true whites and blacks.

In other scenes, you may want the camera to pay more attention to one part of the scene than other parts. One example is when the subject is positioned against a very dark or very light or bright background or when the subject is backlit. That's when you want the camera to bias its light meter reading for the subject while giving less weight to the background. And that's where different metering modes can help you get the best exposure in different types of lighting situations.

NOTE Canon's venerable Evaluative metering mode, which is the default mode, does an admirable job in virtually all the scenes you'll photograph. So if you're just starting out, you can read about the different metering modes, and then use Partial and Center-weighted metering as you gain experience.

Three metering modes

The T3/1100D offers three metering modes that are differentiated by assigning a bias or weighting to different regions in the scene, and the regions with the most weight factor more into calculating the camera's suggested exposure.

NOTE In P, Tv, Av, M, or A-DEP shooting modes, you can choose any of the three metering modes. But in the automatic shooting modes, such as Full Auto, Portrait, Landscape, and CA, you cannot change the metering modes. The Rebel T3/1100D uses Evaluative metering in these modes.

The following sections offer a look at the three metering modes.

Evaluative metering mode

Evaluative metering mode partitions the viewfinder into 63 zones, and it evaluates light throughout those zones while giving more bias to the light reflected back from and surrounding the subject's position. To determine where the subject is, the camera looks at the active AF point or points — the AF points that achieved focus. (Active AF points are the points that light up in the viewfinder when you half-press the shutter button.) Next the Rebel factors in the scene and subject brightness, subject distance and the distance of nearby objects, the background, backlighting, and front lighting. Then it calculates its suggested exposure settings. In a good number of scenes, including some backlit scenes and scenes with reflective surfaces such as glass or water, Evaluative metering mode delivers images with excellent exposures.

For most of your shooting with the T3/1100D, you can leave the camera in the default Evaluative metering mode (see Figures 2.17 and 2.18). Then when you encounter scenes with a predominance of dark or light tones, and backlit scenes where Evaluative metering doesn't give you the exposure you envision, you can switch to one of the other three metering modes, described next, or you can use exposure modification techniques.

NOTE Auto Lighting Optimizer is turned on by default, and it corrects exposure on images that are underexposed or lack contrast. If you want to see the image without this automatic correction, then turn off Auto Lighting Optimizer on the Shooting 2 camera menu.

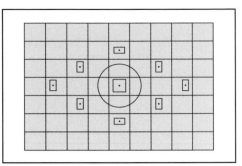

2.18 This is the Evaluative metering mode icon that you see on the LCD and in the viewfinder.

2.17 The Evaluative metering mode evaluates the light in the entire scene with a bias toward the active autofocus point.

Partial metering mode

This metering mode hones in on a much smaller area of the scene — approximately 10 percent of the scene at the center of the viewfinder (see Figures 2.19 and 2.20). By concentrating the meter reading to a small area of the scene, this mode gives good exposures for a small area of the scene such as a small subject that you want to be perfectly exposed.

In everyday shooting, partial metering is a good choice for backlit portraits because it ensures that the subject is properly exposed against the bright background rather than appearing in full or partial silhouette. Partial metering is also a good choice for high-contrast subjects, and when the background is much darker than the subject. It's important to know that this metering mode assumes that the subject is in the center of the frame, and that's where the meter reading is taken. If the subject isn't in the center, then you can take a meter reading using the center AF point, lock in the

2.20 This is the Partial metering mode icon that you see on the LCD and in the viewfinder.

2.19 The Partial metering mode confines light metering to the larger area shown here, or 10 percent of the scene at the center of the viewfinder.

exposure settings using Auto Exposure Lock (AE Lock is detailed later in this chapter), recompose, focus, and shoot. Alternatively, you can use Manual shooting mode to set the aperture and shutter speed from a Partial meter reading.

 While Partial metering mode can be considered advanced, don't be afraid to experiment with it. Trying this mode on appropriate subjects is one way to learn the camera and expand your creative options.

NOTE The T3/1100D's exposure meter is sensitive to stray light that can enter through the viewfinder. If you don't have your eye against the viewfinder, then use the viewfinder eyepiece cover that is attached to the camera strap, or cover the viewfinder with your hand.

Center-weighted Average metering mode

This metering mode weights exposure calculation for the center of the viewfinder, while evaluating light from the rest of the viewfinder to get an average for the entire scene (see Figures 2.21 and 2.22). The center area is larger than the 10 percent Partial metering area. As the name implies, the camera expects that the subject will be in the center of the viewfinder, and it gives approximately 75 percent of the exposure bias to the AF points shown in Figure 2.21.

Center-weighted Average metering mode is useful in scenes where the sky is brighter than a darker landscape. And provided that the subject is in the center of the frame, then Center-weighted Average metering mode is effective for virtually any subject that is in the center of the frame as well as for backlit subjects and subjects against a bright background such as bright white sand on a beach.

2.21 The Center-weighted Average metering mode weights exposure to the area shown here.

2.22 The Center-weighted metering mode icon that you see on the LCD and in the viewfinder.

Figures 2.23 through 2.25 show the effect of using each metering mode in a scene with moderate backlighting. I included the histogram to show the distribution of tones thorough each image.

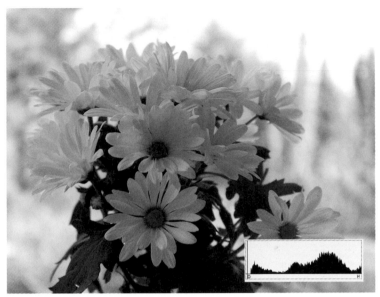

2.23 This figure and Figures 2.24 and 2.25 were shot using natural light with moderate backlighting. I used Av shooting mode and the center AF point for metering and focusing. (The images were later cropped in slightly from the left.) For this image, I used Evaluative metering mode. Exposure: ISO 200, f/5.6, 1/100 second.

 There are nine AF points, but in Center-weighted metering not all the AF points **NOTE** are used — only the seven AF points in the center; hence the name, Center-weighted.

To change to a different metering mode, follow these steps:

1. **In P, Tv, Av, M, or A-DEP, select the Shooting 2 camera menu tab, highlight Metering mode, and then press the Set button.** The Metering mode screen appears on the LCD with text and icons identifying the three metering mode options.

2. **Press the left or right cross key to select the metering mode you want.** The mode you choose remains in effect until you change it. If you switch to an automatic Basic Zone mode such as CA, Portrait, and Landscape, then the camera automatically uses Evaluative metering mode.

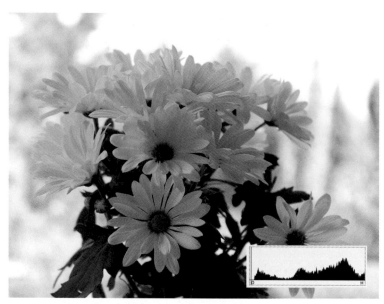

2.24 This image was made using Partial metering mode, and it provides a slightly brighter exposure on the flowers. Exposure: ISO 200, f/5.6, 1/80 second.

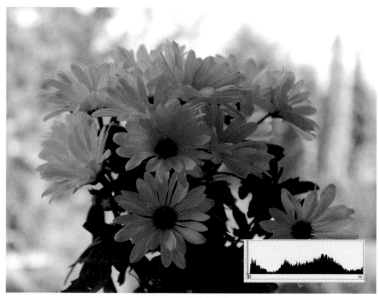

2.25 This image was made using Center-weighted Average metering mode. Exposure: ISO 200, f/5.6, 1/125 second.

 You can also quickly change the metering mode by pressing the Q button, selecting the Metering mode icon, and then turning the Main dial to change the mode.

Evaluating and Modifying Exposure

The goal of shooting is to get the best exposure possible in the camera. Now that you know how to control exposure using shooting modes, set the ISO, and use metering modes, it's important to know how to evaluate exposures and adjust the ones that are not spot-on.

When you evaluate exposures, look for these characteristics:

▶ **Highlights that maintain detail either throughout the image, or at least within the subject.** Highlights that do not retain detail go completely white with no image detail in them, and they are referred to as being *blown out* or *blown*. Particularly with JPEG capture, if you don't retain detail in the highlights, that detail is gone forever.

▶ **Shadows that show detail.** If the shadows go dark too quickly, they are referred to as being *blocked up*. For example, if you're photographing a groom in a black tuxedo, a good exposure shows detail within the shadowy folds of the coat or slacks.

▶ **Visually pleasing contrast, accurate color, and good saturation.** I would add another characteristic that isn't related to the aperture, shutter speed, and ISO, and that, of course, is tack-sharp focus.

Whereas the fundamental goal is getting a good exposure, there are times when the dynamics of the scene itself may simply not allow you to achieve all your exposure goals. For example, in a scene where the range from highlight to shadow is beyond the capability of the Rebel T3/1100D to maintain detail in both the highlights and shadows, then one or another technical characteristic must be sacrificed. In those situations, your goal is to get a proper and pleasing exposure on the subject. Alternatively, you can opt to shoot a series of images bracketed by shutter speed, and use a High Dynamic Range (HDR) program such as Nik Software's HDR Efex Pro to combine the best area exposures from each shot into a single image.

With that as an introduction, the next sections show you how to evaluate exposures as you're shooting, and how to modify exposures when necessary.

Evaluating exposure

After you take a picture, you can best evaluate the image exposure by studying the histogram. A *histogram* is a graph that shows either the brightness levels in the image from black to white, or in Red, Green, Blue (RGB) brightness levels, along the bottom (see Figures 2.26 and 2.27). The vertical axis displays the number of pixels at each location. The T3/1100D offers both types of histograms: a brightness (or luminance) histogram, and RGB (Red, Green, and Blue color channel) histograms.

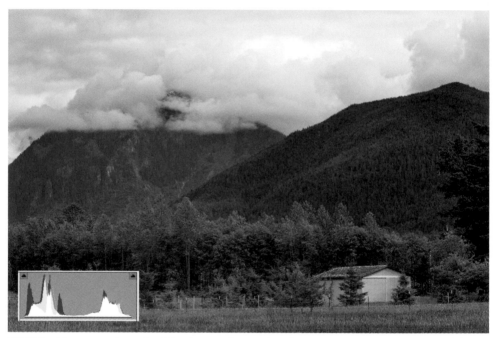

2.26 The histogram inset in this picture shows that the tones are distributed across the full range of levels. The highlights retain detail and the shadows are open, showing good detail. Exposure: ISO 100, f/9, 1/200 second using –2/3-stop of Exposure Compensation.

Histograms are the most useful tools that you can use while you're shooting, especially if you're shooting JPEG images, to ensure that highlights are not blown and that shadows are not blocked up. The following sections offer an overview of each type of histogram.

Brightness histogram

A brightness histogram shows grayscale brightness values in the image along the horizontal axis of the graph. The values range from black to white (level 255 on the

right of the graph) for an 8-bit JPEG image. This histogram shows you the exposure bias and the way that tones are distributed in the image.

 Although the T3/1100D captures **NOTE** 14-bit RAW images, the image preview and histograms are based on an 8-bit JPEG rendering of the RAW file.

The subject you're photographing affects the histogram, of course. For example, in an image of a black train engine, more pixels shift toward the left, shadow, side of the graph. In an image of a white lily, more pixels are on the right, highlight, side of the graph. However, if pixels crowd against the far-right edge of the graph forming a spike, then some highlights in the image are blown out; in other words, they are totally white with no image detail, or at level 255. If pixels spike on the left edge of the graph, then some shadows are blocked up and go to black too quickly.

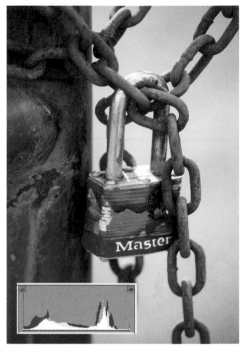

2.27 This image is overexposed, as the spiked pixels on the right side of the histogram show. Exposure: ISO 200, f/2.8, 1/500 second.

In a proverbial average scene, good exposure is shown with pixels spread across the graph from side to side and with no spikes on the left or right edges of the histogram.

 The histogram is a valuable tool to help you get the best exposures while you **TIP** are shooting. Make it a habit to check the histogram after shooting so that you can spot problems and reshoot if necessary.

RGB histogram

An RGB histogram shows the distribution of brightness levels for each of the three color channels — Red, Green, and Blue. Each color channel is shown in a separate graph so you can evaluate the color channel's saturation, gradation, and color bias. The horizontal axis shows how many pixels exist for each color brightness level, whereas the vertical axis shows how many pixels exist at that level. More pixels to the

left indicate that the color is darker and more prominent, whereas more pixels to the right indicate that the color is brighter and less dense. If pixels are spiked on the left or right side, then color information is either lacking or oversaturated with no detail, respectively. If you're shooting a scene where color reproduction is critical, the RGB histogram is likely most useful.

The histogram is a very accurate tool to use in evaluating JPEG captures. However, when you shoot RAW capture, the histogram is based on the JPEG conversion of the image. So if you shoot RAW, remember that the histogram is showing a less robust version of the image than you get during image conversion. To set the type of histogram displayed during image playback, follow these steps:

1. **On the Playback 2 camera menu tab, highlight Histogram, and then press the Set button.** Two histogram options appear.

2. **Press the up or down cross key to select either Brightness or RGB, and then press the Set button.**

To display the histogram during image playback, follow these steps:

1. **Press the Playback button on the back of the camera.** The most recent image appears on the LCD.

2. **Press the Disp. button on the back of the camera two or more times to display the Brightness histogram, or the RGB and Brightness histograms.** As you press the Disp. button, the preview cycles through the four image displays: single-image, single image with basic shooting information, small image with the Brightness histogram and detailed shooting information, and small image with the RGB and Brightness histograms displays and less detailed shooting information.

TIP During image playback, the two displays that include the histogram(s) show blown highlights as blinking areas on the preview image. That display provides a quick way to know if you should reshoot with the modified exposure options detailed later in this chapter.

Now that you know more about evaluating exposure, the next question is what should you do if the exposure needs adjustment? The Rebel T3/1100D offers both automatic and nonautomatic exposure corrections, which are detailed in the following sections.

Differences in Exposing JPEG and RAW Images

When you shoot JPEG images, it's important to expose the image so that highlight detail within the subject is retained. If you don't capture detail in the highlights, it's gone forever. To ensure that images retain detail in the brightest highlights, you can use one of the exposure techniques described in this chapter such as AE Lock or Exposure Compensation.

With RAW capture, you have more exposure latitude because some highlights can be recovered during RAW image conversion in Canon's Digital Photo Professional or Adobe Lightroom or Camera Raw. Without going into detail, it's important to know that fully half the total image data is contained in the first f-stop of the image. This underscores the importance of capturing the first f-stop of image data and of not underexposing the image. In everyday shooting, this means biasing the exposure slightly toward the right side of the histogram, resulting in a histogram in which highlight pixels just touch or almost touch, but are not crowded against, the right edge of the histogram.

With this type of exposure, the image preview on the LCD may look a bit light, but in a RAW conversion program, you can bring the exposure back slightly. So for RAW exposure, expose with a slight bias toward the right side of the histogram to ensure that you capture the full first f-stop of image data. For more details on RAW capture, see Appendix A.

Auto Lighting Optimizer

Auto Lighting Optimizer is an image-correction feature that boosts contrast and brightens images that are too dark (see Figures 2.28 and 2.29). This is one of the goof-proof features that can be useful if you print images directly from the memory card. However, if you edit images on the computer and if you care about controlling the exposure yourself, then you will likely prefer to see the image without automatic corrections. Auto Lighting Optimizer is turned on for all shooting modes at the Standard level. In Basic Zone modes such as Portrait, Landscape, and Sports mode, the optimization can't be turned off, and the level of correction is set to Standard. In P, Tv, Av, M, and A-DEP shooting modes, you can turn off optimization or set the level for Low, Standard, or Strong. And if you shoot RAW capture, you can apply Auto Lighting Optimizer in Canon's supplied Digital Photo Professional program.

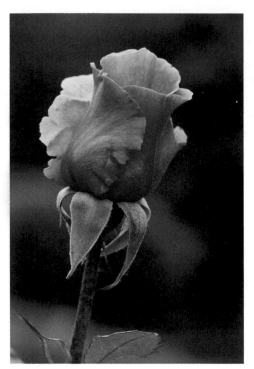

2.28 This image was taken without using Auto Lighting Optimizer. Exposure: ISO 200, f/8, 1/15 second.

2.29 This image was taken using Auto Lighting Optimizer at the High setting. The brightness increased overall and most noticeably in the highlights. It's a good idea to test the three settings, Low, Standard, and Strong, for the optimization before you use it routinely.

Although automatic brightening may seem handy, it also tends to reveal any digital noise in the image. Digital noise appears with a grainy look and as multicolored flecks, particularly in the shadow areas of the image. Also, by using Auto Lighting Optimizer, the effect of exposure modification may not be evident depending on the level of optimization chosen. For example, if you set negative Exposure Compensation (detailed later in this section), then Auto Lighting Optimizer automatically brightens the image and the effect of compensation is masked. The same happens for other exposure modifications such as Auto Exposure Bracketing (AEB) and AE Lock. If you prefer to see the effect of exposure modifications, then you can turn off Auto Lighting Optimizer, but only for Creative Zone shooting modes.

NOTE If you turned on Highlight tone priority using Custom Function II-5, then Auto Lighting Optimizer is turned off automatically in P, Tv, Av, M, and A-DEP shooting modes.

To adjust the level of or to turn off Auto Lighting Optimizer for Creative Zone shooting modes, follow these steps:

1. **In P, Tv, Av, or A-DEP shooting mode, select the Shooting 2 camera menu tab, and then highlight Auto Lighting Optimizer.**

2. **Press the Set button.** The Auto Lighting Optimizer screen appears.

3. **Press the right or left cross key to select the level you want or to turn it off, and then press the Set button.** You can choose Disable, Low, Standard, or Strong. The option you choose remains in effect until you change it. If you are using Highlight tone priority, Auto Lighting Optimizer is automatically set to Disable.

Highlight tone priority

Highlight tone priority is designed to improve or maintain highlight detail, and improve the tonal gradation in the highlights. It does this by extending the camera's dynamic range between 18 percent middle gray to the maximum highlights, thus effectively increasing the *dynamic range*, or the range of highlight to shadow tones as measured in f-stops in a scene. Using Highlight tone priority, however, the lowest ISO setting is 200 instead of 100.

If you have experience working with tonal ranges and curves, then the more technical explanation is that Highlight tone priority helps ensure that the pixel wells on the image sensor do not fill, or saturate, causing blown highlights. Also with the Rebel's 14-bit images, the camera sets a tone curve that is relatively flat at the top in the highlight area to compress highlight data. The trade-off, however, is a more abrupt move from deep shadows to black, which increases shadow noise. The result is an increase in dynamic range, disregarding, of course, the potential for increased shadow noise.

Highlight tone priority is turned off by default. You can turn on Highlight tone priority by following these steps:

1. **In P, Tv, Av, M, or A-DEP shooting mode, select the Setup 3 camera menu tab, highlight Custom Functions (C.Fn), and then press the Set button.** The Custom Functions screen appears.

2. **Press the right or left cross key until the number "6" is displayed in the box at the top right of the screen, and then press the Set button.** The Custom Function option control is activated and the option that is currently in effect is highlighted.

3. **Press the down cross key to highlight 1: Enable, and then press the Set button.** This turns on Highlight tone priority in Creative Zone shooting modes.

As a reminder that Highlight tone priority is enabled, a D+ designation is displayed in the viewfinder and on the LCD.

Exposure Compensation

There are times when you need to change the camera's recommended exposure to lighten or darken the overall image. Common scenarios include scenes with large areas of light or dark tones. For example, in scenes with large expanses of snow, the camera will darken the snow. This happens because the camera expects a scene where all the tones average to 18 percent reflectance, as discussed in the previous sections of this chapter. However, snow scenes are not average because they have a predominance of light tones that reflect more light back to the camera than 18 percent. The same is true for scenes with large expanses of dark tones such as a large body of water or a group of men in black tuxedos that reflect much less light than 18 percent.

To correct the exposure, you can use Exposure Compensation. For a snow scene, set +1- to +2-stop Exposure Compensation to render snow white instead of gray. A scene with predominately dark tones might require –1 to –2 stops of Exposure Compensation to get true dark renderings. You may need to experiment with the amount of compensation that you use in different scenes. Brightly lit scenes with light tones (as shown in Figure 2.30) need a smaller amount of compensation than scenes in overcast light.

> **TIP** The Rebel T3/1100D is set to make exposure changes by 1/3 f-stops by default. If you want larger changes, then you can set C.Fn I-1 to Option 1: 1/2-stop increments.

In addition, you can use Exposure Compensation to modify exposure if the histogram shows that highlights are blown or that shadows are blocked.

> **NOTE** You will hear the term *EV*, or Exposure Value, used. EV means the exposure at a given aperture, shutter speed, and ISO setting. At the same ISO, changing exposure by one EV is halving the light reaching the image sensor by either doubling the shutter speed or halving the aperture.

2.30 To get brighter whites in the snow and ice crystals, I used +1/3-stop of Exposure Compensation. Exposure: ISO 200, f/8, 1/250 second.

Here are some things that you should know about Exposure Compensation:

▶ Exposure Compensation works in P, Tv, Av, and A-DEP shooting modes, but it does not work in Manual mode or during Bulb exposures. In Tv shooting mode, Exposure Compensation changes the aperture by the specified amount of compensation. In Av shooting mode, it changes the shutter speed. In P mode, compensation changes both the shutter speed and aperture by the exposure amount you set.

▶ You can set Exposure Compensation up to +/–5 stops, or Exposure Values (EV). You can also combine Exposure Compensation with +/–2 EV of Auto Exposure Bracketing (AEB).

▶ The amount of Exposure Compensation you set remains in effect until you reset it. This applies whether you turn the camera off and back on, change the memory card, or change the battery. So remember to set the compensation back to zero when you finish shooting in scenes where you need compensation.

You can set Exposure Compensation by following these steps:

1. **In P, Tv, Av, or A-DEP shooting mode, press the Q button to display the Quick Control screen on the LCD.**

2. **Press a cross key to highlight the Exposure level indicator.** The Exposure level indicator is the scale at the upper left of the LCD.

3. **Turn the Main dial to the left to set negative Exposure Compensation or to the right to set positive compensation.** Although the scale initially displays only a +/–3 stops of compensation, you can continue turning the Main dial to set the full +/–5 stops of compensation.

Alternatively, you can set compensation as you're looking through the viewfinder. Just hold down the AV button as you turn the Main dial to set the compensation. The Exposure level indicator in the viewfinder only shows +/–2 EV.

To turn off Exposure Compensation when you finish shooting, repeat these steps, but in Step 3, turn the Main dial until the tick mark is at the center of the exposure level meter that's displayed on the Quick Control screen.

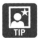 Alternatively, you can set Exposure Compensation and combine it with Auto Exposure Bracketing on the Shooting 2 menu. This approach is useful if you shoot a series of images at different exposures to combine into one High Dynamic Range (HDR) image.

Auto Exposure Bracketing

Though it does not directly modify the camera's recommended exposure, Auto Exposure Bracketing (AEB) fits in the category of exposure modification because it enables you to capture a series of three images, each at different exposures. One image is made at the camera's recommended exposure, one at an increased (lighter) exposure, and another at a decreased (darker) exposure. This ensures that one of the three exposures will be acceptable, particularly in challenging lighting. While bracketing isn't necessary in all scenes, it's a good technique to use in scenes that are difficult to set up or that can't be reproduced. It is also useful in scenes with contrasty lighting, such as a landscape with a dark foreground and a much lighter sky.

The camera is initially set to 1/3 f-stop increment exposure changes. If you want a greater level of exposure difference, you can set C.Fn I-1 to Option 1: 1/2-stop. With either setting, you can bracket image series up to +/–2 f-stops. Here are some things to know about AEB:

▶ You can't use AEB with the built-in or an accessory flash or when the shutter is set to Bulb. If you set AEB, and then pop up the built-in flash or pop it up while you're making one of the three bracketed images, the AEB settings are automatically and immediately cancelled. AEB settings are not retained when you turn the camera off.

▶ The order of bracketed exposures begins with the standard exposure followed by decreased (darker) and increased (lighter) exposures.

▶ You can use AEB in combination with Exposure Compensation for a total of +/–7EV except in M mode where you can set only AEB. If you combine AEB with Exposure Compensation, the shots are taken based on the compensation amount.

▶ If Auto Lighting Optimizer is turned on, the effects of AEB may not be evident in the darker image because the camera automatically lightens dark images. You can turn off Auto Lighting Optimizer on the Shooting 2 camera menu.

The T3/1100D offers the added flexibility of enabling you to shift the entire bracketing range to below or above zero on the meter. As a result, you can set all three bracketed exposures to be brighter or darker than the camera's recommended exposure and skip capturing the camera's standard exposure. Here's how AEB works in the different drive modes:

▶ In Continuous and Self-timer drive modes, pressing the shutter button once automatically takes three bracketed exposures. Since the camera is taking three images instead of one, AEB slows down the burst rate considerably. In the Self-timer drive modes, the three bracketed shots are taken in succession each after the timer interval has elapsed.

▶ In Single-shot drive mode, you have to press the shutter button three times to get the three bracketed exposures.

You can set AEB by following these steps:

1. **In P, Tv, Av, or A-DEP, select the Shooting 2 camera menu tab, highlight Expo. comp./AEB, and then press the Set button.** The Exposure comp./AEB setting screen appears.

2. **Turn the Main dial to the right to set the bracketing amount.** Markers that show increased and decreased exposure settings are displayed on the bracketing scale. You can set bracketing up to +/–2 EV.

 If you want to shift the bracketed exposures so they all are in the negative or positive range, then press the left cross key to set negative exposure bracketing, or the right cross key to set positive exposure bracketing.

3. **If you're in One-shot drive mode, press the shutter button to focus, and then press it completely to take the picture.** Continue pressing the shutter button two more times to take all three bracketed shots. In Continuous or a Self-timer mode, the three shots are taken by pressing the shutter button once. In Self-timer modes, the three bracketed shots are taken automatically.

TIP If you're combining AEB with Exposure Compensation in P, Tv, Av, or A-DEP shooting mode, you can set the compensation or AEB on the Quick Control screen, but it's easier to set both amounts by selecting the Shooting 2 menu tab, highlight Expo. comp./AEB, and then press the Set button.

Locking exposure on a critical area

As you know by now, the camera meters the light with a bias toward the active or selected AF point. But there are times you do not want the camera to take its exposure meter reading at the same place where you set the focus. For example, if you're taking a portrait, you may want the camera to take the meter reading on the person's skin, but you want to focus on the person's eyes.

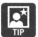 You can also use AE Lock to help prevent blown highlights and to ensure proper exposure for a backlit subject.

So how do you disengage metering from the bias toward the active AF point? To meter on one area of the scene or subject and focus on another area, you can use Auto Exposure Lock (AE Lock). Just press the shutter button halfway down to meter on one area, and then press the AE Lock button to have the T3/1100D retain the exposure settings. Now you can move the camera to recompose the scene and focus on a different area of the scene. The camera maintains the locked exposure for a couple of seconds, and then releases it. As long as the asterisk is displayed in the viewfinder, AE Lock is still in effect.

 You cannot use AE Lock in the automatic Basic Zone shooting modes such as Portrait, Landscape, and Close-up.

Table 2.1 shows how AE Lock works with each metering mode and AF-point selection method and with manual focus.

Table 2.1 AE Lock Behavior with Metering Mode and AF-Point Selection

Metering Mode	Manual AF-Point Selection	Automatic AF-Point Selection	Manual Focus (Lens switch is set to MF)
Evaluative metering mode	AE Lock is set at the selected AF point.	AE Lock is set at the AF point that achieves focus.	AE Lock is set at the center AF point.
Partial and Center-weighted Average metering modes	AE Lock is set at the center AF point.		

You can use AE Lock by following these steps:

1. **In P, Tv, Av shooting mode, set the metering mode you want, and then manually select the AF point that you want to use.** (Manually selecting an AF point is detailed later in this chapter.) Note that in A-DEP mode, the camera

automatically selects the AF points. If you are using Partial or Centered-weighted Average metering modes, then AE Lock is set at the center AF point.

2. **Point the AF point you selected on the part of the scene where you want to set the exposure, and then press the shutter button halfway down.** If you are using Partial or Center-weighted Average metering, or if you are focusing manually, then point the center AF point over the area of the scene where you want to meter. The exposure settings are displayed in the viewfinder.

3. **Continue to hold the shutter button halfway down as you press the AE Lock button.** The AE Lock button is on the back right top of the camera, and it has an asterisk icon on it. When you press this button, an asterisk icon appears in the viewfinder to indicate that AE Lock is activated.

4. **Release the AE Lock button, move the camera to compose the shot, focus by half-pressing the shutter button, and then press the shutter button completely to make the picture.** As long as you see the asterisk in the viewfinder, you can take additional pictures using the locked exposure. Or you can press and hold the AE Lock button to continue shooting at the locked exposure settings.

Getting Tack-Sharp Focus

Whether you're shooting one image at a time or blasting out a burst of images during a soccer match, the Rebel T3/1100D provides autofocus modes for any situation, and its speedy focus performance can keep up with the action. In addition, you can choose any of the nine AF points, or you can have the camera automatically choose the AF points.

The following sections help you get the best performance from the Rebel T3/1100D's autofocus system.

Choosing an autofocus mode

Three autofocus modes are designed to help you achieve sharp focus based on the type of subject you're photographing. In P, Tv, Av, M, and A-DEP shooting modes, you can select from among these AF modes. In Basic Zone modes, the camera automatically chooses the autofocus mode.

In any of these autofocus modes, you can manually select an AF point or have the camera automatically select the AF point(s). Selecting an autofocus point is detailed later in this chapter.

The following list is a brief summary of the autofocus modes and when to use them.

▶ **One-shot AF.** This mode is designed for photographing stationary subjects that will remain still. Choose this mode when you're shooting landscapes, macro subjects, architecture, interiors, and portraits of adults. Unless you're shooting sports or action, One-shot AF is the mode of choice for everyday shooting. In this autofocus mode, the camera won't allow you to make the picture until the camera achieves sharp focus. You can tell the camera has achieved sharp focus when the focus confirmation light in the far right bottom corner of the viewfinder is lit and when the beeper sounds if you have the beeper turned on.

▶ **AI Servo AF.** This mode is designed for maintaining focus on moving subjects. The T3/1100D tracks focus on the subject regardless of the changes in focusing distance or direction. The camera sets both the focus and the exposure at the moment you press the shutter button. In this mode, you can press the shutter button completely even if the focus hasn't been confirmed. You can also use a manually selected starting AF point, although it may not be the AF point that ultimately achieves sharp focus. If you use automatic AF selection where the camera automatically selects the AF points, the camera starts focus tracking using the center AF point and tracks movement as long as the subject remains within the AF points in the viewfinder. In this mode, the camera does not confirm focus by sounding the beep or using the focus confirmation light.

▶ **AI Focus AF.** This mode is designed for photographing still subjects that may begin moving. This mode starts out in One-shot AF mode, but it automatically switches to AI Servo AF if the subject begins moving. Then the camera tracks focus on the moving subject. When focus is achieved, a soft beep alerts you, but the focus confirmation light in the viewfinder does not light. (The beeper beeps only if you have turned on the beep on the Shooting 1 camera menu.) This is a good mode to choose when you photograph wildlife, children, or athletes who alternate between stationary positions and motion.

TIP If you routinely set focus, and then keep the shutter button pressed halfway down, it shortens battery life. To maximize power, anticipate the shot and press the shutter button halfway down just before making the picture.

To change AF modes in Creative Zone modes, ensure that the lens switch is set to AF (autofocus), and then follow these steps:

1. **In P, Tv, Av, M, or A-DEP shooting mode, press the AF (right cross key) button on the back of the camera.** The AF mode screen appears.

2. **Turn the Main dial to change the AF mode, and then press the Set button.** The mode you choose remains in effect until you change it.

Does Focus-Lock and Recompose Work?

Some suggest that you can use the standard point-and-shoot technique of focus-lock and recompose with the Rebel T3/1100D. This is the technique where you lock focus on the subject, and then move the camera to recompose the image. In my experience, however, the focus can shift slightly during the recompose step, regardless of which AF point is selected. As a result, focus is not always tack sharp.

Some Canon documents note that at distances within 15 feet of the camera and when shooting with large apertures, the focus-lock-and-recompose technique increases the chances of *back-focusing*. Back-focusing is when the camera focuses behind where you set the AF point. Either way, the downside of not using the focus-lock-and-recompose technique is that you're restricted to composing images using the nine AF points in the viewfinder. The placement of the nine AF points isn't the most flexible arrangement for composing images. But manually selecting one AF point, locking focus, and then not moving the camera is the best way that I know to ensure tack-sharp focus in One-shot AF mode.

Selecting an autofocus point

One of the requirements for a successful picture is getting tack-sharp focus. When you're shooting in P, Tv, Av, and M modes, you can manually choose one of the nine AF points shown in the viewfinder, as shown in Figure 2.31. Alternatively, you can have the camera automatically select the AF points used for focusing. In the automatic Basic Zone and in A-DEP shooting modes, the camera automatically selects the AF point or points for you.

Having the camera automatically choose the AF points gives you sharp focus in the image, but the sharp focus may or may not be set where it should be in the scene, and here's why. When the camera chooses the AF points, it usually focuses on whatever is nearest the lens or has the most readable contrast. This may or may not be the area that should have the point of sharpest focus.

2.31 Nine AF points are shown on the focusing screen on the Rebel T3/1100D.

> **TIP** If you're using a lens that offers manual focusing, you can switch to manual focus at any time by setting the switch on the side of the lens to the MF (Manual Focus) setting. Then just turn the focusing ring on the lens to focus on the subject.

Improving Autofocus Accuracy and Performance

Autofocus speed depends on factors including the size and design of the lens, the speed of the lens-focusing motor, the speed of the AF sensor in the camera, the amount of light in the scene, and the level of subject contrast. Given these variables, it's helpful to know how to get the speediest and sharpest focusing. Here are some tips for improving overall autofocus performance:

▶ **Light.** In low-light scenes, the autofocus performance depends in part on the lens speed and design. In general, the faster the lens or the larger the maximum aperture of the lens, such as f/2.8, the faster the autofocus performance. But regardless of the lens, the lower the light, the longer it takes for the system to focus.

Low-contrast subjects and/or subjects in low light slow down focusing speed and can cause autofocus failure. In low light, consider using the built-in flash or an accessory EX Speedlite's AF-assist beam as a focusing aid. By default, the Rebel T3/1100D is set to use the AF-assist beam for focusing. This is controlled by C.Fn III-6.

▶ **Focal length.** The longer the lens, the longer the time to focus. This is true because telephoto lenses go farther into defocus range than normal or wide-angle lenses. You can improve the focus time by manually setting the lens in the general focusing range and then using autofocus to set the sharp focus.

▶ **AF-point selection.** Manually selecting a single AF point provides faster autofocus performance than using automatic AF-point selection because the camera doesn't have to determine and select the AF point or points to use first.

▶ **Subject contrast.** Focusing on low-contrast subjects is slower than on high-contrast subjects. If the camera can't focus, shift the camera position to an area of the subject that has higher contrast, such as a higher contrast edge.

▶ **EF Extenders.** Using an EF Extender reduces the speed of the lens-focusing drive.

Think about what is most important in the subject or scene, and set the sharp focus there. In a portrait, the sharp focus should be on the eyes; in a flower image, it should be on the center of the flower; and so on.

You can manually select the AF point by following these steps:

1. **In P, Tv, Av, or M mode, press the AF-point Selection/Magnify button.** The AF-point Selection button is on the back top-right of the camera and has a magnifying glass with a plus sign in its icon below the button. The currently selected AF point displays a red dot in the center of the AF point in the viewfinder.

In A-DEP shooting mode, the camera automatically selects the AF points.

2. **As you look in the viewfinder, turn the Main dial until the AF point that you want to use is highlighted.** You can also use the cross keys to select an AF point. If you select the option where all the AF points are highlighted, then the camera automatically selects the AF point or points. Do not choose this option if you want to control the point of sharpest focus in the image. Rather, choose an option where only one AF point — the one that is on top of the part of the subject where you want sharp focus — is highlighted.

To quickly move to the center AF point, press the Set button once. Press the Set button again to select automatic AF-point selection.

3. **Move the camera so that the AF point you selected is over the point in the scene that should have sharp focus, press the shutter button halfway down to focus on the subject, and then press it fully to make the picture.** When you half-press the shutter button, look to see if the focus confirmation light is lit in the viewfinder if you're in One-shot or AI Focus AF mode.

You can verify image sharpness by pressing the Playback button, and then pressing and holding the AF-point Selection/Magnify button on the back of the camera.

To learn why images are blurry and for tips on avoiding blur, see the Quick Tour.

Selecting a Drive Mode

A drive mode determines how many shots the camera takes at a time, or in a Self-timer mode, it sets the camera to fire the shutter automatically after a 10- or 2-second delay. The Rebel T3/1100D offers three drive modes for different shooting situations: Single-shot, Continuous, and three Self-timer modes.

In some Basic Zone modes, you can choose a different drive mode such as Continuous, and in all Basic Zone modes, you can select one of the Self-timer drive modes. In P, Tv, Av, M, A-DEP, and CA shooting modes, you can choose any of the drive modes.

Single-shot drive mode

As the name implies, Single-shot means that the T3/1100D takes one picture each time you press the shutter button. This is the default mode on the camera in P, Tv, Av, M, and A-DEP modes. In the automatic Basic Zone modes, Single-shot drive mode is used for all shooting modes except Portrait and Sports. In CA mode, you can choose Single-shot, Continuous, and two of the Self-timer drive modes.

Continuous drive mode

In Continuous drive mode, you can shoot at 3 fps, or if you press and hold the shutter button, you shoot a continuous burst of 830 or more JPEG Large images at 3 fps, 5 RAW images at 2 fps, or 1 RAW+JPEG Large image at 0.8 fps. Continuous is the drive mode to choose for shooting sports (see Figure 2.32) or other moving subjects such as children, pets, and wildlife.

 In AI Servo AF mode, the burst rate may be less, depending on factors including the lens and the subject.

When you're shooting a burst of images and the buffer fills up, you can't shoot until some of the images are offloaded to the memory card. With smart-buffering capability, you don't have to wait for the buffer to empty all the images to the memory card before you can continue shooting. After a continuous burst sequence, the camera begins offloading pictures from the buffer to the card. As offloading progresses, the camera indicates in the viewfinder when there is enough buffer space to continue shooting. When the buffer is full, a "busy" message appears in the viewfinder, but if you keep the shutter button pressed, the number of pictures that you can take is updated in the viewfinder. This is where it is useful to have a fast memory card, which speeds up image offloading from the buffer. You can use the flash with Continuous mode, but due to the flash recycle time, shooting will be slower than without the flash.

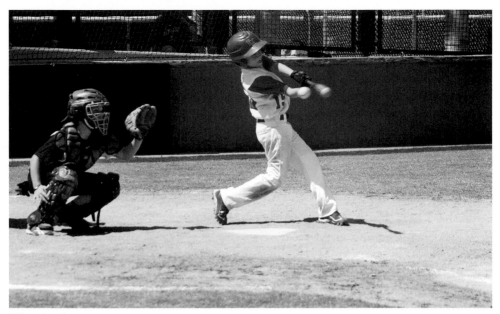

©Bryan Lowrie

2.32 Continuous drive mode and AI Servo AF autofocus mode are the modes of choice for sports photography. Bryan used both modes for this image of a baseball game. Exposure: ISO 200, f/5.6, 1/800 second.

 If the AF mode is set to AI Servo AF, the T3/1100D focuses continually during continuous shooting. However, in One-shot AF mode, the camera only focuses once during the burst.

Self-timer drive modes

In Self-timer drive modes, the camera delays making the picture for 10 or 2 seconds after the shutter button is fully depressed. In addition, you can use the 10-second delay plus Continuous shooting to take a series of images, all with the 10-second delay. For self-timer shots, be sure to use the eyepiece cover included with the camera to prevent stray light from entering through the viewfinder.

Here is a summary of the self-timer modes:

▶ **10-sec. Self-timer/Remote control.** In this mode, the camera waits 10 seconds before firing the shutter, giving you time to get into the picture. In addition, you can use the accessory wireless Remote Controller RC-6 that trips the shutter immediately or after 2 seconds, or a corded Remote Switch RS-60E3 with

this mode. This mode is useful when you want to be in the picture with others, and for nature, landscape, and close-up shooting.

▶ **2-sec. Self-timer.** In this mode, the camera waits for 2 seconds before firing the shutter. This is a good choice when you're photographing documents or artwork.

▶ **10-sec. Self-timer Continuous.** In this mode, you can choose to have the camera take two to ten shots in sequence, each with a 10-second delay.

To change the drive mode, follow these steps:

1. **In P, Tv, Av, M, or A-DEP shooting mode, press the Drive mode button (the left cross key) on the back of the camera.** The Drive mode screen appears. In Basic Zone modes, a limited selection of drives modes are available depending on the shooting mode you've chosen.

2. **Press the left or right cross key to select the drive mode you want, and then press the Set button.** Text identifying each drive mode icon is displayed as you make your selection. You can also turn the Main dial to select the mode you want.

Getting Great Color and Adding Creative Looks to Images

A range of excellent tools on the T3/1100D helps ensure that your images have visually pleasing color regardless of the type of light. Getting great color begins during shooting, when you select the appropriate White Balance or Lighting option and Picture Style.

The T3/1100D also offers image effects to apply for creative looks. In P, Tv, Av, M, and A-DEP shooting modes, you can select Picture Styles that control the color rendering and saturation according to the subject or your personal preferences. In some Basic Zone shooting modes, you can use Ambience effects to create vivid, soft, or intense looks. In this chapter, you learn how each option is useful in different shooting scenarios. But first, it's important to understand the basics of light and its colors.

The T3/1100D delivers true-to-life, vibrant color. Exposure: ISO 200, f/3.2, 1/800 second.

Understanding Color Temperature

Before detailing the camera settings that ensure good color, it's helpful to understand the basics of color temperature. Few people think of light as having color until the color becomes obvious, such as at sunrise and sunset. At sunrise and sunset, the sun's low angle causes light to pass through more of the earth's atmosphere, creating visible and often dramatic color. However, regardless of the time of day, natural light has a color temperature, and each color, or hue, of sunlight renders subjects differently. Likewise, household and commercial light bulbs, candlelight, flashlights, and electronic flashes all have distinct color temperatures.

The color of the light is not always obvious. Human eyes automatically adjust to the changing colors of light so that white appears white, regardless of the type of light in which we view it. Digital image sensors are not, however, as adaptable as the human eye. For example, when the Rebel T3/1100D is set to the Daylight White Balance, it renders color in a scene most accurately in the light at noon on a sunny, cloudless day. But the Daylight White Balance setting does not render color under household light because the temperature of the light is different.

Unlike air temperature, which is measured in degrees Fahrenheit (or Celsius), light temperature is based on the spectrum of colors that is radiated when a black body radiator is heated. Visualize heating an iron bar. As the bar is heated, it glows red. As the heat intensifies, the metal color changes to yellow, and with even more heat, it glows blue-white. In this spectrum of light, color moves from red to blue as the temperature increases.

This concept can be confusing because "red hot" is often thought of as being significantly warmer than blue. But in the world of color temperature, blue is, in fact, a much higher temperature than red. That also means that the color temperature at noon on a clear day is higher (bluer) than the color temperature of a fiery red sunset. And the reason that you care about this is because it affects the color accuracy of your images. So just keep this general principle in mind: The higher the color temperature is, the cooler (or bluer) the light; the lower the color temperature is, the warmer (or yellower/redder) the light.

The color temperature of natural light changes throughout the day. By knowing the predominant color temperature shifts throughout the day, you can adjust the White Balance in Creative Zone shooting modes or the Lighting type in some Basic Zone shooting modes to ensure accurate color.

Using T3 Color Settings

The settings on the T3/1100D that affect image color in Program AE (P), Shutter-priority AE (Tv), Aperture-priority AE (Av), Manual (M), and Automatic Depth of Field (A-DEP) shooting modes are White Balance, Picture Style, and Color Space. In the automatic shooting modes, you can set the Lighting or Scene type and add Ambience effects. Here is a summary of each option:

▶ **White Balance and Lighting or Scene type.** These settings determine the accuracy of color in images. To get accurate color, the camera must know what kind of light is in the scene. The White Balance setting in P, Tv, Av, M, and A-DEP shooting modes, and the Lighting or Scene type in some automatic shooting modes give the camera that information so the T3/1100D can, in turn, render colors accurately. To get accurate color, you need to change the White Balance or the Lighting or Scene type each time the light in the scene changes.

The lighting options that you can adjust in some automatic Basic Zone modes are referred to as Lighting or Scene types, and they work much like White Balance settings in Creative Zone shooting modes.

▶ **Picture Styles.** These settings determine whether the image colors are vivid and saturated, or more subdued, and they affect image sharpness and contrast. How often you change the Picture Style depends on your preferences for color rendering, saturation, and contrast in the images and the type of scene or subject that you are photographing.

▶ **Color Space.** This option determines the breadth of colors that are captured in images. Some color spaces encompass a broad range of colors, and others encompass fewer colors. Choosing a color space also factors into your preferences for editing and printing images; however, you want to keep color space consistent from image capture through editing and printing. The Color Space option is one that most photographers set once and seldom change.

▶ **Ambience effects.** When you're shooting in the Basic Zone modes except for Full Auto and Flash Off shooting modes, you can apply Ambience effects that include Standard, Vivid, Soft, Warm, Intense, Cool, Brighter, Darker, and Monochrome. Much like Picture Styles, these effects enable you to control the color and rendering of images.

Each of these settings plays a unique role in determining image color. The following sections provide more detail on using these settings.

Choosing White Balance Options

To get accurate image color when you're shooting in P, Tv, Av, M, and A-DEP shooting modes, you have to tell the camera what type of light you're shooting in by selecting one of seven White Balance options or by setting a Custom White Balance that measures the specific light in the scene. Using the correct White Balance settings will help you spend less time color-correcting images on the computer and more time shooting. Figures 3.1 through 3.7 show the color bias of different White Balance settings using the same subject. And Figure 3.8 shows the effect of setting the White Balance specifically to match the light temperature in the scene.

3.1 Auto White Balance (AWB) setting. Exposure: ISO 100, f/16, 1/125 second. I used studio strobes for lighting. The Wein Safe Sync adapter that fits on the camera's hot shoe enabled me to use the studio lights with the T3/1100D. The exposure and Picture Style are the same for Figures 3.1 through 3.8. For the type of light in this scene, the Auto White Balance is good, but the Custom White Balance (see Figure 3.8) provides the most accurate color.

3.2 Daylight White Balance setting and the Standard Picture Style

3.3 Shade White Balance setting

3.4 Cloudy White Balance setting

3.5 Tungsten White Balance setting

3.6 Fluorescent White Balance setting

3.7 Flash White Balance setting

3.8 This image was taken using a Custom White Balance.

> **TIP** If you shoot RAW images, you can set and adjust the White Balance in a RAW conversion program such as Digital Photo Professional, a program included on the disk that comes with the camera, after the image is captured.

Using White Balance options

For most scenes where there is clearly defined light, the Preset White Balance options, such as Daylight and Cloudy, provide accurate image color. In mixed lighting situations, you get the most accurate image color by setting a Custom White Balance, detailed in the next section. You may wonder why you can't just set the White Balance to Auto and leave it. Auto White Balance seems very handy, but my experience shows that you will get better color if you choose the Preset White Balance setting that matches the light. Also, the AWB setting tends to have an overall cool, bluish, hue.

AWB is an acceptable choice when you're shooting a scene with mixed light if you don't have time to set a Custom White Balance, but be aware of its cooler color rendering.

The more time you spend faithfully setting the White Balance for the type of light in the scene you're photographing, the more time you'll save color-correcting images on the computer.

To change to a Preset White Balance option, such as Daylight, Tungsten, or Shade, follow these steps:

1. **Set the Mode dial to P, Av, Tv, M, or A-DEP, and then press the WB cross key on the back of the camera.** The WB button is the down cross key. The White Balance screen appears.

2. **Turn the Main dial to select a White Balance setting, and then press the Set button.** For some settings, the color temperature Kelvin (K) is displayed on the White Balance screen. Because the White Balance option you set remains in effect until you change it, remember to reset it when you begin shooting in different light.

You can also change the White Balance setting on the Quick Control screen. Just press the Q button on the back of the camera, and then press a cross key to select the White Balance icon. Then turn the Main dial to change the setting.

Setting a Custom White Balance

Mixed-light scenes, such as scenes with both tungsten light and daylight, can make getting accurate or visually pleasing image color a challenge. In mixed-light scenes, setting a Custom White Balance balances image colors for the specific light or combination of light types in the scene. But a Custom White Balance is not limited to mixed-light scenes. In any type of light, whether it's a single light source or mixed, Custom White Balance is an excellent way to ensure accurate and visually pleasing color.

Another advantage to creating a Custom White Balance setting is that it works whether you're shooting JPEG or RAW capture in P, Tv, Av, M, or A-DEP mode. Just remember that if light changes, you need to set a new Custom White Balance to get accurate color.

Getting Accurate Color with RAW Images

If you are shooting RAW capture, an easy way to get accurate color is to photo-graph a white or gray card that is in the same light as the subject, and then use the card as a reference point for color correction as you convert RAW images on the computer.

For example, if you're taking a series of portraits in the same light, ask the sub-ject to hold the gray or white card under or beside his or her face for the first shot. Then remove the card and continue shooting. When you begin converting the RAW images on the computer, open the picture that you took with the card. Click the card with the White Balance tool to correct the color, and then click Done to save the corrected White Balance settings. If you're using a RAW con-version program such as Adobe Camera Raw or Canon's Digital Photo Professional, you can copy the White Balance settings from the image you just color balanced. Just select all the images shot under the same light, and then paste the White Balance settings to them. In a few seconds, you can color bal-ance 10, 20, 50, or more images.

You can use a number of white and gray card products such as the WhiBal cards from Michael Tapes Design (http://mtapesdesign.com/whibal), ExpoDisc from ExpoImaging (www.expodisc.com), or X-Rite ColorChecker Passport (blog.xrite photo.com/?p=641) to get a neutral reference point. And a gray card is included in the back of this book. There are also small reflectors that do double-duty by having one side in 18 percent gray and the other side in white or silver. You can also use a plain white unlined index card.

 For step-by-step tasks in this chapter that involve the camera menus, press the **NOTE** Menu button, turn the Main dial to move to the camera menu tab you want, and then press the up or down cross key to select an option.

To set a Custom White Balance, follow these steps:

1. **Set the camera to P, Av, Tv, M, or A-DEP shooting mode, and ensure that the Picture Style is not set to Monochrome.** To check the Picture Style, go to the Shooting 2 camera menu, select Picture Style, and then press the Set

button. The Picture Style screen is displayed. To change from Monochrome, press the up or down cross key to select another style, and then press the Set button. Also have the White Balance set to any setting except Custom.

2. **With the subject in the light you'll be shooting in, position a piece of unlined white paper so that it fills the center of the viewfinder, and take a picture.** If the camera cannot focus, switch the lens to MF (Manual Focus) if your lens offers MF, and then focus on the paper. Also ensure that the exposure is neither underexposed nor overexposed, such as by having Exposure Compensation (detailed in Chapter 2) set.

3. **On the Shooting 2 camera menu tab, highlight Custom WB, and then press the Set button.** The camera displays the last image captured (the image with the white piece of paper) with a Custom White Balance icon in the upper left of the display. If the image of the white paper is not displayed, press the left cross key until it is.

4. **Press the Set button again.** The T3/1100D displays a confirmation screen asking if you want to use the White Balance data from this image for the Custom White Balance setting.

5. **Select OK, and then press the Set button.** The camera imports the White Balance data. A second screen appears reminding you to set the White Balance to Custom.

6. **Press the Set button to select OK, and then lightly press the shutter button to dismiss the menu.**

7. **Press the WB (White Balance) cross key on the back of the camera, and then press the right cross key to select Custom White Balance.** The White Balance screen appears. The Custom White Balance icon is on the far right and is identified with text on the screen.

8. **Press the Set button.** You can begin shooting now and get custom color in the images as long as the light doesn't change. The Custom White Balance setting remains in effect until you change it by setting another White Balance.

When you finish shooting in the light for which you set a Custom White Balance and move to a different area or subject, remember to reset the White Balance setting.

Tweaking the White Balance

Given the wide range of indoor tungsten, fluorescent, and other types of light that are available, the Preset White Balance options may or may not deliver spot-on accurate color for the light in the scene. And even if they are accurate, you may prefer a bit

more of a green or blue bias to the overall image color. With the Rebel T3/1100D, you can use White Balance Auto Bracketing to get a set of three images, each a slightly different color bias. The color bias can be set up to +/–3 levels in one-step increments.

White Balance Auto Bracketing is also handy when you don't know which color bias will give the most pleasing color. The White Balance bracketed sequence gives you three images from which you can choose the most pleasing color.

White Balance Auto Bracketing reduces the maximum burst rate of the Rebel T3/1100D by one-third in Continuous drive mode because the camera records three images. If you are using One-shot drive mode, press the shutter button three times to capture all three bracketed images.

To set the White Balance Auto Bracketing setting, follow these steps:

1. **With the camera set to P, Tv, Av, M, or A-DEP shooting mode, select the Shooting 2 camera menu tab.**

2. **Highlight WB Shift/BKT (White Balance Shift/Bracket), and then press the Set button.** The WB Correction/WB Bracketing screen appears, as shown in Figure 3.9.

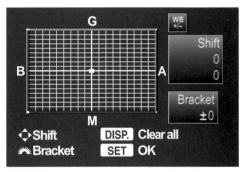

3.9 White Balance Auto Bracketing screen

3. **Turn the Main dial clockwise to set a Blue/Amber bias, or counterclockwise to set a Magenta/Green bias.** As you turn the Main dial, three squares appear and the distance between them increases as you continue to turn the dial. The distance between the squares sets the amount of bias. On the right side of the screen, the camera indicates the bracketing direction and level under Bracket. You can set up to +/–3 levels of bias. If you change your mind and want to start again, press the Info. button on the back of the camera.

4. **Press the Set button.** The Shooting 2 (red) menu appears with the amount of bracketing displayed next to the menu item.

5. **If you're in One-shot drive mode, press the shutter button three times to capture the three bracketed images, or if you're in Continuous drive mode, press and hold the shutter button to capture the three bracketed images.**

With a blue/amber bias, the standard White Balance is captured first, and then the bluer and more amber bias shots are captured. If magenta/green bias is set, then the image-capture sequence is the standard capture, then more magenta bias, and then more green bias. White Balance Auto Bracketing continues in effect until you remove it or the camera is turned off.

 You can combine White Balance Auto Bracketing with Auto Exposure Bracketing. If you do this, a total of nine images are taken for each shot. Bracketing also slows writing images to the memory card.

Correcting the color tone

In certain types of light, the preset White Balance settings might be a bit too cool or too warm. You can correct this color tone by biasing, or shifting, the color tone of images using White Balance Correction. This feature is much like using a color-correction filter on a film camera. The color can be biased toward blue (B), amber (A), magenta (M), or green (G) in +/–9 levels measured as *mireds*, or densities. Each level of color correction that you set is equivalent to five mireds of a color-temperature conversion filter. When you set a color correction or bias, it is used for all images until you change the setting.

 In film photography, densities of color-correction filters range from 0.025 to 0.5. On the Rebel T3/1100D, shifting one level of correction is equivalent to five mireds of a color-temperature conversion filter.

To set White Balance Correction, be sure the camera Mode dial is set to P, Tv, Av, M, or A-DEP shooting mode, and then follow these steps:

1. **On the Shooting 2 camera menu tab, highlight WB Shift/BKT, and then press the Set button.** The WB Correction/WB Bracketing screen appears.

2. **Press a cross key to set the color bias and amount that you want toward blue, amber, magenta, or green.** On the right of the screen, the Shift panel shows the bias and correction amount. For example, B2, A1 shows a two-level blue correction with a one-level amber correction. If you change your mind and want to clear settings or start again, press the Disp. button.

3. **Press the Set button.** The Shooting 2 menu appears. The color shift you set remains in effect until you change it. To turn off White Balance Correction, repeat Steps 1 and 2, and in Step 2, press the Disp. button to return the setting to zero.

Getting accurate color in automatic shooting modes

On earlier Rebels, you could not adjust the camera for the light source in Basic Zone shooting modes such as Portrait, Landscape, and Sports modes. But on the T3/1100D, you can now match the type of light in the scene by setting the *Lighting or Scene type*. Although these options are denoted as Lighting or Scene types, they function the same way as the Preset White Balance settings. However, their names are slightly different in some cases. In the Full Auto, Flash Off, CA, and Night Portrait automatic shooting modes, the T3/1100D automatically chooses the Lighting or Scene type.

The T3/1100D includes these Lighting or Scene types:

▶ **Default.** The T3/1100D makes its best guess at the light and light temperature in the scene. Typically this is a reasonable choice when you have mixed light sources.

▶ **Daylight.** This setting delivers the most accurate color under sunny skies.

▶ **Shade.** This setting corrects the blue color of cool light in the shade.

▶ **Cloudy.** This setting is good to use when the sky is fully overcast.

▶ **Tungsten light.** This setting is ideal for traditional incandescent household light bulbs because it reduces the yellow color they produce.

▶ **Fluorescent light.** This setting is best for all types of fluorescent lighting.

▶ **Sunset.** This setting renders the warm colors of sunset accurately. Alternatively, you can use the Cloudy Lighting/Scene type.

 If you use a flash, the Lighting or Scene type automatically changes to the Default Lighting or Scene type.

You can combine a Lighting or Scene type selection with an Ambience setting, detailed later in this chapter. If you do, it's important to set the Lighting type first so that the camera records the image color correctly before the camera shifts the color, as it does with some Ambience options.

In addition, if you're using a Lighting or Scene type that creates warm image colors, such as Sunset, and then choose an Ambience setting that further increases the color warmth, such as Warm, the combination creates an overly warm and unnatural look. To verify the settings, try using Live View to ensure that the Lighting type and Ambience setting combination creates a pleasing result.

Here is how to set a Lighting or Scene type:

1. **Set the Mode dial to Portrait, Landscape, Close-up, or Sports shooting mode, and then press the Live View shooting button on the back of the camera.** A live view of the scene appears on the LCD. The advantage of using Live View is you get an approximation of the Lighting type effect, and it's good to see the preview before you shoot. However, it is hard to see the effect on the LCD in bright light.

 Alernatively: If you don't want to use Live View mode, then skip to Step 2 without pressing the Live View button.

2. **Press the Q button to display the Quick Control screen, and then press the up or down cross key to highlight the text, Default setting, or the last Lighting or Scene type you selected.** Be sure the text at the bottom of the screen says Shoot by Lighting or Scene type.

3. **Turn the Main dial to select the Lighting type you want.** You can also select the Lighting or Scene type by pressing the left or right cross key. If you're using Live View, the preview scene on the LCD changes to reflect the setting you choose. If the color does not appear accurate, choose another Lighting or Scene type.

4. **In Live View, compose, focus, and make the picture.** If you are not using Live View, use the viewfinder to compose, focus, and make the image.

Changing the Look of Images Using Picture Styles

Once you know how to get great color in your images, you can go a step further by using Picture Styles when you're shooting in P, Tv, Av, M, and A-DEP shooting modes. Picture Styles affect the look of images by adjusting the color tone, saturation, contrast, and sharpness used in images. For example, you can choose the Landscape Picture Style when you want vivid colors and color saturation along with higher contrast and sharpness, or choose the Portrait Picture Style to get warm, soft skin tones and subdued color saturation, contrast, and sharpness.

Choosing a preset Picture Style

The Rebel T3/1100D offers six Picture Styles, which are detailed in Table 3.1. Each Picture Style has settings for sharpness, contrast, color saturation, and color tone that you can use as is or you can modify to suit your preferences when you're shooting in P, Tv, Av, M, and A-DEP shooting modes. In addition, you can create up to three User Defined Styles that are based on one of Canon's Picture Styles.

 The camera uses the Standard Picture Style as the default style for all Basic Zone modes.

 Be sure to test Picture Styles first, and then choose the ones that provide the best prints for your JPEG images.

In addition to forming the basis of image rendering, Picture Styles are designed to give you good prints when you print JPEG images directly from the memory card. If you shoot RAW capture, you can't print directly from the memory card. For RAW capture, the Picture Style is noted in the file, but it's not applied unless you use Canon's Digital Photo Professional program. You can also change the Picture Style during RAW-image conversion using Canon's Digital Photo Professional conversion program. In other RAW conversion programs, the Picture Style is not recognized.

In addition, you can modify a Picture Style on the computer using Canon's Picture Style Editor, as detailed later in this chapter.

Figures 3.10 through 3.15 show how Picture Styles change image renderings. In addition, I included Figure 3.16 that shows the Monochrome Picture Style with a Red filter applied. The differences may not be as apparent in this book due to commercial printing, but they give you a starting point for

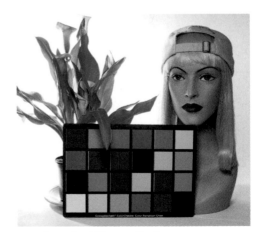

3.10 Standard Picture Style

evaluating differences in Picture Styles. The images were shot using the Daylight White Balance setting. For these images, I chose objects that show the effect of each setting on plants, skin tones, and the rendition of colors in the color checker chart.

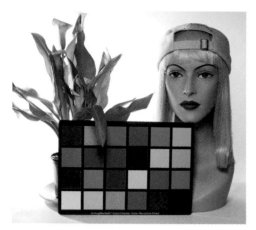

3.11 Portrait Picture Style

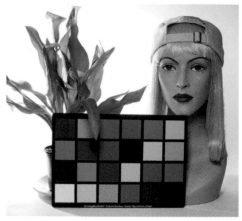

3.12 Landscape Picture Style

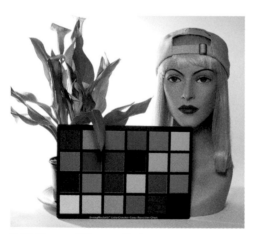

3.13 Neutral Picture Style

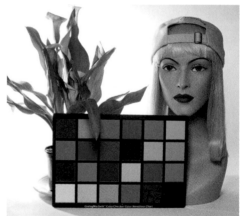

3.14 Faithful Picture Style

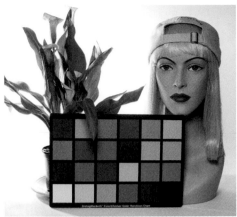

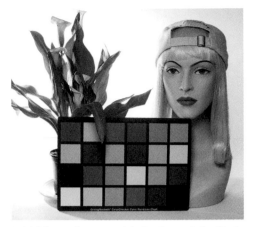

3.15 Monochrome Picture Style

3.16 Monochrome with Sepia and the Red filter

Default settings in Table 3.1 are listed in order of sharpness, contrast, color saturation, and color tone.

Table 3.1 EOS T3/1100D Picture Styles

Picture Style	Description	Sharpness	Color Saturation	Default Settings
Standard	Vivid, sharp, crisp images with uniform colors that are suitable for direct printing from the memory card.	Moderate	High	3,0,0,0
Portrait	Provides a warmer rendition in skin tones, lower contrast and color saturation, and soft texture rendering.	Low	Low	2,0,0,0
Landscape	Deepens blues and brightens greens to create vivid reproduction, high color saturation, and high sharpness to emphasize landscape details.	High	High saturation for greens and blues	4,0,0,0

continued

Table 3.1 EOS T3/1100D Picture Styles *(continued)*

Picture Style	Description	Sharpness	Color Saturation	Default Settings
Neutral	True color reproduction with low contrast and color saturation, reducing the chance of overexposure and oversaturation. Helps retain highlight details. Allows latitude for image editing.	None	Low	0,0,0,0
Faithful	Provides true-to-life color rendition for subjects shot in light with a color temperature of 5200K, low color saturation, and sharpness.	None	Low	0,0,0,0
Monochrome	Black-and-white or toned images with slightly high sharpness.	Slightly high	Yellow, orange, red, and green filter effects available	3,0,N,N

Many people have grown accustomed to seeing images with strong contrast, vivid color, and a high sharpness level. If this is your preference, and if you routinely print images from the memory card without first editing them on the computer, then you'll likely be pleased if you use the Standard Picture Style for everyday shooting, and the Landscape Picture Style for landscapes. The Standard style is the one set on the T3/1100D by default.

However, if you prefer a subtler rendering of color, saturation, and contrast that offers more fine details in the highlights and shadows, and if you enjoy editing images on the computer before printing them, then you'll likely appreciate the Neutral, Portrait, and Faithful styles. You can choose a Picture Style by following these steps:

1. **With the camera in P, Tv, Av, M, or A-DEP shooting mode, select the Shooting 2 menu, and then highlight Picture Style.**

2. **Press the Set button.** The Picture Style screen appears with the current Picture Style highlighted. The screen also shows the default settings for the style.

3. **Press the down or up cross key to highlight the Picture Style you want, and then press the Set button.**

Adjusting Picture Styles

After using, evaluating, and printing with different Picture Styles, you may want to change the default parameters to get a slightly different rendition. If you print directly from the media card, you might prefer a higher contrast setting or increased sharpness. Alternatively, you may want to create a custom style with different settings from what the preset styles offer. On the T3/1100D, you can create up to three custom Picture Styles.

If you want to adjust a preset Picture Style or create your own style, here are the adjustments that you can modify, which are illustrated in Figure 3.17:

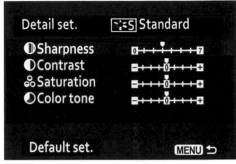

▶ **Sharpness: 0 to 7.** Level 0 applies no sharpening and renders a very soft look, whereas level 7 is the highest sharpening setting. If you print images directly from the memory card, a

3.17 Picture Style modification screen

moderate amount of sharpening, such as level 3, produces sharp images. But if your workflow includes sharpening images after editing and sizing them in an editing program, then you may want to set a lower sharpening level for the Picture Style in the camera to avoid oversharpening.

▶ **Contrast: +/–3.** This setting affects the image contrast as well as the vividness of the color. For images printed directly from the memory card, a 0 to level +1 setting produces snappy contrast in prints. A negative adjustment produces a flatter look and a positive setting produces a snappier look.

▶ **Saturation: +/–3.** This setting affects the strength or intensity of the color with a negative setting, producing low saturation and vice versa. A 0 or +1 setting is adequate for snappy JPEG images destined for direct printing.

▶ **Color tone: +/–3.** This control primarily affects skin tone colors. Negative adjustments to color tone settings produce redder skin tones whereas positive settings produce yellower skin tones.

Although the default Picture Styles are certainly good choices, I highly recommend modifying one or more Picture Styles to suit your visual tastes, and shooting and printing needs. After much experimentation, I settled on a modified Neutral Picture Style

that provides pleasing results for any images that I shoot in JPEG format (see Figure 3.18). Here is how I've modified the Neutral Picture Style settings:

- ▶ Sharpness: +2

- ▶ Contrast: +1

- ▶ Saturation: +1

- ▶ Color tone: 0

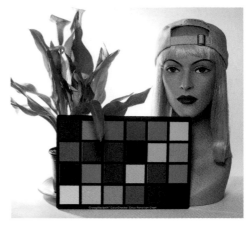

These settings provide excellent skin tones provided that the image isn't underexposed and the lighting isn't flat. You can try this variation and mod-

3.18 This image was shot using my modified Neutral Picture Style.

ify it to suit your work. I also often use the Portrait Picture Style that I modified by increasing the contrast setting to +1. This style is an excellent choice for photographing women and children. For men, I've found that the rendering is a bit too subtle, and I prefer to use the Standard Picture Style for men with a decreased Sharpness setting. I decrease the Sharpness setting because I want a softer rendering of the skin details in portraits, and then I apply sharpening selectively in Adobe Photoshop.

 Adjusting the color tone of a Picture Style shifts the color subtly. For example, in the Portrait Picture Style a +2 setting shifts skin tones to a more yellow rendering whereas a −2 setting shifts the color to a more reddish rendering.

To modify a Picture Style, follow these steps:

1. **In P, Tv, Av, M, or A-DEP shooting mode, select the Shooting 2 menu, select Picture Style, and then press the Set button.** The Picture Style screen appears.

2. **Press the up or down cross key to highlight the Picture Style that you want to modify, and then press the Disp. button.** The Detail. set. screen for the selected Picture Style appears.

3. **To change the Sharpness parameter, which is selected by default, press the Set button.** The Sharpness control is activated.

4. **Press the left or right cross key to change the parameter, and then press the Set button.** For all the parameter adjustments, negative settings decrease sharpness, contrast, and saturation, and positive settings increase sharpness, contrast, and saturation. Negative color tone settings render reddish tones, and positive settings render yellowish skin tones.

5. **Press the down cross key to move to the next adjustment that you want to change, and then press the Set button and repeat Step 4 and this step for the remaining adjustments.**

6. **Press the Menu button.** The Picture Style screen appears where you can modify other Picture Styles. The Picture Style changes are saved, changes are shown in blue, and the changes remain in effect until you change them. Press the Set button to return to the Shooting 2 menu.

Creating your own Picture Styles

Once you get a sense of how handy Picture Styles are for creating different looks or renderings of your pictures, you likely will want to expand your selection of styles. On the T3/1100D, you can do just that by creating up to three of your own styles, called User Defined Styles. Each User Defined Style is based on one of Canon's existing styles, but you set your preferences for Sharpness, Contrast, Saturation, and Color tone. Then you can save the style as a User Defined Style on the camera so you can select and use it as you do the preset Picture Styles.

Using Monochrome Filter and Toning Effects

While you can customize the Monochrome Picture Style, only the Sharpness and Contrast parameters can be changed. But you have the additional option of applying a variety of Filter and/or Toning effects:

▶ **Monochrome Filter effects.** Filter effects mimic the same types of color filters that photographers use when shooting black-and-white film. The Yellow filter makes skies look natural with clear white clouds. The Orange filter darkens the sky and intensifies the colors of sunsets. The Red filter further darkens a blue sky, and makes autumn leaves look light and sharp. The Green filter makes tree leaves look crisp and bright and skin tones look natural. You can increase the effect of the filter by increasing the Contrast setting.

▶ **Monochrome Toning effects.** You can choose to apply a creative toning effect when shooting with the Monochrome Picture Style. The Toning effect options are None, S: Sepia, B: Blue, P: Purple, and G: Green.

Because you can create up to three of your own styles, you have the latitude to create styles for different types of shooting situations. For example, you might want to create your own Picture Style for everyday photography that is less contrasty than the Standard Picture Styles. Obviously, you could simply modify the existing Standard Style, but you may want to leave that style unmodified and use it for images you're going to print directly from the memory card. Then you can create a second User Defined Style for portraits of women and children, and a third style for portraits of men. Because the styles are named and displayed as 1, 2, and 3, just remember which style you set up for each number.

To create and register your own Picture Style, follow these steps:

1. **In P, Tv, Av, M, or A-DEP shooting mode, go to the Shooting 2 menu, select Picture Style, and then press the Set button.** The Picture Style screen appears.

2. **Select User Def. 1, 2, or 3, and then press the Disp. button.** To get to the User Def. 1 entry, press the down cross key and go past the Monochrome Picture Style entry. The Detail set. User Def. screen appears with the current Picture Style displayed, as shown in Figure 3.19.

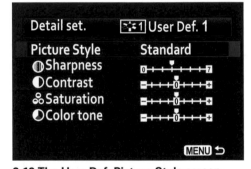

3.19 The User Def. Picture Style screen

3. **With the Picture Style name still highlighted, press the Set button, and then press the up or down cross key to select the Picture Style you want to use as the base style for your new style.** When you press the Set button, scroll arrows are added to the Picture Style control box.

4. **Press the Set button, and then press the down cross key to highlight the parameter you want to change, such as Sharpness.** The camera activates the parameter's control.

5. **Press the Set button, and then press the left or right cross key to set the parameter.**

6. **Repeat Steps 4 and 5 to change the remaining settings.** The remaining parameters are Contrast, Saturation, and Color tone.

7. **Press the Menu button to save the style.** The Picture Style changes are saved, and the changes remain in effect until you change them. If you chose to Clear all camera settings, the changes you make to your User Defined Styles are also cleared.

You can repeat these steps to set up User Def. 2 and 3 styles.

Using the Picture Style Editor

One approach to getting Picture Styles that you like is to set or modify one of the styles provided in the camera. But that approach is experimental: You modify the style, use the style for shooting images, and then check the results on the camera and in prints. If the style needs adjustment, you go through the process again until you get the results you want.

There is a more precise way to modify Picture Styles using Canon's Picture Style Editor, a program that comes on the disc included in the camera box. With the Picture Style Editor, you can make precise changes to Picture Styles. The process is to open one of your RAW images in the Picture Style Editor program, apply a Picture Style, and then make changes to the style while watching the effect of the changes as you work. Then you save the changes as a Picture Style file (.PF2), and use the EOS Utility, a program that's also provided on the disc, to register the file in the camera and apply it to images.

The Picture Style Editor looks deceptively simple, but it offers powerful and exact control over the style. Because the goal of working with the Picture Style Editor is to create a Picture Style file that you can register in the camera, the adjustments that you make to the RAW image are not applied to the image. Rather, the adjustments are saved as a file with a .PF2 extension. After saving the settings as a PF2 file, you can apply them to images in Digital Photo Professional.

If you use the Picture Style Editor, it's best to use a Color Management System (CMS) that includes calibrating your monitor, using the correct monitor and printer profiles, and using a consistent color space among the camera, monitor, and printer. For monitor calibration, I recommend the Spyder3Pro or Spyder3Elite from Datacolor (http://spyder.datacolor.com/product-mc-s3pro.php).

While the full details of using the Picture Style Editor are beyond the scope of this book, I encourage you to read the Picture Style Editor descriptions on the Canon website at http://web.canon.jp/imaging/picturestyle/editor/index.html.

Color Spaces

A *color space* defines the range of colors that can be reproduced and the way that a device such as a digital camera, a monitor, or a printer reproduces color. You can choose one of two color spaces on the T3/1100D: Adobe RGB (Red, Green, Blue) and sRGB (standard RGB). Of the two color spaces, the Adobe RGB color space supports a broader gamut, or range, of colors than the sRGB color space option. And in digital photography, the more data captured, or, in this case, the more colors the camera captures, the richer and more robust the file. It follows that the richer the file, the more data you have to work with during image editing whether you're working with RAW or JPEG images. And with the T3/1100D's 14-bit analog/digital conversion, you get a rich 16,384 colors per channel when you shoot in RAW capture.

But as you'll learn, the color space you choose depends on many different factors, detailed next.

Comparing color spaces

The following histograms show the difference between a large and small color space in terms of image data. Spikes on the left and right of the histogram indicate colors that will be clipped, or discarded, from the image.

For details on evaluating histograms, see Chapter 2.

As shown on the histograms, much more image data is retained by using the wider Adobe RGB color space. Richer files can withstand editing, which is by nature destructive, much better than files with less color data. So if you routinely edit images on the computer, Adobe RGB provides richer files. But if you don't edit images on the computer, and if you want to print and display images straight from the camera on the web or in e-mail, then sRGB is a good choice. The inset histograms for Figure 3.20 show the difference that color space makes in the image. In the Adobe RGB histogram, far fewer highlight tones are discarded — as shown in the height of the spike on the right side of the histogram — than in the sRGB color space. Ideally, you want no spike of pixels on the right, but the higher the spike, the more pixels that will be discarded.

Adobe RGB is the color space of choice for printing on inkjet printers and for printing by some commercial printers, although other commercial printing services use sRGB. If you print at a commercial lab, check with the lab to see which color space they use.

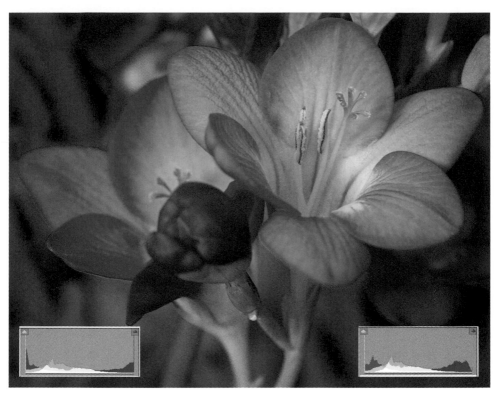

3.20 This RAW image was converted in Adobe Camera Raw and edited in Photoshop. The inset histogram on the left shows the image data in the sRGB color space and the histogram on the right shows the image data in the Adobe RGB color space. Exposure: ISO 100, f/5.6, 1/50 second.

For images destined to be used in e-mail or on the web, sRGB provides the best image color display. Although this may sound like it presents a conflict in choosing color spaces, for most photographers it translates into using Adobe RGB in the camera, and for editing and printing. Then when an image is needed for the web or e-mail, you can make a copy of the image and convert it to sRGB in an image-editing program such as Photoshop. By using Adobe RGB, you capture more color information, and it's easy to move the image to sRGB during editing. But if you shoot in sRGB, you're limiting the information in the file.

The High Bit-Depth Advantage

A digital picture is made up of many pixels that are each made up of a group of bits. A bit is the smallest unit of information that a computer can handle. In digital images, each bit stores information that, when aggregated with other pixels and color information, provides an accurate representation of the picture.

Digital images are based on the RGB color space. That means that an 8-bit JPEG image has 8 bits of color information for Red, 8 bits for Green, and 8 bits for Blue. This gives a total of 24 bits of data per pixel (8 bits × 3 color channels). Because each bit can be one of two values, either 0 or 1, the total number of possible values is 2 to the 8th power, or 256 values per color channel.

On the other hand, a 14-bit file, which is offered on the T3/1100D, provides 16,384 colors per channel.

High bit-depth images offer not only more colors but also more subtle tonal gradations and a higher dynamic range than low bit-depth images. If you're shooting JPEG images, this high bit-depth means that when the camera automatically processes and converts the images to 8-bit JPEGs, it uses the much richer 14-bit color file to do so. You get better tonal range and gradations as a result. And if you're shooting RAW files, then you get the full advantage of the 14-bit color, and you can save the images to 16-bit in an editing program such as Adobe Photoshop.

Choosing a color space

On the T3/1100D, you can select either the sRGB or Adobe RGB color space for shooting in the P, Tv, Av, M, and A-DEP shooting modes. The color space you choose applies to both JPEG and RAW files shot in Creative Zone modes. In all Basic Zone modes, the camera automatically selects sRGB.

If you choose Adobe RGB, image file names are appended with _MG_.

NOTE The Rebel T3/1100D does not append an ICC (International Color Consortium) profile with the image, so you will need to embed it when you're editing the file in an editing program. An ICC profile identifies the color space so that it is read by other devices, such as monitors and printers that support ICC profiles.

To set the color space on the T3/1100D, set the Mode dial to P, Tv, Av, M, or A-DEP shooting modes, and follow these steps:

1. **On the Shooting 2 camera menu tab, highlight Color space, and then press the Set button.** The camera displays two color space options, shown in Figure 3.21.

2. **Select the color space you want, either sRGB or Adobe RGB, and then press the Set button.** The color space remains in effect until you change it or switch to a Basic Zone mode.

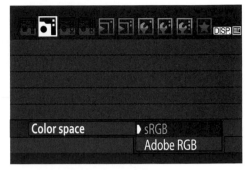

3.21 The Color space options

Adding Ambience Effects

The T3/1100D offers options to apply in-camera image processing for creative color and image effects. Ambience options are available only in the automatic Basic Zone shooting modes with the exceptions of the Full Auto and Flash Off modes.

Ambience settings are somewhat like Picture Styles, but with a much more pronounced effect. You can apply Ambience settings only when you're shooting in Creative Auto (CA), Portrait, Landscape, Close-up, Sports, or Night Portrait modes. When you choose an Ambience option, you can adjust the strength of the effect to a Low, Standard, or Strong setting.

Here are the Ambience options you can select:

▶ **Standard.** The default setting has punchy contrast and color.

▶ **Vivid.** At the Standard level, this setting provides snappy colors and more sharpness.

▶ **Soft.** This option decreases color saturation and intensity as well as overall contrast. This is a good choice for portraits of women and children.

▶ **Warm.** This setting adds a noticeable shift to more prominent yellows and reds.

▶ **Intense.** Just as the name implies, this setting makes saturation and contrast pronounced and the colors slightly cooler (more bluish) as compared with colors produced by Standard. This is not the option to use if you want to show good detail in the shadows.

▶ **Cool.** This option delivers extremely blue skies and a cool (bluish) tint in foliage. The contrast and color saturation are both higher than in the Standard setting.

▶ **Brighter.** This setting lightens the image overall, including opening up shadow detail. It is a reasonable option for a scene or subject with predominately light tones; in other words, a high-key scene or subject.

▶ **Darker.** This setting creates a noticeably darker image with snappy contrast.

▶ **Monochrome.** This option offers a blue, sepia, and black-and-white option. The black-and-white option delivers bright whites and deep blacks with moderate overall contrast.

If you check the exposure settings for Ambience effects, you can see how the effect is achieved in most cases. I include the exposure that the camera automatically set for Figures 3.22 through 3.32, which were shot in Close-up shooting mode. In some Ambience effects, the T3/1100D increases or decreases the saturation and contrast, just as can be done when using Picture Styles. A word of warning is in order. Some styles, such as Brighter, can cause blown high-lights while others can cause blocked shadows — where the shadows go to black too quickly and do not show detail. So use Ambience selections with care.

These images were lit by window light, and the Lighting or Scene type was set to Default. For all except the Brighter and Darker images, the level was set to Standard level. The Brighter and Darker images were set to the Low level.

3.22 This image was taken using the Standard setting. This and the following images were made using Close-up shooting mode with the flash firing in each image. Automatic exposure setting: ISO 1250, f/5.6, 1/160 second.

3.23 This image was taken using the Vivid setting. Automatic exposure setting: ISO 1250, f/5.6, 1/160 second.

3.24 This image was taken using the Soft setting. Automatic exposure setting: ISO 2000, f/5.6, 1/160 second with +2/3-stop of Exposure Compensation.

3.25 This image was taken using the Warm setting. Automatic exposure setting: ISO 2000, f/5.6, 1/160 second with +2/3-stop of Exposure Compensation.

3.26 This image was taken using the Intense setting. Automatic exposure setting: ISO 800, f/5.6, 1/160 second with −2/3-stop of Exposure Compensation.

3.27 This image was taken using the Cool setting. Automatic exposure setting: ISO 800, f/5.6, 1/160 second with –2/3-stop of Exposure Compensation.

3.28 This image was taken using the Brighter setting. Automatic exposure setting: ISO 2000, f/5.6, 1/160 second with +1.33-stops of Exposure Compensation.

3.29 This image was taken using the Darker setting. Automatic exposure setting: ISO 800, f/5.6, 1/160 second with –2/3-stops of Exposure Compensation.

3.30 This image was taken using the Monochrome setting. Automatic exposure setting: ISO 1250, f/5.6, 1/160 second.

3.31 This image was taken using Monochrome with a blue filter. Automatic exposure setting: ISO 1250, f/5.6, 1/160 second.

3.32 This image was taken using Monochrome with the sepia filter. Automatic exposure setting: ISO 1250, f/5.6, 1/160 second.

To apply an Ambience setting, follow these steps:

1. **In CA, Portrait, Landscape, Close-up, Sports, or Night Portrait shooting mode, press the Live View/Movie mode shooting button on the back of the camera.** A live view of the scene appears on the LCD. The advantage of using Live View is that you get a preview of the Ambience effect. The disadvantage of using Live View is that it is hard to see the effect on the LCD in bright light.

 Alternatively: If you don't want to use Live View mode to set the Ambience, then skip to Step 2 without pressing the Live View button.

2. **Press the Q button to display the Quick Control screen, and then press the up or down key to highlight Standard setting or the name of the currently selected Ambience setting.** The text Shoot by ambience selection appears at the bottom of the LCD screen.

3. **Turn the Main dial to select the Ambience effect you want.** The preview scene on the LCD shows the scene with the Ambience effect applied.

4. **Press the down cross key to select Effect level, and then press left or right to set the strength: Low, Standard, or Strong.** The text at the bottom of the LCD shows the current selection. Then you can return to shooting to make the picture using the effect.

Customizing the EOS Rebel T3/1100D

Customizing the Rebel T3/1100D can make the camera even more enjoyable for you to use, enabling you to set your shooting preferences to suit your most common shooting situations. The T3/1100D offers three helpful features for customizing how the camera operates and how the LCD screen looks:

- ▶ **Custom Functions.** A group of ten Custom Functions enable you to control everything from whether noise reduction is applied for long-exposure and high-ISO images to the way the camera controls operate.

- ▶ **My Menu.** This camera tab is where you can include six of your most-often-used menu items in priority order for fast access.

Customization options such as turning on Highlight tone priority helped retain highlight detail and provided smooth tonal transitions in this image of daisy petals. Exposure: ISO 100, f/2.8, 1/25 second.

- ▶ **Shooting screen color modifications.** You can customize the colors used on the LCD when the Quick Control screen is displayed.

Setting Custom Functions

Custom Functions can save you time because they enable you to customize camera settings, controls, and operations to better suit your shooting style. The T3/1100D offers ten Custom Functions ranging from choosing the amount of exposure changes to changing the functions of various buttons. You should keep in mind a couple of specifics regarding Custom Functions:

▶ They can be set only in Creative Zone modes such as Program AE (P), Shutter-priority AE (Tv), Aperture-priority AE (Av), Manual (M), and Automatic Depth of Field (A-DEP).

▶ When you change a Custom Function, the change remains in effect until you change it again.

 Canon denotes Custom Functions using the abbreviation C.Fn [group Roman numeral]-[function number]; for example, C.Fn II-3.

Some Custom Functions are useful for specific shooting specialties or scenes whereas others are more useful for everyday shooting. For example, the Highlight tone priority Custom Function is useful in specific scenarios, such as when you're shooting scenes or subjects with many light tones, but it is not a good choice for scenes and subjects with a predominance of dark tones. On the other hand, the Custom Function that enables the Set button to be used during shooting is an example of a function that is broadly useful for everyday shooting.

Custom Function groupings

Canon organized the ten Custom Functions into four main groups denoted with Roman numerals, all of which you can access from the Setup 3 camera menu.

Table 4.1 delineates the groupings and the Custom Functions within each group. In addition, the function and options that are either enabled or disabled in Live View and/or Movie shooting modes are noted.

Custom Function specifics

In this section, I explain each of the Custom Functions and the options that you can set. As you read about each Custom Function, consider how you could use it to make

the camera more useful for your common shooting scenarios. You don't have to set each option, and it is likely you may find only a few that are useful to you in the beginning. But as you continue shooting, you may recognize other functions that you want to use. Over time, you'll grow to appreciate the power that Custom Functions offer.

4.1 The Custom Functions (C.Fn) menu item

Keep in mind that you can go back and reset Custom Functions if you don't like the changes that you've made. In addition, you can reset all Custom Functions to the original settings if necessary. The steps to reset all Custom Functions are included at the end of this section.

Table 4.1 Custom Functions

C.Fn Number	Function Name
Group I: Exposure	
1	Exposure level increments
2	Flash sync. speed in Av mode
Group II: Image	
3	Long-exp. (exposure) noise reduction
4	High ISO speed noise reduct'n (reduction)
5	Highlight tone priority
Group III: Autofocus/Drive	
6	AF-assist beam firing (Works only when you use Quick Autofocus mode in Live View shooting)
Group IV: Operation/Others	
7	Shutter /AE (Auto Exposure) lock button
8	Assign SET button (Option 3 does not work when you use Live View shooting)
9	Flash button function
10	LCD display when power ON (Does not work during Live View shooting)

C.Fn I: Exposure

In this group, the three Custom Functions enable you to determine the level of fine control you have over exposure and over flash exposure synchronization speeds when you're shooting in Aperture Priority AE (Av) mode.

C.Fn I-1: Exposure-level increments

Here you can choose to set the exposure increment — the amount of change — to use for shutter speed, aperture, Exposure Compensation, and Auto Exposure Bracketing (AEB). Your choice depends on the level of control you want. For example, if you're setting Exposure Compensation to get truly white snow in a snow scene, then I recommend using the 1/2-stop increment to get to a +1- or 2-stop compensation in fewer steps. But if you're tweaking the exposure on a portrait, you may find that the small 1/3-stop increment is more exact. Here are the C.Fn I-1 options (shown in Figure 4.2) with a description of each one:

4.2 The Exposure level increments Custom Functions (C.Fn) screen

- ▶ **0: 1/3-stop.** This is the Rebel T3/1100D's default option, and it offers the finest (smallest) level of change. Using this option, the camera displays shutter speeds in finer increments, such as 1/60, 1/80, 1/100, and 1/125 second. And it offers apertures such as f/4, f/4.5, f/5, f/5.6, f/6.3, and f/7.1.

- ▶ **1: 1/2-stop.** This option offers a larger amount of exposure change. The T3/1100D displays shutter speeds in increments such as 1/60, 1/90, 1/125, and 1/180 second. And it offers apertures such as f/4, f/4.5, f/5.6, f/6.7, f/8, and f/9.5. You may want to set this option when you want to quickly make larger changes in exposure settings with minimal adjustments.

C.Fn I-2: Flash sync. speed in Av mode

With this function, you can set the flash sync speed range, have the Rebel set it automatically, or set it to a fixed 1/200 second when you're using Av shooting mode. At the default setting, the T3/1100D is set to provide fill flash where the flash brightens the subject while factoring in the existing light in the scene to provide natural-looking illumination. However, the default setting can also result in shutter speeds that are too

slow for you to handhold the camera and get a sharp image. So you can use this Custom Function to ensure that the slowest shutter speed in the range is fast enough for you to handhold the camera and avoid blur from handshake when you're shooting in Av mode, depending on the lens you're using. The slowest 1/60-second shutter speed in Option 1 is not fast enough to handhold telephoto lenses that do not have Image Stabilization. Here are the options (shown in Figure 4.3) and a description of each one:

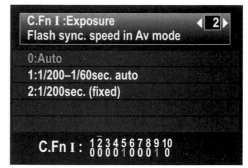

4.3 The Flash sync. speed in Av mode Custom Functions (C.Fn) screen

- ▶ **0: Auto.** With this option, the T3/1100D chooses a shutter speed of 1/200 second to 30 seconds depending on the level of existing light. Slower flash sync speeds allow the scene to be illuminated by both the flash and the existing light in the scene. However, you must watch the shutter speed because at slow shutter speeds, you can get blur from handshake, or from subject movement that appears as a blur, creating a doubling effect known as a *ghost image*. As long as the shutter speed is reasonably fast, this option is nice because the combination of ambient light and flash creates a more natural-looking image. You can also use high-speed flash sync if your Speedlite offers it.

- ▶ **1: 1/200-1/60 sec. auto.** This option prevents shutter speeds slower than 1/60 second. The advantage is that it can help prevent blur from slow shutter speeds. If the existing light is low, the background will be dark because less existing light and more flash light factors into the exposure. With this setting, you cannot use high-speed flash sync with an accessory Speedlite.

- ▶ **2: 1/200 sec. (fixed).** With this option, the flash sync speed is always set to 1/200 second. The flash will provide the main illumination with less existing light being included in the exposure. This depends, of course, on the amount of existing light. Although this option prevents blur from subject or camera movement that you may get using Option 0 and Option 1, the background will be dark because little of the existing light is included in the exposure. With this setting, you cannot use high-speed flash sync with an accessory Speedlite.

C.Fn II: Image

The Image Custom Function group concentrates primarily on avoiding and reducing digital noise that can cause a grainy appearance with flecks of color, particularly in the shadows, and increasing the camera's range so that you get better detail in highlights.

C.Fn II-3: Long-exposure noise reduction

With this function, you can choose how noise reduction works for exposures that are 1 second or longer. If you choose one of the noise-reduction options, then the noise-reduction process takes the same amount of time as the original exposure. In other words, if the original image exposure is 10 seconds, then noise reduction takes an additional 10 seconds. This slows down shooting because you cannot take another picture until the noise reduction process finishes. Options 1 and 2 also significantly reduce the maximum number of images that you can shoot consecutively when you use Continuous drive mode — even at shutter speeds faster than 1 second. If you

choose Option 1 or 2, the camera displays a Busy message on the LCD during the noise reduction process in Live View shooting. Weigh the options based on the shooting situation. If you need to shoot with little or no delay, then Option 0 or 1 is preferable. But if you want to save time applying noise reduction during image editing, then Option 1 or 2 is the ticket. Here are the options (shown in Figure 4.4) and a description of each one:

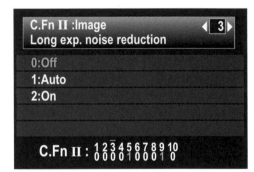

4.4 The Long exp. noise reduction Custom Functions (C.Fn) screen

> ▶ **0: Off.** This is the default setting where no noise reduction is performed on long exposures. This increases the chances of noise in images of 1 second or longer. With this option, there is no reduction in the maximum burst rate when you're using Continuous drive mode.

> ▶ **1: Auto.** The camera automatically applies noise reduction on 1 second or longer exposures if it detects digital noise. If the Rebel T3/1100D detects noise, then it takes a second picture at the same exposure time as the original image and uses the second image, called a *dark frame*, to subtract noise from the first image. Although technically two images are taken, only one image — the original exposure with noise subtracted — is stored on the memory card.

▶ **2: On.** The Rebel T3/1100D automatically performs noise reduction on all exposures of 1 second or longer. This option slows down shooting considerably because the Rebel T3/1100D always makes the dark frame to subtract noise from the original image, and the dark frame is exposed for the same amount of time as the first image. At ISO settings of 1600 and higher, digital noise can be more evident with this option than with Options 1 or 2.

C.Fn II-4: High ISO speed noise reduction

This function applies additional noise reduction when you shoot at high ISO speed settings. (The camera applies some noise reduction to all images.) Noise reduction smooths the appearance of grain, and can cause a loss of fine detail in the image. Because Canon has good noise-reduction processing, the Standard and Low options maintain an acceptable level of fine detail in images. The extra in-camera image processing slows down the maximum number of images that you can take when you are shooting in Continuous drive mode, and it reduces the maximum burst rate for both JPEG and RAW images. Here are the options (shown in Figure 4.5):

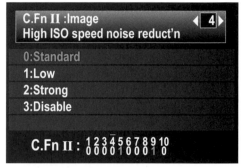

4.5 The High ISO speed noise reduct'n (reduction) Custom Functions (C.Fn) screen

▶ **0: Standard.** With this option and when shooting at low ISO settings, the in-camera noise reduction is applied to the shadow areas where digital noise is most likely to appear.

▶ **1: Low.** With this option, a low amount of noise reduction is used, and thus, more fine detail in the image is preserved.

▶ **2: Strong.** This option can result in the watercolor look that happens with higher levels of noise reduction. The *watercolor look* means that fine details tend to blur together due to the smoothing effect of noise reduction and the loss of fine details.

▶ **3: Disable.** No noise reduction is applied. While this may speed up shooting somewhat, I'd recommend not using this option if you regularly use ISO settings of 800 and above.

C.Fn II-5: Highlight tone priority

One of the most useful functions is Highlight tone priority, which helps ensure good image detail in bright areas of the image such as those on a bride's gown. With the function turned on, the high range of the camera's dynamic range (the range between deep shadows and highlights in a scene as measured in f-stops) is extended from 18 percent gray (middle gray) to the brightest highlights. This results in better detail in the highlights that might otherwise *blow out* — go completely white with no image detail in them. Also, the gradation from middle gray tones to highlights is smoother with this option turned on. In other words, using this function provides smoother tones with more detail in the bright areas of the image. The downside of enabling this option is increased digital noise in shadow areas. So if you shoot weddings or other scenes that have a predominance of light tones, then the trade-off is worthwhile. If noise in the shadow areas is objectionable, you can apply noise reduction in an image-editing program. But if you're shooting in low light or if you're shooting subjects with deep shadows, I suggest turning off Highlight tone priority because the noise will increase in the shadows.

If you turn on Highlight tone priority, the lowest ISO setting is 200 rather than 100. The ISO display in the viewfinder, on the LCD, and in the Shooting information display uses a D+ to indicate that this Custom Function is in effect. Here are the options (shown in Figure 4.6) and a description of each one:

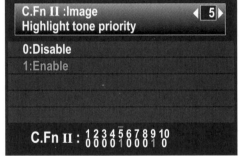

4.6 The Highlight tone priority Custom Functions (C.Fn) screen

▶ **0: Disable.** Highlight tone priority is not used and the full range of ISO settings is available.

▶ **1: Enable.** The T3/1100D improves tonal gradation of highlight areas by shifting some of the camera's dynamic range from the midtones to the highlights. Shadows go dark quicker and tend to show more digital noise. Also the lowest ISO changes from 100 to 200. When you press the ISO button to change the ISO, the ISO speed screen notes Highlight tone priority at the bottom to remind you that this function is set. Choosing this option also automatically turns off Auto Lighting Optimizer regardless of the setting that you've chosen for it.

C.Fn III: Autofocus/Drive

This group has only one function that enables you to set the camera so that a beam from the flash can help the camera focus on the subject.

C.Fn III-6: AF-assist beam firing

This function enables you to control whether the Rebel T3/1100D's built-in flash or an accessory EX Speedlite's autofocus-assist light is used to help the camera's autofocus system establish focus. Enabling one of the options speeds up focusing in low-light or low-contrast scenes, depending on whether you are using the built-in flash or an accessory Speedlite. Here are the options (shown in Figure 4.7) and a description of each one:

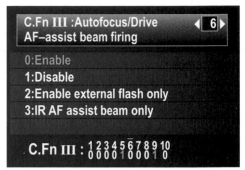

4.7 The AF-assist beam firing Custom Functions (C.Fn) screen

▶ **0: Enable.** This option allows the AF-assist beam from either the built-in flash or a Canon Speedlite to help the camera focus. Enable is the default setting for the Rebel T3/1100D.

▶ **1: Disable.** If you choose this option, neither the built-in flash nor the Speedlite AF-assist beam lights help establish focus. While this option is useful in shooting situations where the AF-assist light may be annoying or intrusive, it can be difficult for the T3/1100D to establish accurate focus in low-light scenes.

▶ **2: Enable external flash only.** If you choose this option, the AF-assist beam emits light only when a Canon Speedlite is mounted on the camera's hot shoe. The Speedlite's AF-assist beam is more powerful than the beam of the built-in flash, and that makes this option good for low-light and low-contrast subjects that are farther away from the camera. However, be aware that if you have set the Custom Function on the Speedlite so that the AF-assist beam does not fire, then the Speedlite's Custom Function option overrides the camera's Custom Function option.

▶ **3: IR AF-assist beam only.** If your accessory Speedlite has an infrared (IR) AF-assist beam, this option will enable using the IR AF-assist beam, and it prevents flash units that use a series of small flashes from firing the AF-assist beam. If your Speedlite is equipped with an LED light, the LED light is not used to assist in focusing.

C.Fn IV: Operation/Others

This group of Custom Functions enables you to change the functionality of camera buttons for ease of use to suit your shooting preferences, and to control the LCD.

C.Fn IV-7: Shutter/AE Lock button

This function changes what happens when you press the shutter button and the AE Lock button (the button located at the top-right back of the camera with an asterisk above it) for focusing and locking the exposure metering in P, Tv, Av, M, and A-DEP shooting modes. To understand this function, it's important to know that the Rebel T3/1100D biases, or weights, the light metering in Evaluative metering mode toward the active AF point, which it assumes is the subject.

However, there are times when you want to take a meter reading somewhere other than where you focus. To make a light meter reading on one area and focus on another area, you can use AE Lock.

The options for this function enable you to switch or change the functionality of the shutter button and the AE Lock button, or to disable AE Lock entirely when you use continuous focusing via AI Servo AF mode.

In the options that follow, the first listed control tells you how the focus will function when you press the shutter button, and the second listed control tells you how AE Lock will function when you press the AE Lock button. Here are the options (shown in Figure 4.8) and a description of each one:

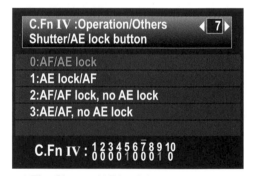

4.8 The Shutter/AE Lock button screen

► **0: AF/AE Lock.** This is the default setting where you set the focus using the shutter button, and you can set and lock the exposure by pressing the AE Lock button.

► **1: AE Lock/AF.** Choosing this option switches the function of the shutter button and the AE Lock button. Pressing the shutter button halfway locks the exposure, and pressing the AE Lock button focuses.

▶ **2: AF/AF Lock, no AE Lock.** If you're shooting in AI Servo AF mode where the camera automatically tracks focus on a moving subject, choosing this function enables you to press the AE Lock button to stop focus tracking momentarily, such as when an object moves in front of the subject. This way, focus is not lost on the subject by shifting to whatever momentarily obstructs the camera's view of the subject. If you enable this option, you cannot use AE Lock.

▶ **3: AE/AF, no AE Lock.** With this option, you can start and stop AI Servo AF focus tracking by pressing the AE Lock button. For example, if you are photographing an athlete who starts and stops moving intermittently, you can press the AE Lock button to start and stop focus tracking (AI Servo AF). In AI Servo AF mode, the exposure and focusing are set when you press the shutter button. You cannot use AE Lock if you choose this option.

C.Fn IV-8: Assign Set button

This function enables you to use the Set button while you're shooting rather than only when you're using camera menus. The Set button continues to function normally when you're accessing camera menus. Here are the options (most of which are shown in Figure 4.9) and a description of each one:

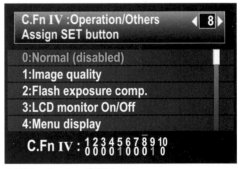

4.9 The Assign SET button screen

 This function has a scrolling screen, so just press the Set button to activate the options, and then press the down cross key to scroll through all the options.

▶ **0: Normal (disabled).** With this option selected, pressing the Set button during shooting has no effect.

▶ **1: Image quality.** With this option, you can press the Set button as you shoot to display the Quality screen on the LCD so that you can make changes.

▶ **2: Flash exposure comp. (compensation).** With this option, you can press the Set button to display the Flash Exposure Compensation (FEC) setting screen to set or change the amount of FEC.

▶ **3: LCD monitor On/Off.** With this option, pressing the Set button toggles the LCD monitor display on or off, replicating the functionality of the Disp. button.

▶ **4: Menu display.** With this option, pressing the Set button displays the last camera menu that you accessed with the last menu item highlighted. When the camera menu appears, you can use the Set button as you normally do to open submenus and confirm menu changes.

▶ **5: Depth-of-field preview.** With this option, pressing the Set button stops down the lens to the current aperture (f-stop) so that you can preview the depth of field in the viewfinder or on the LCD if you're shooting in Live View. The larger the area of darkness, the more extensive the depth of field will be. Unlike most Rebel cameras, the T3/1100D does not have a Depth-of-Field Preview button, so this is the only way that you can get a preview of the depth of field. That makes this a good option to choose.

C.Fn IV-9: Flash button function

This function enables you to change the flash pop-up button so that it displays the ISO setting screen instead of raising the built-in flash. This might be useful for photographers who seldom use the built-in flash and who set the ISO based on the subject or scene rather than using Auto ISO. Here are the options (shown in Figure 4.10):

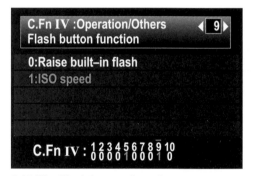

4.10 The Flash button function screen

▶ **0: Raise built-in flash.** This is the default setting where pressing the flash button raises the built-in flash.

▶ **1: ISO speed.** Choose this setting if you want to have the ISO setting screen displayed in the viewfinder when you press the flash button. When the ISO setting screen appears, you can turn the Main dial to change the setting. You cannot manually raise the flash in P, Tv, Av, M, or A-DEP shooting modes if you choose this option.

C.Fn IV-10: LCD display when power ON

This function enables you to save a bit of battery power by choosing whether the shooting information is displayed on the LCD when you turn on the Rebel T3/1100D. Here are the options (shown in Figure 4.11) and a description of each one:

▶ **0: Display on.** This is the default setting where the T3/1100D always displays shooting information on the LCD when you turn on the camera. To turn off the display, you must press the Disp. button on the top of the camera.

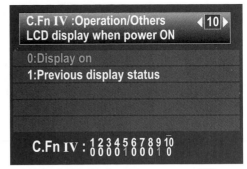

▶ **1: Previous display status.** With this option, the T3/1100D remembers the last state of the LCD display when you turn the

4.11 The LCD display when power ON Custom Functions (C.Fn) screen

camera off, and then it returns to that state when you turn on the camera again. So if you turned off the LCD display by pressing the Disp. button, and then turn off the camera, the LCD display is not turned on when you turn on the camera and vice versa. If you want to use this option to save battery power or simply to have the camera behave in one or the other way, you have to remember to press the Disp. button to either turn on or off the LCD before powering down the camera each time.

Setting Custom Functions

Depending on your shooting preferences and needs, you may immediately recognize functions and options that would make your shooting faster or more efficient. You may also find that combinations of functions are useful for specific shooting situations. Whether used separately or together, Custom Functions can significantly enhance your use of the T3/1100D.

 For step-by-step tasks in this chapter that involve the camera menus, just press the Menu button, turn the Main dial to move to the camera menu tab you want, and then press the up or down cross key to select an option.

To set a Custom Function, follow these steps:

1. **In P, Tv, Av, M, or A-DEP shooting mode, select the Setup 3 camera menu tab, highlight Custom Functions (C.Fn), and then press the Set button.** The most recently accessed Custom Function screen appears.

2. **Press the right or left cross key to move to the Custom Function number that you want, and then press the Set button.** The Custom Function option control is activated and the option that is currently in effect is highlighted.

C.Fn I :Exposure
Exposure level increments
◀ 1 ▶

0:1/3–stop
1:1/2–stop

Custom Function options Custom Function number

4.12 The Custom Functions (C.Fn) screen controls

3. **Press the up or down cross key to highlight the option you want, and then press the Set button.** You can refer to the previous descriptions in this section of the chapter to select the function option that you want. Repeat Steps 2 and 3 to select other Custom Functions and options. Lightly press the shutter button to return to shooting.

If you want to reset one of the Custom Functions, repeat these steps to change it. If you want to restore all Custom Function options to the camera's default settings, follow Step 1 in the previous steps. Then, press the down cross key to highlight Clear Settings, and press the Set button. On the Clear Settings screen, select Clear all Custom Func. (C.Fn), and then press the Set button. Press the right cross key to select OK, and then press the Set button.

Customizing My Menu

Given the number of menus and menu options on the T3/1100D, and given that in an average day of shooting you may use only a few menus and options consistently, it makes sense to add your most frequently used items to My Menu. This gives you easy access to both menu items and Custom Functions on a single menu.

You can add and delete items to My Menu easily, and you can change the order of items by sorting the items you register. You can also set the T3/1100D to display My Menu first when you press the Menu button.

Before you begin registering items to My Menu, look through the camera menus and Custom Functions carefully and choose your six most frequently changed items.

To register camera Menu items and Custom Functions to My Menu, follow these steps:

1. **In P, Av, Tv, M, or A-DEP shooting mode, select the My Menu camera tab, denoted as a green star icon.**

2. **Highlight My Menu settings, as shown in Figure 4.13, and then press the Set button.** The My Menu settings screen appears.

4.13 The My Menu settings option shown on a screen that already has items added to My Menu

3. **Highlight Register to My Menu, as shown in Figure 4.14, and then press the Set button.** The Select item to register screen appears, as shown in Figure 4.15. This screen contains a scrolling list of all the camera's menu items, options, and Custom Functions.

4. **Press the down cross key until you get to a menu item or Custom Function that you want to register, and then press the Set button.** As you press the down cross key to scroll, a scroll bar on the right of the screen shows your relative progress through the list. When you select an item and press the Set button, a confirmation screen appears.

4.14 The Register to My Menu option

5. **Press the right cross key to highlight OK, and then press the Set button.** The Select item to register screen reappears.

4.15 The Select item to register screen

6. **Repeat Steps 4 and 5 until you've selected and registered as many items as you want.** You can select up to six items.

7. **When you finish registering menu items, press the Menu button.** The My Menu settings screen appears. If you want to sort items, go to Step 2 in the next set of steps.

To arrange your My Menu items in the order you want, follow these steps:

1. **On the My Menu camera tab, highlight My Menu settings, and then press the Set button.** The My Menu settings screen appears.

2. **Press the down cross key to highlight Sort, and then press the Set button.** The Sort My Menu screen appears.

3. **Press the down or up cross key to select the item that you want to move, and then press the Set button.** The sort control for the selected item is activated and is displayed with up and down arrow icons, as shown in Figure 4.16.

4.16 The Sort My Menu screen with the first item selected and ready to be moved down in the list.

4. **Press the up cross key to move up the item in the list, or press the down cross key to move it down in the list, and then press the Set button.**

5. **Repeat Steps 3 and 4 to move other menu items in the order that you want.**

You can delete either one or all items from My Menu. You can choose to have My Menu displayed first every time you press the Menu button.

To delete one or more items from My Menu, follow these steps:

1. **On the My Menu camera menu tab, highlight My Menu settings, and then press the Set button.** The My Menu settings screen appears.

2. **Press the down cross key to highlight Delete item/items, or highlight Delete all items to delete all registered items, and then press the Set button.** The Delete item from My Menu or the Delete all My Menu items screen appears depending on the option you chose.

3. **If you chose to delete individual menu items, press the down cross key to highlight the menu item you want to delete, and then press the Set button.** The Delete My Menu confirmation screen appears. If you chose to Delete all items, the Delete all My Menu items screen appears.

4. **Press the right cross key to select OK, and then press the Set button.**

If you want the My Menu tab to be the first menu displayed when you press the Menu button, follow these steps:

1. **On the My Menu camera menu tab, highlight Display from My Menu, and then press the Set button.** The My Menu settings screen appears, as shown in Figure 4.17.

2. **Press the down cross key to select Enable, and then press the Set button.**

4.17 The Display from My Menu options

Changing the Shooting Screen Color

Another customization option on the Rebel T3/1100D is choosing the screen color you want for the LCD shooting information display. You can choose from four options:

▶ White text on a black background, which is the default setting

▶ Black text on a light gray background

▶ White text on a light gray background

▶ Green text on a dark gray background

To set the screen color, follow these steps:

1. **On the Setup 1 camera menu tab, highlight Screen Color, and then press the Set button.** The Screen color screen appears, as shown in Figure 4.18.

4.18 The Screen color options screen

2. **Press the up or down cross key to select the color scheme that you want, and then press the Set button.** The option you choose remains in effect until you change it.

The T3/1100D offers you a high level of customization. With the full complement of choices, you can set up the camera to suit your personal shooting style.

Shooting with a Live View on the LCD

If you are upgrading from a point-and-shoot camera to the T3/1100D, then shooting while the LCD screen displays a live view of the scene will be a familiar way of shooting for you. With Live View shooting, you can view, compose, and focus using a real-time view of the scene on the camera's 2.7-inch LCD monitor. This is handy if you are in situations where looking through the view-finder is awkward or impossible. To ensure precise focus, just enlarge the view on the LCD to 5X or 10X. Live View shooting gives you added flexibility in shooting scenarios that normal shoot-ing doesn't provide.

Although Live View shooting isn't suited for every situation, it works well for still-life shooting and scenes where using the viewfinder is difficult. And it takes only a few minutes of shooting to convince you that a tripod is an essential accessory for Live View shooting.

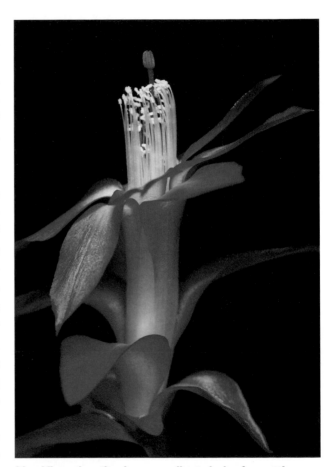

Live View shooting is an excellent choice for getting tack-sharp focus on a still subject such as this cactus blossom. Exposure: ISO 100, f/11, 1/4 second.

About Live View Shooting

Live View shooting is now a staple feature on dSLR (digital single lens reflex) cameras such as the T3/1100D. The concept of a dSLR being able to hold the shutter open to give you a real-time view of the scene and yet pause long enough to focus is impressive. Normally, the camera can't see the live scene because the shutter and reflex mirror block the view to the image sensor. The T3/1100D overcomes this blind spot with a mechanical shutter that stays completely open during Live View shooting.

Live View offers some advantages that you don't get with non-Live View shooting. For example, Live View provides a 99 percent view of the scene on the LCD, and it offers Face Detection focusing, which automatically identifies faces of people in the scene and focuses on one of the faces.

Although Live View shooting has a high coolness factor, it comes at the price of a few side effects:

▶ **Temperature affects the number of shots you can get using Live View.** With a fully charged LP-E10 battery, you can expect 240 shots without flash use and approximately 220 shots with 50 percent flash use in 73-degree temperatures. In freezing temperatures, expect 230 shots without flash use and 210 shots with 50 percent flash use per charge. With a fully charged battery, you get approximately 2 hours of continuous Live View shooting before the battery is exhausted, although my experience shows a shorter duration.

▶ **High ambient temperatures, high ISO speeds, and long exposures can cause digital noise or irregular color in images taken using Live View.** Before you start a long exposure, stop shooting in Live View and wait several minutes before shooting. With continual use of Live View, the sensor heats up quickly. Both high internal and external temperatures can degrade image quality and cause Live View to automatically shut down until the internal temperature is reduced.

Icons that resemble a thermometer are displayed on the LCD when internal and/ or external temperatures are high enough to degrade image quality. If a white icon appears, you can keep shooting, but the image quality can be degraded. As the internal temperature rises, a red icon appears. If you see the red icon start blinking, stop shooting until the temperature cools down. Otherwise, the camera automatically stops shooting if the internal temperature gets too high. Turning off the camera aids in reducing the internal temperature. Additionally,

high ISO settings combined with high temperatures can result in digital noise and inaccurate image colors.

▶ **The Live View may not accurately reflect the captured image in several different conditions.** Image brightness may not be accurately reflected in low and bright-light conditions. If you move from low to a bright light and if the LCD brightness level is high, the Live View may display chrominance (color) noise, but the noise will not appear in the captured image. Suddenly moving the camera in a different direction can also throw off accurate rendering of the image brightness. If you capture an image in magnified view, the exposure may not be correct. And if you focus and then magnify the view, the focus may not be sharp.

Live View Features and Functions

Although some key aspects of Live View shooting differ significantly from standard shooting, other aspects are similar. For example, you can use the Quick Control screen during Live View shooting to change settings, including the focusing, and drive modes; the White Balance; the Picture Style; the Auto Lighting Optimizer; the Image-recording quality; and the ISO. In Program AE (P), Shutter-priority AE (Tv), Aperture-priority AE (Av), and Manual (M) shooting modes you can set the shutter speed, aperture, and ISO setting, and you can use Auto Exposure Lock, Auto Exposure Compensation, and Auto Exposure Bracketing. Likewise, you can press the Disp. button one or more times to change the display to include more or less shooting information along with a real-time Brightness histogram. The following sections give you a high-level view of setting up for and using Live View shooting. Some of the functions for Live View shooting carry over to shooting in Movie mode as well.

You can shoot in Live View in any of the shooting modes, but fewer menu options are available when you're shooting in Basic Zone modes and in CA mode than when you're shooting in Creative Zone modes. The Quick Control screen also offers fewer options when you're shooting in Basic Zone and CA shooting modes.

Live View focus options

With the T3/1100D's large and bright LCD monitor, you can use Live View shooting to get tack-sharp focus. You can choose from four types of focusing when you're shooting in Live View, as shown in Figure 5.1. Here is an overview of the focusing options so that you can decide in advance which is best for the scene or subject that you are shooting:

▶ **Live mode.** With this focusing option, the camera's image sensor is used to establish focus. This focusing mode keeps the reflex mirror locked up so that the Live View on the LCD is not interrupted during focusing. However, focusing takes longer with Live mode because the camera is detecting contrast in the scene rather than using the regular autofocus system. This focusing mode works best with

5.1 These are the focusing mode options that are available on the Quick Control screen in Live View mode.

nonmoving subjects and in brighter scenes. To focus using this mode, press a cross key to move the focusing point, displayed as a rectangle, over the subject, and then press the shutter button halfway to focus. The AF point turns green when focus is achieved. Then you can make the picture by fully pressing the shutter button. If the camera can't focus, then the AF point will be orange.

▶ **Face Detection Live mode.** This is the same as Live focusing except that the camera automatically looks for and focuses on a human face in the scene. If the camera does not choose the face of the subject you want, you can move the focusing frame to the correct face by pressing the left or right cross key. If the camera cannot detect a face, then the AF point reverts to the center AF point, and you can manually move the AF point to a face using the cross keys. And if multiple faces are in the scene, the focusing frame displays left and right arrows so that you can use the left and right cross keys to move the focusing frame over the face that you want. Half-press the shutter button to focus and look for the rectangle to turn green. If it turns orange, then focus can't be achieved. If your lens offers full-time manual focusing, you can turn the focusing ring to assist with focus.

If the person is a long way from the camera, you may need to manually focus to get the subject in reasonable focus range, and then focus by half-pressing the shutter button. Face Detection does not work with extreme close-ups of a face, if the subject is too far away, too bright or dark, partially obscured, or tilted horizontally or diagonally. In Face Detection Live mode, you can't magnify the image on the LCD using the AF-point Selection/Magnify button. In both Live and Face Detection Live modes, focus at the edges of the frame is not possible and the face focusing frame is grayed out. Instead, the T3/1100D switches to the center AF point for focusing.

▶ **Quick mode.** This focusing option uses the camera's autofocus sensor to focus. When the camera focuses, it suspends the Live View on the LCD long enough for the reflex mirror to drop down so the camera can establish focus. With Quick focusing mode, you can select any of the nine AF points if you are shooting in P, Tv, Av, or M shooting mode. With the Live View displayed on the LCD, press the Q button, and then press the up or down cross key multiple times until the AF points are activated. Next turn the Main dial to select an AF point. Then half-press the shutter button to focus. The reflex mirror flips down to focus, and then flips up again. To verify that focus was achieved, the AF point turns green. Then press the shutter button fully to make the picture.

▶ **Manual focus.** This focusing option is the most accurate, and you get the best manual focusing results when you magnify the image to focus. Another advantage to this option is that Live View is not interrupted during focusing. To focus manually, you need a lens that offers a Manual Focus (MF) switch on the side of the lens. Then set the lens switch to MF, and then press the cross keys to move the magnifying frame wherever you want. Press the AF-point Selection/Magnify button once to zoom in to 5X or twice to magnify it to 10X, and then focus by turning the focusing ring on the lens.

 If you use Live View with Continuous shooting, the exposure is set for the first shot and is used for all images in the burst. If the light changes during a burst of shots, the exposure may not be correct.

Metering

For Live View, the camera uses Evaluative metering. Unlike standard shooting, the most recent meter reading is maintained by default setting for 16 seconds even if the lighting changes. You can set how long the camera maintains the current exposure by setting the Live View Metering timer from 4 seconds to 30 minutes. If the light or your shooting position changes frequently, set a shorter meter time. Longer meter times speed up Live View shooting operation, and longer times are effective in scenes where the lighting remains constant.

 Auto Lighting Optimizer automatically corrects underexposed and low-contrast images. If you want to see the effect of exposure modifications, then turn off Auto Lighting Optimizer on the Shooting 2 menu when you are shooting with Live View in P, Tv, Av, M, and A-DEP shooting modes.

Using a flash

You can use the flash when you're shooting in Live View mode. When you're shooting in Live View with the built-in flash, the shooting sequence (after fully pressing the shutter button) is for the reflex mirror to drop to allow the camera to gather the pre-flash data. The mirror then moves up out of the optical path for the actual exposure. As a result, you hear a series of clicks, but only one image is taken. Here are some things you should know about using Live View shooting with a flash unit:

▶ With an EX-series Speedlite, Flash Exposure Lock (FE Lock), modeling flash, and test firing cannot be used.

▶ FE Lock cannot be used with the built-in or an accessory Speedlite. But you can set Flash Exposure Compensation (FEC) for either the built-in flash or an accessory Speedlite.

▶ When you're shooting Live View in Basic Zone shooting modes such as Portrait or Landscape, the flash fires automatically.

▶ To use the built-in flash in P, Tv, Av, M, and A-DEP modes, you have to pop up the built-in flash first.

You can learn more about flash in Chapter 7.

Setting up for Live View Shooting

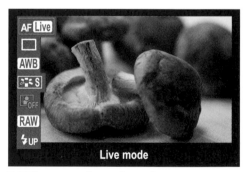
Live mode

5.2 These are the options that you can set for Live View shooting on the Quick Control screen when you shoot in P, Tv, Av, M, or A-DEP shooting mode. Fewer options are available in automatic shooting modes.

The settings on the Shooting 4 menu in Creative Zone shooting modes or on the Shooting 2 menu in Basic Zone modes not only activate Live View shooting, but they also enable you to set your preferences for shooting in this mode, including setting the focusing mode, displaying a grid, and choosing a time for the camera to retain the last meter reading. Options are also available on the Quick Control screen.

Just press the Q button to display the screen shown in Figure 5.2. Then you can press the Disp. button one or more times to display more or less information.

For step-by-step tasks in this chapter that involve the camera menus, just press the Menu button, turn the Main dial to move to the camera menu tab you want, and then press the up or down cross key to select an option.

You can shoot in Live View in any of the camera's shooting modes, except, of course, Movie mode. To set up the T3/1100D for Live View shooting and to set your preferences, follow these steps:

1. **In P, Tv, Av, M, or A-DEP shooting mode, select the Shooting 4 camera menu tab, highlight Live View shoot., and then press the Set button.** In Portrait, Landscape, and other Basic Zone modes, select the Shooting 2 menu instead. The Enable and Disable options appear.

2. **Press the up or down cross key to select Enable, and then press the Set button.** The Shooting 4 or Shooting 2 menu options appear depending on the shooting mode you are using.

3. **Highlight any of the following options, and then press the Set button to display the settings you can select.** After you select the option you want, press the Set button again.

 - **AF mode.** Select Live mode, Face Detection Live mode, or Quick focusing mode, and then press the Set button. See the previous descriptions of how each mode works.

 - **Grid display.** Select a 3 × 3 or 4 × 6 grid to help you align horizontal and vertical lines in the scene. Or select Off if you do not want to use a grid, and then press the Set button.

 - **Metering timer.** This option is available only when you are shooting in P, Tv, Av, M, or A-DEP shooting modes. Choose 4, 16, or 30 seconds, or 1, 10, or 30 minutes to determine how long the camera retains the exposure, and then press the Set button. If the light changes often, choose a shorter time. (In Basic Zone modes, the metering timer is set to 16 seconds, and you can't change it.)

Working with Live View

Now that you've chosen the focusing mode and selected the shooting options, you're ready to begin shooting. Here are a few tips to get you started:

▶ **For still life and macro shooting, manual focusing with the image enlarged to 5X or 10X helps ensure tack-sharp focus.** To enlarge the view, press the AF-point Selection/Magnify button on the top right back of the camera. Note that manual focusing is possible only with lenses that have a manual focusing switch on the side of the lens barrel.

▶ **Just a few minutes of watching the real-time view will convince you that a tripod is necessary for Live View shooting.** With any focal length approaching telephoto, Live View provides a real-time gauge of just how steady or unsteady your hands are.

Shooting in Live View

The operation of the camera during Live View shooting differs from traditional still shooting, but the following steps guide you through the controls and operation of the camera. Be sure that you have set the options on the Shooting 4 or Shooting 2 menu detailed in the previous section before you begin using Live View.

To shoot in Live View using autofocus, follow these steps:

1. **Press the Live View/Movie shooting button on the back of the camera.** A real-time view of the scene appears on the LCD.

2. **Press the Q button to display the Quick Control screen.** Options that you can change appear as an overlay on the LCD screen.

3. **To change the White Balance, Picture Style, and so on in P, Tv, Av, M, or A-DEP shooting mode, press the up or down cross key to select the option you want to change, and then turn the Main dial to adjust the setting.** Alternatively, you can press the Set button to display a screen with all the options for the setting. The options you can change are the focus mode, drive mode, White Balance, Picture Style, Auto Lighting Optimizer, Image-recording quality, and the ISO setting.

 Alternatively: In automatic shooting modes such as Portrait, Landscape, and Sports modes, highlight Default setting on the Quick Control screen, and then turn the Main dial to change the Lighting or Scene type.

4. **Press the Disp. button one or more times to show more or less information, and to display the histogram.**

5. **Compose the image.** As you move the camera, the exposure changes are displayed at the bottom of the display. If the histogram is displayed, it shows the changes as you move the camera as well.

6. **If you are using Quick mode to focus in P, Tv, Av, or M shooting mode, press the Q button to display the Quick Control screen, press the up or down cross key repeatedly until the AF-point is activated, and then turn the Main dial to select the AF point.** Point the AF point so it is over the subject, and then half-press the shutter button to focus. The reflex mirror flips down, temporarily interrupting your view of the scene. When focus is achieved, the mirror flips back up. If the AF point rectangle is green, press the shutter button completely to make the picture.

 Alternatively: If you are using Live Focusing mode, press a cross key to move the AF point. Then point the AF point over the subject, and half-press the shutter button to focus. Wait until the AF point rectangle turns green before shooting.

 Alternatively: If you're using manual focusing, press the AF-point Selection/ Magnify button on the top far-right corner of the camera to magnify the view. The first press of the button enlarges the view to 5X, and a second press enlarges the view to 10X. The magnifications are shown on the LCD as X5 and X10. Turn the focusing switch on the side of the lens to MF, and then turn the focusing ring on the lens to focus. Zoom back out before making the picture.

7. **Press the shutter button completely to make the picture.** The shutter fires to make the picture, the image preview is displayed, and then if you're using Quick focusing mode, Live View resumes.

5.3 Live View is a great mode to use for close-up shots such as this image of red flowers. A tripod helped ensure a sharp image in the overcast light of a nursery. Exposure: ISO 100, f/2.8, 1/50 second.

Using Movie Mode

The Movie mode on the EOS T3/1100D enables you to capture your visual stories in high-definition video. Whether you shoot movies of family, sports, weddings, or nature, you have the opportunity to expand your creative expression with the T3/1100D. The T3/1100D's movie quality is among the best available. Not only do you have the advantage of being able to shoot videos with a lightweight camera, but also you can choose among more than 60 lenses to enhance your videos in ways that traditional video cameras cannot. Combine your creative vision with the capabilities that the camera offers, and you have all you need to cre-

© Bryan Lowrie

The T3/1100D is a very capable and fun camera to use for video recording, including shooting kids' sports events such as this middle school football game. Exposure: ISO 3200, f/4.5, 1/250 second.

ate compelling movies. And with a little editing, you can combine your still images with your movies for a polished presentation.

Although this chapter is by no means exhaustive, it is a good starting point for you to begin exploring the world of digital video with the T3/1100D.

About Video

If you've previously only shot still images, shooting videos is like learning a new visual language. Though videography is different from traditional still photography, both are forms of creative storytelling. And with the Rebel T3/1100D, you can use still images with video to create multimedia stories during video editing. Although it's likely you'll shoot impromptu videos of family and friends, you can also put your creative skills to work planning out movies with storyboards that sequence the beginning, middle, and end of the story you want to tell.

If you are new to videography, then it is good to have a basic understanding of digital video and how it relates to the T3/1100D.

Video standards

Video standards sounds like a seriously dull topic, but it's important to understand at least the basic standards so that you can record movies that will display well when played back on the device you choose, whether it's your computer, the web, or your TV.

In the world of video, there are several industry standards, including the following resolutions: 720p, 1080i, and 1080p.

The numbers 720 and 1080 represent vertical resolution. The 720 standard has a resolution of 921,600 pixels, or 720 (vertical pixels) × 1280 (horizontal pixels). The 1080 standard has a resolution of 2,073,600 pixels, or 1080 × 1920. It seems obvious that the 1080 standard provides the highest resolution, and so you would think that it would be preferable. But that is not the entire story.

The rest of the story is contained in the *i* and *p* designations. The *i* stands for *interlaced*. Interlaced is a method of displaying video where each frame is displayed on the screen in two passes — first a pass that displays odd-numbered lines, and second, a pass that displays even-numbered lines. Each pass is referred to as a *field*, and two fields comprise a single video frame. This double-pass approach was engineered to keep the transmission bandwidth for televisions manageable. And the interlaced transmission works only because your mind automatically merges the two fields, so that the motion seems smooth with no flickering. Interlacing, however, is the old way of transmitting moving pictures.

The newer way of transmitting video is referred to as *progressive scan*, hence, the *p* designation. Progressive scan quickly displays a line at a time until the entire frame is displayed. And the scan happens so quickly that you see it as if it were being

displayed all at once. The advantage of 720 standard resolution progressive scanning is most apparent in scenes where either the camera or the subject is moving fast. With interlaced transmission, fast camera action or moving subjects tend to blur between fields. That is not the case with 720p, which provides a smoother appearance. So whereas 1080i offers higher resolution, 720p provides a better video experience, particularly when there are fast-action scenes.

Another piece of the digital video story is the frame rate. In the world of film, a frame rate of 24 frames per second (fps) provided the classic cinematic look of old movies. In the world of digital video, the standard frame rate is 30 fps. Anything less than 24 fps, however, provides a jerky look to the video. The TV and movie industries use standard frame rates, including 60i, which produces 29.97 fps and is used for NTSC; 50i, which produces 25 fps and is used for PAL, a standard used in some parts of the world; and 30p, which produces 30 fps, a rate that produces smooth rendition for fast-moving subjects.

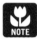 NTSC is the standard for North America, Japan, Korea, Mexico, and other countries. PAL is the standard for Europe, Russia, China, Australia, and other countries.

 Videographers who want a cinematic look prefer cameras that convert, or *pull down*, 30 fps to 24 fps.

Now that you have a very brief background on video, it is time to look at the digital video options on the T3/1100D.

Video on the T3/1100D

By now, you probably have questions, like how the T3/1100D compares to industry standards, how long of a video you can record on your memory card, and how big the files are. On the T3/1100D you get the following:

▶ **HD (High-Definition) video at 1280 × 720p at 30 (actual 29.97) for NTSC TV format, or 25 fps for PAL TV format.** The 30 fps option is the standard for movies played online, such as those posted on Vimeo.com or YouTube.com, as well as for North American TV playback. Video exposure is automatic so that the T3/1100D adjusts exposure settings on the fly to accommodate light changes as you move the camera.

▶ **Approximately 17 minutes of recording time with a 4GB card, and 1 hour, 8 minutes with a 16GB card.**

▶ **A file size that records approximately 222.6MB per minute.**

There is a 4GB or 30-minute length limit to individual movie clips, and the clips are MPEG-4 avch/H.264-compressed movie files with a .MOV file extension. You can also do some basic editing in the camera by trimming the beginning and end of a clip in 1-second increments in the camera.

You have two frame rate options on the T3/1100D. The 30 fps option is the traditional recording speed for online use whereas the actual 29.97 speed is the TV standard in North America. As a result, the 30 (actual 29.97) fps option is suitable for materials destined for DVD or display on a standard definition or HD TV. Although 25 fps may be more filmlike, it can produce jerky motion for subjects that are moving, and it requires slower shutter speeds. In addition, the actual 29.97 frame rate makes it easier to sync separately recorded audio using a video-editing program.

Here are other aspects to consider when shooting video:

▶ **Audio.** You can use the T3/1100D's built-in monaural microphone, which is adequate for recording sound. The 16-bit audio is recorded at a 48kHz sampling frequency in mono. If you use the built-in microphone, be aware that all the mechanical camera functions are recorded, including the sound of the Image Stabilization (IS) function on the lens, and the focusing motor. The audio recording format is Linear PCM (Pulse Code Modulated Audio), a compressed audio format that works with DVD, HD DVD, and Blu-ray.

▶ **Exposure and camera settings.** The T3/1100D offers full automatic exposure, which sets the aperture, shutter speed, and ISO automatically. The ISO is set automatically in a range from 100 to 6400. You can use Auto Exposure Lock (AE Lock) or Exposure Compensation of up to +/–3 stops in 1/3-stop increments. The camera uses Center-weighted and Evaluative metering depending on the focusing mode you choose.

You can change the focus mode, White Balance, Picture Style, and the Auto Lighting Optimizer level before you begin shooting.

▶ **Movie exposure simulation.** During shooting, the movie reflects the settings you've chosen, including Picture Style, White Balance, exposure, depth of field, adjustments made by Auto Lighting Optimizer, lens vignette correction, and the use of Highlight tone priority if you've chosen to use it.

▶ **Battery life.** At normal temperatures, you can expect to shoot for 1 hour and 50 minutes on a fully charged battery, with the time diminishing 1 hour and 30 minutes in colder temperatures.

▶ **Video capacities and memory cards.** The upper limit is 4GB of video per movie. When the movie reaches the 4GB point, the recording automatically

stops. You can start recording again by pressing the Live View/Movie shooting button provided that you have space on the card, and the camera creates a new file. As the card reaches capacity, the T3/1100D warns you by displaying the movie size and time remaining in red. Also, Canon recommends a large-capacity SD (Secure Digital) card that is rated as Class 6 or higher. Slower cards may not provide the best video recording and playback.

▶ **Focusing.** You have the same options for focusing as you have in Live View shooting detailed in Chapter 5. In Quick focusing mode, the reflex mirror has to flip down to establish focus, and this blackout is not the best video experience. However, Quick focusing mode can be suitable for an interview or other still subject where you can set the focus before you begin recording. Most professional videographers prefocus at the beginning of recording, and then they focus manually during recording. You can use this approach if you're using a lens that provides manual focusing.

▶ **HDMI output.** The T3/1100D offers HDMI-CEC (High-Definition Multimedia Interface–Consumer Electronics Control) video output connectivity. This means that when you play back movies on your HD TV, you can use the TV remote control to play back movies or view still images to control image playback, display an index, display the shooting information, rotate images, and run a slide show.

▶ **Frame grabs.** You can opt to pull a still image from the video footage rather than shooting a still image during movie recording. Stills grabbed from a 1280 × 720 movie are 920,000 pixels. Also because the shutter speeds during automatic exposure tend to be slow to enhance video movement, frame grabs can appear blurry.

Avoid shooting videos in places where the ambient temperature is high. Shooting for long periods in high temperatures can degrade the video quality and causes the internal camera temperature to heat up quickly.

Recording and Playing Back Videos

Some of the setup options for Movie shooting are the same as or similar to those offered in Live View shooting. In particular, the focusing modes are the same in both cases. Also when you set the Mode dial to Movie, the camera menus change, showing the options that you can set for recording movies.

The following sections help you set up the T3/1100D for video recording.

Setting up for movie recording

To set up for movie shooting, you can choose the frame rate, focusing mode, and whether to record audio using the built-in microphone. As with Live View shooting, you can also display a grid to line up vertical and horizontal lines, and set the amount of time the camera retains the last metering for exposure.

 Be sure to review Chapter 5 for details on the focusing modes, grid display, and Metering timer because the same options are used in Movie mode shooting.

To set up options for shooting movies using the Movie Shooting menus, follow these steps. Some steps involve additional steps that are included in the menu option descriptions.

 For step-by-step tasks in this chapter that involve the camera menus, just press the Menu button, turn the Main dial to move to the camera menu tab you want, press the up or down cross key to select an option, and then press the Set button to confirm your selection.

1. **Set the Mode dial set to Movie shooting mode, press the Menu button, and then select the Movie 1 menu.** When you switch to Movie mode, the reflex mirror flips up and a current view of the scene appears on the LCD.

2. **On the Movie 1 menu, highlight any of the following options, and then press the Set button to display the settings that you can select.** After you make your selection, press the Set button to confirm your choice.

Here are the options you can set on the Movie 1 Shooting menu (shown in Figure 6.1):

▶ **AF mode.** Select Live mode, Face Detection Live mode, or Quick focusing mode, and then press the Set button. These focusing modes are detailed in Chapter 5.

You can focus at the beginning of the movie, and then set the lens switch to MF (Manual Focus) and manually focus during shooting provided that the lens you're using has a manual focusing option (an MF switch on the side of the lens).

6.1 The Movie 1 shooting mode menu

▶ **AF w/ shutter button during [Movie icon].** Choose Enable for this option if you want to be able to focus by half-pressing the shutter button while you're recording the movie. Adjusting focus during movie recording causes a visual transition that isn't optimal, and it can change the exposure settings that can also cause a visual disconnect in the movie. Of course, you may need to focus during recording if the subject moves. The T3/1100D does not focus continuously.

 If you set Quick focus mode, and you focus during movie recording, the camera switches to Live mode to focus.

▶ **[Movie icon] Shutter/AE Lock button.** This option enables you to swap the functions of the shutter button and the AE Lock button. The AE Lock button is on the top right back of the camera and has an asterisk above it. Switching functions is helpful if you find it easier to use one button over the other. The options include:

- **AF/AE Lock.** No change from the standard function of these buttons. Press the shutter button to focus, and press the AE Lock button to lock the exposure.

- **AE Lock/AF.** Choosing this option swaps the function of the shutter button and the AE Lock button. Pressing the shutter button locks the exposure, and pressing the AE Lock button focuses.

- **AF/AF Lock, no AE Lock.** This option enables you to use the shutter button to focus, but you can stop and resume focusing by pressing the AE Lock button. To focus, half-press the shutter button. Then if you want to pause focusing, just press and hold the AE Lock button on the back right top of the camera. Releasing the AE Lock button resumes the focusing function. With this option, you cannot use AE Lock.

- **AE/AF, no AE Lock.** This option swaps the function of metering and focusing buttons so that pressing the AE Lock button focuses and pressing the shutter button meters the light. There is no AE Lock function with this option.

▶ **Highlight tone priority.** Choosing Enable improves the T3/1100D's dynamic range so that highlights are less likely to blow out, or go completely white with no image detail in them. The shadow range is reduced, and I don't recommend using this if you're shooting scenes where there are a lot of shadows. If you enable Highlight tone priority, the lowest ISO the camera selects is 200, and Auto Lighting Optimizer is automatically turned off regardless of the setting you choose for it.

These are the options you can set on the Movie Shooting 2 menu shown in Figure 6.2:

▶ **Movie rec. (recording) size.** Select the frame rate for your movie, either 30 or 25 fps. For North America, Japan, Korea, Mexico, and some other countries, choose 30 fps. For Europe, Russia, China, Australia, and some other countries, choose 25.

▶ **Sound recording.** You can choose On or Off. Choose On to have the camera automatically set the recording level for monaural sound. Choose Off if you do not want to record sound. You can later add background music to the video on the computer.

 For the best sound recording, be as close to the subject or sound source as possible, and try to shoot in an area that has little or no background noise.

▶ **Metering timer.** Choose 4, 16, 30 seconds, or 1, 10, or 30 minutes. Your choice depends on how often the light in the scene will change. If the light is constant, then a longer time is the best choice and vice versa.

▶ **Grid display.** Select a 3 × 3 or 4 × 6 grid to help you align horizontal and vertical lines in the scene. Or select Off if you do not want to use a grid.

Here are the options you can set on the Movie Shooting 3 menu shown in Figure 6.3:

▶ **Exposure Compensation.** You can set up to +/–3 stops of Exposure Compensation for movie recording. Exposure Compensation is detailed in Chapter 2.

 When you move the camera from a light to a dark subject or vice versa, the overall exposure changes. You can help prevent this change by pressing the AE Lock button before or during shooting.

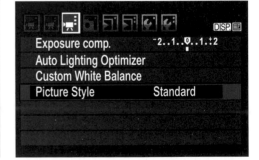

6.2 The Movie Shooting 2 menu

6.3 The Movie Shooting 3 menu

▶ **Auto Lighting Optimizer.** This feature automatically adjusts exposure that is too dark or has low contrast. If you set Exposure Compensation, Auto Lighting Optimizer masks the effect of the compensation. If you turn on optimization, it is automatically disabled if you use Highlight tone priority on the Movie Shooting 1 menu.

▶ **Custom White Balance.** To set the color for the type of light you're shooting in, you can set a Custom White Balance. Details on setting a Custom White Balance are in Chapter 3.

▶ **Picture Style.** Select the Picture Style that you want to use for movie recording. Picture Styles affect the color, color saturation, sharpness, and contrast of the recording. Picture Styles are detailed in Chapter 3.

In addition to the Movie Shooting menus, the Shooting 1, Playback 1 and 2, and Setup 1 and 2 menus are also available for setting playback and setup options.

Recording movies

Here are a few things to do before you begin shooting a movie:

▶ **Plan the movie sequences.** If you want a video that holds the viewer's attention, plan the movie segments as if you are telling a story that has a beginning, middle, and an end. Sketching the segments or clips on paper — storyboarding the video — beforehand helps you tell an interesting and compelling story, and it helps you to plan for changes in camera setup between clips, and changes in location and lighting.

▶ **Use lenses to enhance the story.** One advantage of Movie mode is that you can create the mood you want by selecting the lenses to complement the story and subject. For example, if you're recoding a grandmother recalling the times of her childhood, you can create a soft effect by choosing a short telephoto lens of 80 to 100mm. Regardless of the subject and story, plan ahead for the look you want to create.

▶ **Charge the battery.** Movie recording consumes battery power faster than still-image shooting, so have the battery charged, and have a backup charged battery handy as well.

TIP Memory cards with a fast read/write speed of 8MB/second or faster are recommended. Also, movie files are large, so have ample storage on your computer. For example, a 15-minute HD movie with sound can be as large as 5GB.

▶ **Make camera adjustments.** If you're using the built-in microphone, think through all the camera adjustments that you can make before you begin shooting to keep the camera sounds they produce to a minimum during recording. Also, when you switch to Movie mode, press the Q button to access the Quick Control screen shown in Figure 6.4. And then set the focus mode, White Balance, Picture Style, and Auto Lighting Optimizer before you begin shooting.

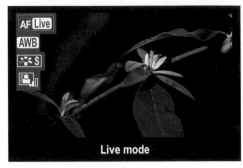

Live mode

6.4 The Quick Control screen

▶ **Test the microphone.** If you're using the built-in microphone, the recording level is set automatically. If you don't want to record sound with the video, you can add background music during movie editing.

▶ **Stabilize the camera.** Use a tripod or specialized holding device for video shooting to ensure smooth movement. You can use a tripod with a sturdy ball head or pan-and-tilt head, but there are other options. The pricey Steadicam Merlin frees you from the tripod and gives you steady handheld shooting because the apparatus absorbs your body movement. Alternatively, Manfrotto and other companies produce more affordable camera stabilizers and support systems. And if you stabilize the camera, turn off Image Stabilization on the lens if the lens has IS.

▶ **Set a Custom White Balance.** If you're shooting under mixed light or indoors, you can set a Custom White Balance for the light you're shooting in before you begin recording the movie. Then when you have the camera ready to shoot, simply switch to the Custom White Balance setting on the Quick Control screen.

▶ **Focus on the subject.** Although you can focus during shooting, it creates a visual disconnect that isn't optimal. This is especially important if you use Quick focusing mode, where the reflex mirror flips down to establish focus. Alternatively, you may want to adjust focus manually if the subject distance changes frequently during recording.

Before you begin recording, set up the camera by following these steps:

1. **Set the Mode dial to Movie.** The reflex mirror flips up and a current view of the scene appears on the LCD.

2. **Press the Q button to display the settings you can adjust.** The settings you can change are the focus mode, White Balance, Picture Style, and the Auto Lighting Optimizer setting. Press the up or down cross key to move to the setting you want to change, and then turn the Main dial to make changes.

3. **Focus on the subject.** Here is how to use the focusing options that are the same as in Live View shooting:

 • **Live mode.** Press a cross key to move the white magnifying rectangle so that it is over the part of the subject that you want in focus, and then half-press the shutter button. When focus is achieved, the AF-point rectangle turns green. If focus is not achieved, the AF-point rectangle turns orange. In Live mode, focus takes slightly longer than you are accustomed to.

 • **Face Detection Live mode.** The camera looks for a face or faces in the scene, and displays corner marks over the face it finds. You can press the left or right cross key to move the focusing frame to another face. To focus, half-press the shutter button. When focus is obtained, the corner marks appear in green. If the camera cannot find a face in the scene, it displays a solid rectangle and the camera uses the center AF point for focusing.

 • **Quick mode.** Press the Q button to display the nine AF points. Press the up or down cross key multiple times until an AF point is highlighted in blue, and then turn the Main dial to select the AF point you want.

 • **Manual focusing.** You need to have a lens that offers manual focusing to use this option. Set the switch on the side of the lens to MF (Manual Focus). Then turn the focusing ring on the lens to focus on the subject. If you have to change focus during shooting, manual focusing avoids the noise of the AF motor being recorded, but the focusing adjustment can be intrusive to the video.

You can't focus continuously on a moving subject in Movie shooting mode.

Now the camera is set up for video shooting. Note that video recording can raise the camera's internal temperature. If an icon that resembles a thermometer appears, wrap up shooting and let the camera cool.

To begin recording, follow these steps:

1. **With the Mode dial set to Movie mode, press the Live View/Movie shooting button to begin recording the movie.** The Movie mode (red) dot appears at the top right of the screen.

2. **Press the Disp. button one or more times to cycle through the various shooting displays to display more or less shooting and camera setting information.**

3. **To stop recording, press the Live View /Movie shooting button.** Each time you stop and start recording, a new file is created.

After you download videos to the computer, you can do basic editing in Canon's MovieEdit Task, a program included on the EOS Digital Solution Disk that comes with the camera. Just start ImageBrowser, select a MOV file, and then select Movie Edit from the Edit menu. This program is simple, fun, and enables you to do basic editing and add text, effects, and audio.

Easy Movie Uploading to YouTube

After you've recorded your videos and transferred them to your computer, you can then upload the videos to YouTube using the program provided on the EOS Digital Solution Disk. If you've already installed the EOS Digital Solution Disk, navigate to the Canon Utilities folder. In the list of folders, open the Movie Uploader for YouTube folder. Double-click the Movie Uploader for YouTube file. Under List, click the Add button, and then navigate to the folder that contains the movie you want to post on YouTube. The movie is added to the left column along with information about the shooting date and time, file size, and the playback time.

Click the text entry field under Title, and type a catchy title for the movie. Then delete the default text in the Explanation field and type a description for the video. Click the Publish button to have the video published or viewable on YouTube. Then click the Upload button.

Playing back videos

For a quick preview of your movies, you can play them back on the camera's LCD. Of course, with the high-definition quality, you will enjoy the movies much more by playing them back on a television or computer.

To play back a movie on the camera LCD, follow these steps:

1. **Press the Playback button, and then press the left or right cross key until you get to a movie file.** Movies are denoted with a movie icon and the word *Set* in the upper-left corner of the LCD display. You must be in Single-image Playback mode to display movies. They cannot be displayed in Index Playback mode where multiple images are shown on the LCD at the same time.

2. **Press the Set button.** A progress bar appears at the top of the screen, and a control bar appears at the bottom of the display.

3. **Press the Set button to begin playing back the movie, or press the right cross key to select a playback function, and then press the Set button.** You can choose from the following options, pointed out in Figure 6.5:

6.5 The movie playback options

- **Exit.** Select this control to return to single-image playback.

- **Play.** Press the Set button to start or pause the movie playback.

- **Slow motion.** Press the left or right cross key to change the slow-motion speed.

- **First frame.** Select this control to move to the first frame of the movie.

- **Previous frame.** Press the Set button once to move to the previous frame, or press and hold the Set button to rewind the movie.

- **Next frame.** Press the Set button once to move to the next frame, or press and hold the Set button to fast forward through the movie.

- **Last frame.** Select this control to move to the last frame or the end of the movie.

- **Edit.** Select this control to display the editing screen where you can edit out 1-second increments of the first and last scenes of a movie.

- **Volume.** This is denoted as ascending green bars; just turn the Main dial to adjust the audio volume.

4. **Turn the left cross key to select Exit, and then press the Set button.** The playback screen appears.

Editing Movies in the Camera

One of the playback options for movies is the Edit option. During playback, press the left or right cross key to select the Edit option, and then press the Set button. On the editing screen, in a ribbon of controls at the bottom, the left two icons enable you to cut the beginning or end of the movie, respectively. Select the Cut beginning or Cut end icon, and then press the Set button. Press the left or right cross key to move frame by frame, or press and hold to fast-forward or rewind. When you reach the part you want to cut, press the Set button. Edits are made in 1-second segments, and the scissors indicates the position of the cut. At the top of the screen, a blue bar shows the portion of the movie that will not be cut.

Then press the Play button at the bottom of the screen and press the Set button to play the segment of the movie that remains. Then you can save the edited movie as a new file or you can overwrite the original file.

There are many movie-editing programs available, but it you want to do basic editing, you can use the program supplied by Canon on the EOS Digital Solution Disk. After you have your movie downloaded to the computer, follow these steps to edit the movie.

1. **Start ImageBrowser.** ImageBrowser is a program included on the EOS Digital Solution Disk.

2. **Choose a folder that contains a movie from the list of folders in the left panel, and then choose a movie file.** Movie files have a .MOV file extension.

3. **On the ImageBrowser Edit menu, choose Movie Edit.** A screen appears as the program creates a "working movie." The MovieEdit Task program has four main tabs that take you through the process of editing. The tabs are as follows:

 1. **Arrange tab.** Here you can add still images within your movie, rotate, move frames left and right, and play the movie. This is the tab to use to sequence your movie.

 2. **Effect tab.** On the Effect tab, you can correct the color of the movie with Filter Effect, and you can apply Sepia, Monochrome, Emboss, and Film noise to the movie. You can also add text and position it, and you can add transitions.

 3. **Audio tab.** On the Audio tab, you can add music from your computer, adjust the sound level, and use fades.

 4. **Save tab.** On this tab, you can play and save the edited video.

Regardless of the editing program you use, the movies you create using the T3/1100D offer a great opportunity to record the memories of your life.

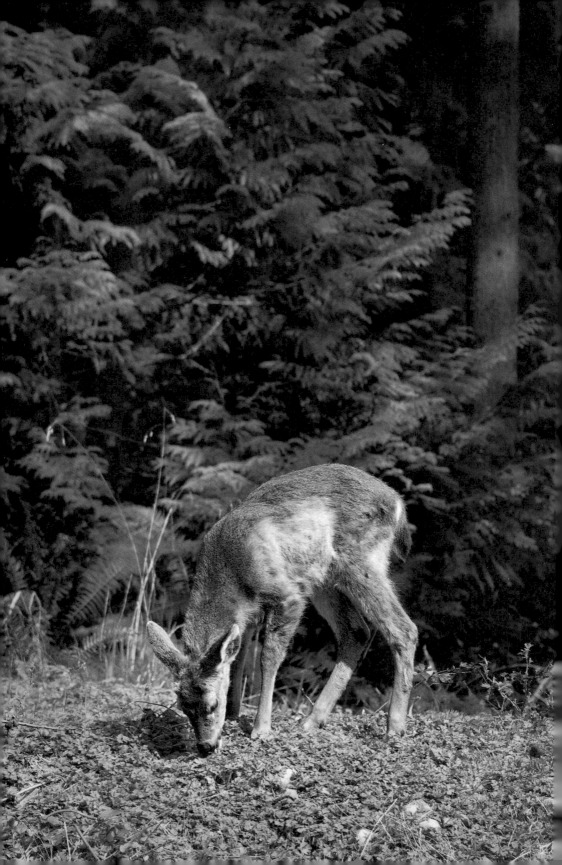

Working with Flash

The EOS T3/1100D opens a world of opportunity for you to use the built-in flash either as an accessory light or as the primary light in the scene. With an accessory, or fill light, you can bring up the light on the subject while maintaining natural-looking light through the rest of the scene. And if you have one or more accessory Canon EX-series Speedlites, you can set up the flash units directly from the T3/1100D menus, and then fire the flashes wirelessly. In addition, you can control the Custom Function settings for accessory Speedlites such as the 580EX II, 550EX, 430EX II, 320EX, and the 270EX II from the T3/1100D's flash menus.

You can also control the output of both the built-in and accessory flash directly

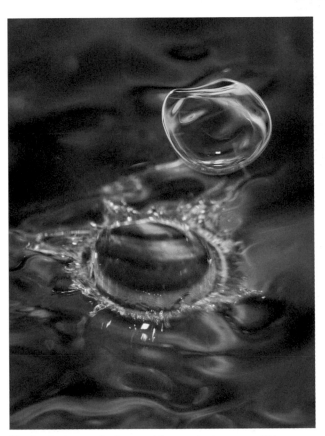

Flash photography is great for capturing everything from portraits to the action of water. For this image, I used the built-in flash to stop the motion of the water drop as it splashed up. Exposure: ISO 100, f/11, 1/200 second.

from the camera to get professional-looking results. Whether you're using the built-in flash or one or more Speedlites, the T3/1100D makes flash setup and shooting quick and easy.

Flash Technology and the T3/1100D

Canon flash units, whether they're built-in flashes or accessory EX-series Speedlites, use *E-TTL II technology*. To make a flash exposure using Evaluative metering, the camera takes a reading of the light in the scene when you half-press the shutter button. After the shutter button is fully pressed but before the reflex mirror goes up, the flash fires a preflash beam. The camera compares the existing and preflash readings to determine the best flash output, and then stores that information in its internal memory. The camera also detects when there is a difference between the existing and flash light readings, and assumes that the difference is the subject. If the camera detects areas where there are large differences in readings, it attributes them to a highly reflective surface, such as glass or a mirror, and ignores them when calculating the exposure.

During this process, the flash unit also receives information from the camera, including the focal length of the lens, distance from the subject, and exposure settings, and

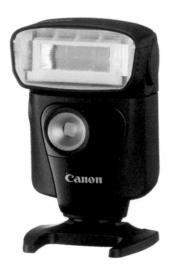

Courtesy of Canon, Inc.

7.1 The Speedlite 320EX is one of a new generation of Canon Speedlites that offers regular flash functions as well as a built-in LED continuous light option that is great for shooting video on the T3/1100D when the subject is a short distance from the camera. This flash offers six positions for bounce flash, and it can trigger other flash units wirelessly.

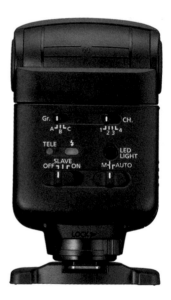

Courtesy of Canon, Inc.

7.2 These are the controls on the back of the Canon Speedlite 320EX.

this information confirms if the subject distance from the flash reading is correct. The flash also automatically figures in the angle of view for the smaller T3/1100D image sensor. Thus, the built-in and EX-series Speedlites automatically adjust the flash zoom mechanism to get the best flash angle and to illuminate only key areas of the scene, which also conserves power.

The sequence for a flash image is that the camera's reflex mirror flips up, the first shutter curtain opens and the flash fires, the image sensor is exposed to make the exposure, and then the second curtain closes.

Why Flash Sync Speed Matters

If flash sync speed isn't set correctly, there is enough time for only part of the image sensor to receive light while the shutter curtain is open. The result is an unevenly exposed image. The T3/1100D doesn't allow you to set a shutter speed faster than 1/200 second, but you can set a slower flash sync speed. Using Custom Function C.Fn I-2, you can set whether the T3/1100D sets the flash sync speed automatically (Option 0), sets the sync speed to 1/200 to 1/60 second (Option 1), or always sets the sync speed at 1/200 second (Option 2) when you shoot in Aperture-priority AE (Av) shooting mode.

Shooting with the built-in flash

The built-in flash is handy when you need a pop of fill flash for a portrait, or when you are in low-light scenes where you might not otherwise be able to get a shot without a flash. The built-in flash offers coverage for lenses as wide as 17mm and sync speeds between 1/200 and 30 seconds, and it recycles in approximately 2 seconds. Depending on the shooting mode you choose, Tables 7.1 and 7.2 show what you can expect when you use the built-in flash and the flash range estimates.

Table 7.1 T3/1100D Exposure Settings Using the Built-in Flash

Shooting Mode	Shutter Speed	Aperture
Program AE (P) and A-DEP	The T3/1100D automatically sets the shutter speed in the range of 1/200 second to 1/60 second.	The T3/1100D automatically sets the aperture. With flash use, you cannot shift, or change, the exposure in P mode. In A-DEP mode, the camera sets the aperture, but it does not achieve the maximum depth of field.

continued

Table 7.1 T3/1100D Exposure Settings Using the Built-in Flash *(continued)*

Shooting Mode	Shutter Speed	Aperture
Shutter-priority AE (Tv)	You set the shutter speed from 1/200 second to 30 seconds. If you set a shutter speed faster than 1/200 second, the camera automatically readjusts it to 1/200 second.	The camera automatically sets the appropriate aperture and bases the flash output on the aperture.
Aperture-priority AE (Av)	The camera automatically sets the shutter speed from 1/200 second to 30 seconds. You can determine the flash sync speed by setting C.Fn I-2 to either Option 1, 1/200 to 1/60 second, or to Option 2, 1/200 second fixed. The T3/1100D uses slow-speed flash sync in low light so that the flash exposes the subject properly while the existing light registers with the slow shutter speed. If you use slow-speed flash sync, use a tripod if the shutter speed is slow to avoid blur from hand shake.	You set the aperture.
M (Manual)	You can set the shutter speed from 1/200 second to 30 seconds, and Bulb.	You set the aperture manually. Flash exposure is set automatically based on the aperture.
Bulb (B)	Exposure continues until you release the shutter button.	You set the aperture.
Creative Auto (CA), Portrait, Close-up, and Full Auto	The T3/1100D automatically sets the shutter speed in the range of 1/60 second to 1/200 second.	The T3/1100D automatically sets the Background blur setting (the aperture).
Night Portrait	The T3/1100D sets the shutter speed between 1/200 second and 2 seconds. Given the potential for a very long exposure, use a tripod and ensure that the subject stays stock-still.	The T3/1100D automatically sets the aperture.

From the information in Table 7.1, you can see that flash use differs based on the shooting mode you choose. In Av and Tv shooting modes, the T3/1100D balances the existing light with the flash light to provide fill flash. Fill flash uses the light in the scene for the exposure and provides just enough flash illumination to fill shadows and brighten the subject for natural-looking illumination.

Table 7.2 T3/1100D Built-in Flash Range

ISO Sensitivity Setting	Using the EF-S 18-55mm f/3.5-5.6 IS II Lens: Feet (Meters)	
	Wide-angle	Telephoto
100	3.3-8.5 (1-2.6)	3.3-5.2 (1-1.6)
200	3.3-12.1 (1-3.7)	3.3-7.5 (1-2.3)
400	3.3-17.4 (1-5.3)	3.3-10.8 (1-3.3)
800/Auto (A lower ISO may be set for fill flash when using Auto ISO)	3.3-24.3 (1-7.4)	3.3-15.1 (1 -4.6)
1600	3.3-34.4 (1-10.5)	3.3-21.7 (1-6.6)
3200	3.3-48.8 (1-14.9)	3.3-30.5 (1-9.3)
6400	3.3-68.9 (1-21.0)	3.3-43 (1-13.1)
Information in this table provided by Canon.		

In Av shooting mode, you can choose the aperture you want, but because more of the existing light is used for the exposure, it's up to you to ensure that the shutter speed is fast enough to prevent the blur that can occur from the slight shake of your hands when you're handholding the camera. Just monitor the shutter speed in the view-finder when you're using the flash in Av shooting mode. If the shutter speed is too slow, you can use a wider aperture, use a tripod, or set a higher ISO setting. Also, you can use Custom Function (C.Fn) I-2 to set the flash sync speed to help prevent the blur that comes from handholding the camera.

In Tv mode, you can set a shutter speed up to 1/200 second to prevent handshake. But if you set a shutter speed that is out of range for the amount of light in the scene, the aperture value flashes in the viewfinder, alerting you that the camera can't record enough of the existing light to get a balanced fill-flash exposure. In those cases, set a slower shutter speed, use a tripod, or increase the ISO setting.

In Manual mode, you have full control over the balance between existing and flash light. With fast shutter speeds, less of the existing light is captured — unless the existing light is very bright — and the background goes dark. If you choose a very slow shutter speed, you run the risk of blur from camera shake if you're handholding the camera, but the background will be brighter because more of the existing light factors into the exposure.

Gauging the Power of the Built-in Flash

Understanding the power of the built-in flash is important because it helps you evaluate whether the flash will provide the coverage you need for the scene you're photographing. The classic way to gauge the relative power of the flash is by the flash unit's guide number. Although the guide number is not something that you deal with each time you use the built-in flash, understanding guide numbers helps you use the flash more effectively.

A *guide number* indicates the amount of light that the flash emits, or the power of the flash. The guide number is measured at ISO 100 for a field of view of 105mm. From that number, you or the camera can determine what aperture to set given the subject distance and the ISO. The guide number for the T3/1100D's built-in flash is 30 feet (9.2 meters) at ISO 100. Divide the guide number by the flash-to-subject distance to determine the appropriate aperture to set.

The relationship between the aperture and the flash-to-subject distance is Guide Number ÷ Aperture = Distance for optimal exposure and Guide Number ÷ Distance = Aperture for optimal exposure.

Thus, if the subject is 15 feet from the camera, you divide 30 (the guide number) by 15 feet (camera-to-subject distance) to get f/2.0 at ISO 100. Or just round up the aperture to f/2.8

If you want a different aperture, you can change the camera-to-subject distance, or you can increase the ISO sensitivity setting on the camera. By increasing the ISO, the camera needs less light to make the exposure, and it simultaneously increases the range of the flash. When you increase the ISO from 100 to 200, the guide number increases by a factor of 1.4X; increasing from 100 to 400 doubles the guide number.

Working with the built-in flash

On the T3/1100D, the E-TTL II setting automatically takes effect when the flash pops up. By default, the camera automatically provides reduced flash output — just enough power from the flash to fill shadows in a natural-looking way. Fill flash help ensure that you don't get the blasted-with-flash look of flash images of years gone by.

 When you use the built-in flash, be sure to remove the lens hood to prevent obstruction of the flash coverage.

You can control the flash behavior using the Flash Control options (Shooting 1 menu) when you shoot in P, Tv, Av, M, and A-DEP modes. And you can control the flash output by using Flash Exposure Compensation (FEC) and Flash Exposure Lock (FE Lock). To use the flash in P, Tv, Av, M, and A-DEP shooing modes, you have to press the flash pop-up button. In automatic shooting modes except Flash Off, Landscape, and Sports shooting modes, the flash fires automatically when the T3/1100D determines it's needed. In CA shooting mode, you can control use of the flash on the Quick Control screen.

NOTE For all step-by-step instructions in this chapter, you can access the T3/1100D camera menus by pressing the Menu button. Then turn the Main dial to select the menu tab, press the up or down cross key to highlight a menu option, and then press the Set button to confirm your selection.

To set options for the built-in flash, follow these steps:

1. **On the Shooting 1 camera menu tab, highlight Flash control, and then press the Set button.** The Flash Control options appear.

2. **Highlight Flash firing, and then press the Set button.** Two options appear.

3. **Highlight Enable, and the press the Set button.** The Flash control screen appears.

4. **Highlight Built-in flash func. setting, and then press the Set button.** The Built-in flash func. setting screen appears. Table 7.3 details the options you can set for the built-in flash. Follow the steps in the table headings to make the changes you want.

Table 7.3 Built-in Flash Control Options

Press a cross key to highlight the following Built-in flash func. settings.	Press the Set button to see these options:	Select an option, and then press the Set button.
Flash mode	E-TTL II	For the built-in flash, E-TTL II is the only option, and it is automatically set.
Shutter sync	First curtain, or second curtain	First curtain: Flash fires at the beginning of the exposure. Can be used with a slow-sync speed to create light trails in front of the subject.
		Second curtain: Flash fires just before the exposure ends. Can be used with a slow-sync speed to create light trails behind the subject.

continued

Table 7.3 Built-in Flash Control Options *(continued)*

Press a cross key to highlight the following Built-in flash func. settings.	Press the Set button to see these options:	Select an option, and then press the Set button.
Flash exp. comp	You can set +/–2 EV of compensation	Press the Set button to activate the Flash Exposure level indicator, and then press the left or right cross key to set +/–2 stops of Flash Exposure Compensation.
E-TTL II meter.	Evaluative, Average	Evaluative: This default setting sets the exposure based on an evaluation of the entire scene. Average: Flash exposure is metered and averaged for the entire scene, which results in brighter output on the subject and less balancing of ambient background light.

Red-eye Reduction

The red appearance in a person's eye is caused when the bright flash reflects off the retina, revealing the blood vessels in the eye. When you use Red-eye Reduction, the flash fires a preflash, causing the pupils of the subject's eye to contract when the subject looks at the preflash. For the best results, have the subject look at the preflash when it fires.

You can turn on Red-eye Reduction on the Shooting 1 menu. Just highlight Red-eye Reduction, press the Set button, and then choose Enable. Then press the Set button.

Modifying flash exposure

There are times when the flash output won't produce the image that you envisioned, and there are times when you want a slightly increased or decreased flash exposure. In these situations, you can modify the flash output using either Flash Exposure Compensation (FEC). Alternatively, you can lock in the flash output for a specific area of the scene by using Flash Exposure Lock (FE Lock). You can set both of these options for the built-in flash and an accessory Speedlite.

Flash Exposure Compensation

Flash Exposure Compensation (FEC) enables you to manually adjust the flash output without changing the aperture or the shutter speed in P, Tv, and Av shooting modes. This is useful when the subject is brighter or darker than the average 18 percent reflectance that the camera expects. FEC is effective when you want to adjust the balance between the foreground and background exposure, and it can help

compensate for highly reflective or nonreflective subjects. FEC is also useful for balancing lighting in unevenly lit scenes and reducing the dark background flash shadows. If you're using the flash for fill light, then you can use FEC as a dimmer switch to turn the amount of light up or down.

Figures 7.3 through 7.5 show the difference that no flash, unmodified flash, and flash with FEC make.

With FEC, you can increase the flash output up to +/–2 stops in 1/3-increments. As a result, you can maintain the camera's original E-TTL (Evaluative Through-the-Lens) readings while manually increasing or decreasing the flash output.

7.3 For this image, no flash was used. The image is lit by large windows to the left of the subject. A large silver reflector on the right bounces light onto the right side of the face. This image is a point of comparison for Figures 7.4 and 7.5, where the built-in flash was used with and without modification. Exposure: ISO 100, f/5.6, 1/20 second.

7.4 For this image, I used the built-in flash with no modifications. The flash provides an overly bright look on the face and the typical dark flash shadow behind the mannequin, who I've named Jane. Exposure: ISO 100, f/5.6, 1/20 second.

7.5 Here –2-stops of FEC balances the flash with the existing light so that the flash shadow is significantly reduced. More important, the light on Jane's face is pleasing and the extra light brings the face visually forward in the image as compared to Figure 7.3 but without the overly bright look in Figure 7.4 or the dark background shadow. Exposure: ISO 100, f/5.6, 1/20 second.

If you use an accessory Speedlite, you can set FEC either on the camera or on the Speedlite. However, the compensation that you set on the Speedlite overrides any compensation that you set using the T3/1100D's FEC function. In short, set compensation either on the Speedlite or on the camera, but not on both.

FEC can also be combined with Exposure Compensation. If you shoot a scene where one part of the scene is brightly lit and another part of the scene is much darker — for example, an interior room with a view to the outdoors — then you can set Exposure Compensation and FEC to make the transition between the two differently lit areas more natural.

 Auto Lighting Optimizer can mask the effect of FEC. If you want to see the effect of the compensation, turn off Auto Lighting Optimizer by setting it to Disable on the Shooting 2 menu.

To set FEC for the built-in flash or for a Speedlite, follow these steps:

1. **In P, Tv, Av, or M shooting mode, select the Shooting 1 camera menu, highlight Flash control, and then press the Set button.** If you're using a Speedlite, attach it to the hot shoe and turn it on. Also ensure that Flash firing is set to Enable on the Flash control screen.

2. **To set FEC for the built-in flash, highlight Built-in flash func. setting, and then press the Set button.** The Built-in flash func. setting screen appears.

 Alternatively: For a Speedlite, highlight External flash func. setting, and then press the Set button. The External flash func. setting screen appears.

3. **For the built-in flash, highlight the Flash exp. comp option, and then press the Set button.** The FEC control is activated.

 Alternatively: On the External flash func. setting screen, press the down arrow to highlight Flash exp. comp., and then press the Set button. The FEC control is activated.

4. **Press the left cross key to decrease the flash output or press the right cross key to increase it, and then press the Set button.** The FEC icon appears in the viewfinder when you half-press the shutter button.

5. **Make the picture and check the exposure. If necessary, adjust the amount of compensation by repeating these steps.** The FEC you set on the camera remains in effect until you change it. To remove FEC, repeat these steps, but in Step 4, move the tick mark on the Flash Exposure Compensation indicator back to the center point.

Flash Exposure Lock

Flash Exposure Lock (FE Lock) is a good way to lock the flash output for any part of the scene or subject, especially if the subject is not in the center of the frame. The traditional way to use FE Lock is to lock the exposure on a middle-tone area in the scene or on a gray card such as the one in the back of this book. A middle-tone area is one that has 18 percent reflectance. FE Lock fires a preflash that is read from a very precise area at the middle of the frame, so be sure to point the center of the viewfinder over the part of the scene or subject from which you want to take the meter reading. This preflash meter reading is stored temporarily so that you can move the camera to recompose the scene, focus, and make the image.

 If you are shooting a series of images under unchanging existing light, then FEC adjustment is a more efficient approach than using FE Lock.

To set FE Lock, follow these steps:

1. **In P, Tv, Av, M, or A-DEP shooting mode, press the Flash button to raise the built-in flash or attach an accessory Speedlite.** The flash icon appears in the viewfinder when you half-press the shutter button.

2. **Point the center of the viewfinder over the area of the subject where you want to lock the flash exposure, or over a gray card, and then press the AE Lock/FE Lock button on the back right of the camera.** This button has an asterisk icon on it. The camera fires a preflash. FEL is displayed momentarily in the viewfinder, and the flash icon in the viewfinder displays an asterisk beside it

to indicate that flash exposure is locked. If the flash icon in the viewfinder blinks, the subject is beyond the flash range, so move closer and repeat the process.

3. **Move the camera to compose the image, half-press the shutter button to focus, wait for the scale displayed at the bottom of the viewfinder to turn off, and then completely press the shutter button to make the image.** As long as the asterisk is displayed, you can take other images at the same compensation amount.

Using the flash AF-assist beam to help the camera focus

In some low-light scenes, you may not want or be allowed to use the built-in flash or an accessory flash, but the light may be too low for the camera to establish focus easily. This is when you can use the flash unit's AF-assist beam to help the camera establish focus without actually firing the flash.

Before you begin, go to the Custom Functions menu, and set C.Fn III-6, AF-assist beam firing to Option 0: Enable. Also if the Speedlite's Custom Function is set to Disabled, the Speedlite AF-assist beam does not fire until you change the Custom Function on the Speedlite. You can change the Speedlite's Custom Functions on the T3/1100D. Custom Functions are detailed in Chapter 4.

To disable flash firing, but use the flash's AF-assist beam to help the camera focus, follow these steps:

1. **On the Shooting 1 camera menu tab, highlight Flash control, and then press the Set button.** The Flash control screen appears.

2. **Press the up or down cross key to highlight Flash firing, and then press the Set button.** Two options appear.

3. **Select Disable, and then press the Set button.** Neither the built-in flash nor an accessory Speedlite will fire.

4. **Press the flash pop-up button, or mount an accessory EX-series Speedlite.**

5. **Half-press the shutter button to fire the flash AF-assist beam to help the camera establish focus.**

In low-light scenes, the flash often illuminates the subject properly, but the background is too dark. You can switch to Av or Tv shooting mode and use a wide aperture or slow shutter speed respectively to allow more of the existing light to contribute to the exposure. With a slow shutter speed, use a tripod and ask the subject to remain still.

Shooting with a Speedlite

A single Speedlite offers many advantages, and one main advantage is that it is more powerful than the built-in flash. Thanks to E-TTL II technology, you can simply attach the Speedlite to the hot shoe and begin shooting good exposures. The camera and Speedlite communicate so that the smaller sensor size and the lens you're using are automatically calculated.

If you're using a Speedlite on the hot shoe or in a wireless setup, you have the option of setting up the Speedlite directly from the T3/1100D. Table 7.4 details the options you can set.

To set up a Speedlite for use on the camera's hot shoe, attach the flash to the hot shoe, turn it on, and then follow these steps:

1. **On the Shooting 1 camera menu tab, highlight Flash control, and then press the Set button.** The Flash control screen appears. Ensure that the Flash firing option is set to Enable on the Flash control screen.

2. **Highlight External flash func. setting, and then press the Set button.** The External flash func. setting screen appears with a scrollable list of functions you can set.

3. **Choose one of the options detailed in Table 7.4.** Just highlight the option, press the Set button, make your choice, and then press the Set button again to confirm your choice.

Table 7.4 External Flash Control Options

Setting	Option(s)	Suboptions/Notes
External flash func. setting	Flash mode	E-TTL II, Manual flash, MULTI flash, and depending on the Speedlite, TTL, AutoExtFlash, and Man.ExtFlash. Note that the settings may depend on Speedlite settings.
	Shutter sync	First curtain: Flash fires immediately after the exposure begins.
		Second curtain: Flash fires just before the exposure ends. Can be used with a slow-sync speed to create light trails behind the subject.
		High-speed: Enables flash at speeds faster than 1/200 second. However, the flash range is shorter.
	FEB	Flash Exposure Bracketing up to +/–3 stops.
	E-TTL II meter.	Evaluative: This is the normal metering mode that takes into account light throughout the scene with a bias toward light reflected back from the subject. For most of your flash images, this is the best option to choose.
		Average: The flash concentrates the metering toward the center area of the viewfinder, giving less bias to the edges of the scene light. Although this is considered an advanced option, it can be useful when the subject is in the center of the scene and the periphery areas are much lighter or darker than the center.
	Zoom	Auto, or press the Set button to activate the control and then press the up or down cross key to set the zoom setting from 24-105mm.
	Wireless func.	Enable or Disable. If you are shooting with the Speedlite on the hot shoe, choose Disable. (Wireless flash is detailed later in this chapter.)
	Flash exp. comp	Flash Exposure Compensation up to +/–2 stops. Press the Set button to activate the Flash Exposure level indicator, and then press the left or right cross key to set +/–2 stops of Flash Exposure Compensation.

Note that if you enable wireless flash, Flash Exposure Compensation is not available, but it is available with wireless flash disabled.

Flash Exposure Bracketing

Much like Auto Exposure Bracketing, Flash Exposure Bracketing (FEB) takes three images, each at different flash exposures — one image at the standard exposure, one with less flash exposure, and one with more flash exposure. This is a great way to

ensure that at least one of the three exposures is pleasing. The exposures are varied by +/–3 stops in 1/3-stop increments. You can set bracketing only for an accessory Speedlite.

To set FEB, mount the Speedlite on the camera's hot shoe, turn it on, and then follow these steps:

1. **With the camera set to P, Tv, Av, A-DEP, or M shooting mode, go to the Shooting 1 menu, select Flash control, and then press the Set button.** The Flash control screen appears.

2. **Highlight External flash func. setting, and then press the Set button.** The External flash func. setting screen appears.

3. **Select FEB, and the press the Set button.** The FEB control is activated.

4. **Press the right cross key to set the amount of bracketing up to 3 stops, and then press the Set button.** As you press the cross key, the tick mark expands to three marks to show the bracketing amount.

5. **In One-shot drive mode, press the shutter button three times to make all three bracketed exposures.** Be sure to allow time for the flash to recycle between exposures.

Setting Speedlite Custom Functions

Being able to control the Speedlite's Custom Functions from the camera is a handy option that enables you to control all the Speedlite settings on the T3/1100D's large, bright LCD. In addition to changing Custom Function settings, you can also clear all the settings directly from the Flash control menu.

Be sure to mount the Speedlite on the camera's hot shoe, and turn it on. Then follow these steps to set the Speedlite's Custom Functions.

1. **With the camera set to P, Tv, Av, A-DEP, or M shooting mode, select the Shooting 1 menu, highlight Flash control, and then press the Set button.** The Flash control screen appears.

2. **Highlight External flash C.Fn. setting, and then press the Set button.** The Custom Function screen for the Speedlite appears.

3. **Press the left or right cross key to move to the Custom Function you want, and then press the Set button.** As you press the cross key, the Custom Function number in the box at the top right of the screen changes. When you press the Set button, the options for the function are activated.

4. **Press the up or down cross key to select the option you want, and then press the Set button.** The number control is activated so you can choose another Custom Function.

 To clear the Speedlite's Custom Functions, choose Clear ext. flash C.Fn set. on the Flash Control menu, and press the Set button. Select OK on the Clear ext. flash C.Fn set. screen, and then press the Set button.

Using One or More Wireless Speedlites

With the introduction of several new and inexpensive Speedlites in the past few years, it's more affordable to have more than one Speedlite. And when you combine multiple Speedlites with multiwireless flash on the T3/1100D, you have new opportunities for creating and controlling light for your images. You can set the External flash function to enable wireless flash, and then set up the Speedlites so that one Speedlite on the camera's hot shoe controls the other Speedlite. Alternatively, you can use a flash cable instead of mounting a Speedlite on the hot shoe and have it control another off-camera Speedlite.

You can also add flash modifiers. Modifiers can be as simple and inexpensive as a Sto-Fen cap that diffuses the flash light on each Speedlite. Alternatively, you can mount one Speedlite on a stand and shoot it into an umbrella. With any of these options, you can position and diffuse the flash light for excellent results.

When you use multiple Speedlites, you can set up lighting ratios to replicate studio lighting. You also have the option of using one or more flash units to supplement existing light for natural-looking illumination. Plus, unlike studio lighting systems, a multiple Speedlite system is lightweight and portable.

If you use wireless flash, here are some terms that you should understand before setting up the flash units:

▶ **Master and Slave.** A master flash controls the firing of Speedlites that are set up as slaves. The master unit can be the built-in flash, or it can be a Speedlite that you set up as a master. The master flash can be used only to fire slave units, or it can also fire and contribute to the overall exposure. Figure 7.6 shows the Speedlite 270EX II that makes a nice slave unit.

7.6 The new Canon Speedlite 270EX II is a very small and handy flash unit that enables bounce flash from four positions ranging from 0 to 90 degrees. Just lift up the top head of the flash to change the bounce position. You can set the flash functions directly from the T3/1100D, and it can be used as a slave unit. This flash is small enough to fit into a shirt pocket.

▶ **Group IDs.** One or more Speedlites that you designate, or group, by name or ID. Flash units that are in a group fire as a single unit. Groups are identified by letter designations such as A, B, and C. You can have one or multiple flash units in a group. You can also vary the output of each group to create different lighting patterns.

▶ **Channel.** A communication channel, much like a frequency. If you're shooting in a place where other photographers are using Speedlites, then you want to set your flashes to a channel different from the channels that other photographers are using to prevent your flashes from firing their flashes. Channels have numeric designations from 1 to 4. Be sure to set the flash unit or units to the same channel so they can communicate with each other.

▶ **Ratios.** A way to express the relative power of one flash to another or one group of flash units to another. A colon represents ratio control between the built-in and Speedlite flash units. Ratios and stops are equivalent. A ratio of 8:1 means that one flash is eight times brighter than another flash. One stop is twice the power of another stop, so the formula is $2 \times 2 \times 2 = 8$, or 3 stops. Thus an 8:1 ratio represents a 3-stop difference. Ratio control such as A:B ratio determines the relative power or brightness between these two flash groups.

TIP You'll find that it is much easier to position one or more flash units if you have flash stands. Flash stands with a bracket for the Speedlite are relatively inexpensive. Alternatively, you can use the slide-on stand that comes with most Speedlites and position the flash on a table so that it illuminates the subject appropriately.

Also, because a good number of EX-series Speedlites work with the T3/1100D, it's not possible to provide instructions for setting individual Speedlites. Just have the manual for your Speedlites handy as you set up your flashes.

Before you begin using any of the following wireless flash options, be sure to

▶ Set one Speedlite as a master and the other unit or units as slaves.

▶ Set the communications channel on the Speedlite(s). If you set Channel 1 on the camera, then set Channel 1 on the Speedlite(s).

▶ Position the flash unit or units with the sensor facing the camera. Always remember that the Speedlite's wireless sensor must have line-of-sight to the camera. You can then rotate the flash head to face the subject.

Basic wireless multiple flash

With the basic wireless setup, you need at least two Speedlites. With this setup, both flash units will fire at the equal intensity, as shown in Figure 7.7. Although this is not typically the approach you'd use for portraits, it can produce pleasing portrait light, and you can also use this approach when you need to light a larger size area with full output from the flash units.

7.7 For this image, I used a Canon 580 EX II Speedlite mounted on the camera's hot shoe as the master flash that wirelessly fired a 580 EX Speedlite that was set up as a slave. I handheld the 580 EX at a 45-degree angle and slightly above the subject, with the wireless sensor on the front of the flash pointed toward the 580 EX II flash. Exposure: ISO 100, f/5.6, 1/20 second.

Before you begin, set up the Speedlite on the camera hot shoe, set it as the master unit. Then set up the off-camera flash as a slave. On some Speedlites, you need to access the flash controls to set up the unit, whereas on the Speedlite 320 EX, the control can be set on the back of the camera. Ensure that both Speedlites are set to the same channel, such as Channel 1.

1. **On the Shooting 1 camera menu tab, highlight Flash control, and then press the Set button.** The Flash control screen appears. Double-check that Flash firing is set to enable.

2. **Highlight External flash func. setting, and then press the Set button.** The External flash func. setting screen appears.

3. **Set each of the following options, and then press the Set button after you set each option.** To scroll through to all of the options, press the down cross key.

 • **Flash mode:** Set to E-TTL II.

 • **Shutter sync:** Set to 1st curtain.

 • **E-TTL II meter.:** Set to Evaluative.

 • **Wireless setting:** Set to Enable.

 • **Master flash:** Set to Enable.

 • **Firing group:** Set to All.

 You can set FEC if you want, and whatever you set on the master Speedlite will be transmitted to the slave Speedlite as well.

4. **With both Speedlites turned on and positioned within their flash range, make a test shot.** If the image is too bright or too dark, you can set FEC to adjust the output of both flash units. Just be sure to go to the External flash func. setting menu to set compensation. Take another test shot until you get the exposure that you want.

7.8 For this picture of a miniature Schnauzer, I used the basic two-Speedlite setup described in this section. I opted to use 2/3-stop of Exposure Compensation to brighten the dog's dark face. I converted the image to black-and-white using Nik Software Silver Efex Pro, a Photoshop plug-in program. Exposure: ISO 100, f/5.6, 1/8 second, +2/3-stop of Exposure Compensation.

While this technique fires both Speedlites at the same output, you can also choose to not have the master flash fire, using it only as a wireless transmitter to fire the slave Speedlite. With this approach, you have the advantage of using an off-camera Speedlite, which not only provides much nicer lighting, but also reduces the incidence of red-eye. Alternatively, you can add a third Speedlite setup as a slave to get a two-light setup, while still using the on-camera Speedlite as a wireless transmitter to control the two slave flash units.

As you continue exploring flash photography, you can refer to the manual for your Speedlite units. The Speedlite manuals detail more complex setups that enable you to set flash ratios so that each Speedlite, or group of Speedlites, contributes different amounts of light to the exposures.

Exploring flash techniques

Although it is beyond the scope of this book to detail all the lighting options that you can use with one or multiple Speedlites, I cover some common flash techniques that provide better flash images than using straight-on flash.

Using bounce flash

One frequently used flash technique is *bounce flash*, which softens hard flash shadows by diffusing the light from the flash. To bounce the light, turn the flash head to point toward the ceiling or a nearby wall, so that the light hits the ceiling or wall and then bounces back to the subject. This technique spreads and softens the flash illumination, as shown in the comparison of Figures 7.9 and 7.10.

If the ceiling is high, it may underexpose the image. As an alternative, I often hold a silver or white reflector above the flash to act as a ceiling. This technique offers the advantage of providing a clean light with no colorcast. A few tips will help you get the best bounce-flash results:

▶ Bounce the flash off a neutral and light color surface to reduce light loss and avoid throwing the color of the wall onto the subject.

▶ Bounce the flash off the ceiling rather from directly above the subject to avoid casting shadows on the subject's face. Better yet, bounce the flash off a side wall to create shadow patterns that add depth, or *modeling*, to the subject.

▶ Bounce the flash as far as possible. The farther the bounce distance, the softer the light (at the same flash level). However, ensure that the distance isn't so far that the flash becomes ineffective.

7.9 This image was made with the 580EX II Speedlite mounted on the hot shoe with no modification to the flash. Although the lighting is acceptable, the light on the face is a little brighter than I wanted. Exposure: ISO 100, f/5.6, 1/20 second.

7.10 This image softens the light on the face. I bounced the light from the 580EX II off a nearby wall. The bounce was just enough to take off the bright-light edge of the straight-on flash in Figure 7.9. Exposure: ISO 100, f/5.6, 1/20 second.

Adding catchlights to the eyes

Another frequently used technique is to create a catchlight in the subject's eyes by using the white panel that is tucked into the flash head of some Speedlites. Just pull out the translucent flash panel on the Speedlite. A white panel, which you can use to create catchlights, comes out simultaneously. The translucent panel is called the *wide* panel and you use it with wide-angle lenses to spread the light. Push the translucent panel back in while leaving the white panel out. Point the flash head up, and then take the image. The white panel throws light into the eyes, creating catchlights that add a sense of vitality to the eyes. For best results be within 5 feet of the subject.

 If your Speedlite doesn't have a white panel, you can tape an index card to the top of the flash to create catchlights.

Flash Tips

Here are a few pointers that will help you get better flash images:

▶ **Be sure to allow time between images for the flash to recharge.** For the built-in flash, allow approximately 2 seconds, or just wait until the timer display in the viewfinder is fully gone before you shoot. If you are using a Speedlite, check the manual for the recharge time. As the flash heats up or becomes over-heated, the recycle time is extended.

▶ **Reduce red-eye by using a Speedlite instead of the built-in flash, and, even better, using the Speedlite off the hot shoe.** You can use a flash bracket to get the Speedlite off the camera or use a flash sync cord and handhold the flash unit. Using a Speedlite also avoids the unattractive pinpoint-size catchlights produced by the built-in flash.

▶ **Monitor the shutter speed when you're using flash in Av shooting mode.** The shutter speed can be very slow since the camera bases the exposure on the existing light in the scene and uses the flash to add fill light on the subject. In other words, the camera assumes that the existing light in the scene is the primary light. And if that light is low, the shutter speed will be slow. Be sure to use a tripod, or switch to P shooting mode, which sets the shutter speed between 1/200 and 1/60 second. In low existing light, the faster shutter speed will cause the background to go dark, but the shutter speed will be fast enough in general to handhold the camera.

▶ **Use flash diffusion accessories.** Diffusers such as a Stofen cap, soft screen, or softbox reduce the amount of light from the flash, but as long as you're using E-TTL metering, the camera automatically adjusts the exposure.

▶ **Avoid dark background flash shadows by moving the subject far from the background or to an area without a background, such as outdoors.** Alternatively, use a dark background or add extra light to a light color background.

Exploring Lenses and Accessories

Together with the T3/1100D, your lens broadens your ability to express your creative vision. As you continue with photography, you'll doubtless add more lenses to your camera bag; and with careful selection, you can add lenses that enable you to photograph everything from portraits and sports to wildlife and landscapes.

Most photographers know that "the camera is only as good as the lens," and this is no less true for the T3/1100D. However, as you may have already discovered, lenses are an investment. For most photographers, buying lenses is a gradual process. Over time, the investment in lenses far exceeds the investment in the camera body. However, your investment in lenses will pay excellent dividends in image quality for years to come.

For this picture of a calla lily, I wanted crisp contrast and extensive depth of field that kept the flower and portions of the leaves in sharp focus. I used a narrow f/16 aperture on the Canon EF 100mm f/2.8L IS Macro USM lens. Exposure: ISO 100, f/16, 1/125 second.

Evaluating Lens Choices for the T3/1100D

Canon offers more than 60 Canon EF and EF-S lenses that are compatible with the T3/1100D, and new lenses continue to be introduced periodically. Combine that with a variety of lens accessories, as well as third-party lenses, and you have a wide range of choices for expanding your photography options. In fact, the number of lens options can be confusing as you think about adding lenses to your gear bag. A common question is, "What lens should I buy next?" While no one can tell you which lens is best for your work, this chapter helps you develop a strategy for adding lenses that serve you well.

Building a lens system

By now, you have at least one lens, and you may want to add one or two lenses to your gear bag. A few basic strategies can help you create a solid plan for adding new lenses to your system. A practical approach is to have two lenses that cover the range from wide-angle to telephoto of 14mm or 18mm to 200mm or 300mm. These two lenses are the foundation for your lens system. And with them, you can shoot 80 to 95 percent of the scenes and subjects that you encounter, ranging from landscapes with the wide-angle zoom lens to portraits and wildlife with the telephoto zoom lens.

Because you'll use these lenses often, they should be high-quality lenses that produce images with pleasing contrast and excellent sharpness, and ideally they should be fast enough to allow you to shoot in low-light scenes. A *fast lens* is generally considered to be a lens with a maximum aperture of f/3.5, f/2.8, or faster. With a fast lens, you have a better chance of handholding the camera in low light and getting sharp images. And if the lens has Image Stabilization, a lens feature detailed later in this chapter, you gain more stability.

When I bought my first lenses, I followed the approach of buying two lenses that cover a wide focal range. Because I shoot professionally, I chose to buy L-series lenses. My first two Canon lenses were the EF 24-70mm f/2.8L USM lens and the EF 70-200mm f/2.8L IS USM lens — two excellent lenses that cover the focal range of 24-200mm (38mm to 320mm on the T3/1100D). Although these are professional quality lenses, Canon offers a variety of less expensive lenses in the same ranges. For example, you can consider the EF-S 10-22mm f/3.4-4.5 USM lens and the EF 70-300mm f/4.5-5.6 IS USM lens. Today these two lenses are still the ones I use most often. And because I shoot with a variety of Canon EOS cameras, I know that I can use these lenses on the T3/1100D, the 60D, the 5D Mark II, or the 1Ds Mark III and get beautiful images.

If you bought the T3/1100D as a kit with the EF-S 18-55mm f/3.5-5.6 IS II lens, then you may already know that this lens lacks a telephoto capability to bring distant

subjects closer. Also, because this lens doesn't have the USM designation for the ultrasonic motor drive, it is a bit noisy during focusing, but it's a capable lens. Your next step might be to add a telephoto lens to your gear bag.

8.1 The reach of the EF 70-200mm lens set to 200mm combined with the focal length multiplication factor worked to my advantage in bringing the distant horses closer in this rural Washington state scene. With the multiplier, the focal length was equivalent to 320mm. Exposure: ISO 200, f/9, 1/320 second using –1/3-stop of Exposure Compensation.

Understanding how the T3/1100D sensor size relates to lenses

The T3/1100D sensor is smaller in size than a full-frame 35mm size sensor, and the smaller sensor changes the *effective focal length* (the amount of the scene that the lens sees and includes in the frame) of lenses. I say the "effective" focal length because the lens's focal length does not change, but only how much of the scene it "sees" compared to how much of the scene it would "see" with a larger image sensor. The T3/1100D has an APS-C-size image sensor. APS-C is simply a designation that indicates that the image sensor is 1.6 times smaller than a traditional full 35mm frame. As a result, the lenses you use on the T3/1100D have a smaller angle of view, meaning that they don't "see," or include, as much of the scene from side to side and top to bottom as they would on a full-frame camera, as shown in Figure 8.2.

8.2 This image shows the approximate difference in image size between a full-frame 35mm camera and the T3/1100D. The smaller image size represents the T3/1100D's image size.

You may wonder why I mention a 35mm full-frame size. The photography industry has a long history of using a 35mm film frame size as the standard for single lens reflex (SLR) cameras. While cameras are primarily digital now, camera and lens manufacturers still use the 35mm frame size as the standard for manufacturing many lenses, as well as for some image sensors. In short, the 35mm frame size remains a standard of comparison for many aspects of digital photography.

The smaller APS-C sensor size has a reduced angle of view that is sometimes called the *focal-length multiplication factor* and other times referred to as a *crop factor*. On the T3/1100D, the multiplication factor is 1.6. You can use that factor to figure out how a lens that is designed for a full-frame camera will perform on the T3/1100D. For example, if you buy the EF 100mm f/2.8L IS Macro USM lens, you multiply 100mm by 1.6 to get its effective focal length on the Rebel, in this case, 160mm. Of course, the lens's focal length doesn't actually change; only the effective focal length changes when the lens is used with a smaller sensor.

Also in everyday conversation, most photographers refer to the lens's actual focal length rather than to its effective focal length. If someone asks me what lens I used for a picture, I say that I used a 50mm lens rather than saying an 80mm. I do that

because lenses have characteristics that set them apart from other lenses regardless of the camera sensor size they are used on, and many photographers know the specific characteristics of different lenses, and that's what they are interested in when they ask the question. At other times, I qualify the statement by including the name of the camera with the name of the lens so they know the effective focal length.

The focal-length multiplication factor works to your advantage when you're using a telephoto lens because it gives you more reach — it brings distant subjects closer. As an example, the 70-200mm lens on the Rebel is effectively a 112-320mm lens. And because telephoto lenses tend to be more expensive than other lenses, it means you can buy a shorter and less expensive telephoto lens and get 1.6X more magnification at no extra cost.

The focal-length multiplication factor works to your disadvantage with a wide-angle lens; the sensor sees less of the scene because the effective focal length is magnified by 1.6. However, because wide-angle lenses tend to be less expensive than telephoto lenses, you can buy an ultrawide 14mm lens to get the equivalent of an angle of view of 22mm.

As you learn later in this chapter, lenses have characteristics that you can use creatively in your photography. One of the characteristics is how different lenses render the depth of field. In short, a telephoto lens produces a shallow depth of field (more blur in the background details), and the longer the telephoto lens, the shallower the depth of field. Wide-angle lenses produce more extensive depth of field (sharper background details). As you think about the focal-length multiplier effect on telephoto lenses, it seems reasonable to assume that the focal length multiplier would produce the same depth of field that a longer lens — the equivalent focal length — does. That isn't the case, however. Although an 85mm lens on a full 35mm-frame camera is equivalent to a 136mm lens on the T3/1100D, the depth of field on the T3/1100D matches the 85mm lens, not a 136mm lens. This depth of field principle also holds true for enlargements. The depth of field in the print is shallower for the longer lens on a full-frame camera than it is for the T3/1100D.

Another important lens distinction for the T3/1100D is that you can use both EF-mount and EF-S-mount lenses. The EF lens mount is compatible across all Canon EOS cameras regardless of image sensor size, and regardless of camera type, whether digital or film. However, the EF-S lens mount is specially designed to have a smaller image circle: the area covered by the image on the sensor plane. EF-S lenses can be used only on cameras with cropped frames, such as the T3/1100D, 60D, and 7D among others, because the rear element on EF-S lenses protrudes back into the camera body. EF-S lenses have the additional advantage of being lighter and smaller than their EF lens counterparts.

As you buy lenses, think about whether you want lenses that are compatible with both a full-frame and a cropped sensor camera. As your photography progresses, you'll most likely buy a second, backup camera body or move from the T3/1100D to another EOS camera body. If your next EOS camera body has a full 35mm frame sensor, you'll want the lenses you've already acquired to be compatible with it, which means you should consider buying the EF-mount lenses.

Zoom Versus Prime Lenses

My photography students often ask me which lens they should buy next. It is virtually impossible to answer that question for someone else. If that's your question too, then the best thing to do is to think about the scenes and subjects you photograph most often or the ones you want to begin photographing, your budget, and your goals for expanding your photography.

Also it is important to be familiar with the different characteristics of lenses so that you know what to expect from them creatively. The following sections provide a foundation for evaluating lenses by category and by characteristics.

Lenses are categorized in many ways, and one basic categorization is *zoom* and *prime*. The primary difference is that a zoom lens offers a range of focal lengths in a single lens. For example, the 24-105mm lens goes from a wide-angle 24mm focal length to a short telephoto 105mm focal length. By contrast, a prime lens has a fixed, or single, focal length. An example of a prime lens is the EF-S 60mm f/2.8 Macro lens. Most photographers use both zoom and prime lenses. Within these two categories, lenses are further grouped by focal length (the amount of the scene included in the frame) in three main types: wide-angle, normal, and telephoto. And macro lenses are a subcategory. Macro lenses serve double-duty as macro and either normal or telephoto lenses.

Zoom lenses

Zoom lenses provide variable focal lengths so that you can zoom in to bring the subject closer or zoom out to move the subject farther away. This makes zoom lenses very versatile in a variety of scenes. Consequently, two zoom lenses — such as the Canon EF 17-40mm f/4L USM lens and the Canon EF 70-300mm f/4.5-5.6 IS USM lens — give you the focal range to shoot everything from portraits to sports. On the T3/1100D, this combination of lenses provides the equivalent of approximately 27mm to 480mm.

Zoom lenses, available in wide-angle and telephoto ranges, are able to maintain focus during zooming. To keep the lens size compact and to compensate for aberrations with fewer lens elements, most zoom lenses use a multigroup zoom with three or more movable lens groups.

8.3 Wide-angle zoom lenses such as the Canon EF 16-35mm f/2.8L USM (on the left) and EF 24-70mm f/2.8L USM (on the right) help bridge the focal-length multiplier gap by providing a wide view of the scene.

Most midpriced and more expensive zoom lenses offer high-quality optics that produce sharp images with excellent contrast. Many Canon lenses offer full-time manual focusing. These lenses have a button on the side of the lens that can be set to MF (Manual Focusing).

Some zoom lenses are slower than prime lenses, and getting a fast zoom lens — with a maximum aperture of f/2.8 or faster — means paying a higher price. Although using zoom lenses allows you to carry around fewer lenses, they tend to be heavier than prime lenses.

> **NOTE** Maximum aperture refers to the widest aperture of the lens. For the 70-200mm f/4L IS USM lens, the maximum, or widest aperture, is represented by the f/4 designation. Maximum aperture is also often referred to as the lens *speed*.

Some zoom lenses have a variable aperture, which means that the maximum aperture changes at different zoom settings on the lens. For example, an f/4.5 to f/5.6 variable-aperture lens means that at the widest focal length, the maximum aperture is f/4.5

and at the longer end of the focal range, the maximum aperture is f/5.6. In practical terms, this limits the versatility of the lens at the longest focal length for shooting in all but bright light or at a high ISO setting. And unless you use a tripod and your subject is stone still, your ability to get a crisp picture in lower light at f/5.6 is questionable.

More expensive zoom lenses offer a fixed and fast, or relatively fast, maximum aperture; with maximum apertures of f/2.8, you get faster shutter speeds, enhancing your ability to get sharp images when handholding the camera. But the lens speed comes at a price: the faster the lens, the higher the price.

Prime lenses

Prime lenses are worth careful evaluation, and they make a great addition to your lens system. With a prime lens, the focal length is fixed, so you must move closer to or farther from your subject to change image composition. Canon's venerable EF 50mm f/1.4 USM and EF 100mm f/2.8L IS Macro USM lenses are only two in the Canon lineup of prime lenses. The prices for prime lenses range from highly affordable to very expensive.

8.4 Prime lenses such as the EF 50mm f/1.2L USM (on the left) and the EF 50mm f/1.4 USM (on the right) provide excellent sharpness, contrast, and resolution when used on the T3/1100D.

Unlike zoom lenses, prime lenses tend to be fast, with maximum apertures of f/2.8 or wider. The fast maximum apertures allow fast shutter speeds, which enables you to handhold the camera in lower light and still get a sharp image. Many prime lenses are

lighter and smaller than zoom lenses, and many photographers believe that some prime lenses are sharper than some zoom lenses.

Though most prime lenses are lightweight, you need to carry more of them to cover the range of focal lengths. It's also harder to make quick composition changes by zooming in or out with prime lenses.

I am a fan of prime lenses, and I use prime lenses as often as zoom lenses. My prime lenses include the EF 50mm f/1.2L USM, EF 100mm f/2.8L Macro IS USM, 85mm F/1.2L II, and 180mm f/3.5L Macro USM.

The 50mm and 85mm lenses are especially useful in low-light venues, such as music concerts, where I can't get fast enough shutter speeds using slower zoom lenses. And the 85mm is an ideal portrait lens. On the T3/1100D, the 50mm lens is equivalent to 80mm, and the 85mm lens is equivalent to 136mm.

Working with Different Types of Lenses

Within the zoom and prime lens categories, lenses are grouped by their focal lengths. Although some lenses fall into more than one group, the groupings are still useful when talking about lenses in general. Before going into specific lenses, it is helpful to understand a couple of concepts.

First, the lens's *angle of view* is expressed as the angle of the range that's being photographed, and it's generally shown as the diagonal angle of view. The image sensor is rectangular, but the image captured by the lens is circular, and it's called the *image circle*. The image that's captured is taken from the center of the image circle.

For a 15mm fisheye lens, the angle of view is 180 degrees on a full-frame 35mm camera; for a 50mm lens, it's 46 degrees; and for a 200mm lens, it's 12 degrees. Simply stated, the shorter the focal length, the wider the scene coverage, and the longer the focal length, the narrower the coverage. These focal length equivalents change for EF-mount lenses used on a cropped-sensor camera such as the T3/1100D. Therefore, when I refer to an EF lens's focal length, the 1.6X multiplier must be applied to get the focal length equivalent for the T3/1100D.

Second, the lens you choose affects the perspective of images. *Perspective* is the visual effect that determines how close or far the background appears to be from the main subject. The shorter (wider) the lens, the more distant background elements appear to be, and the longer (more telephoto) the lens, the closer, or more compressed the elements appear.

What's the Difference Between EF and EF-S Lenses?

The designations EF and EF-S identify the type of mount that the lens has and which cameras can use that lens. EF stands for *electro focus*, a mount that uses its contacts to provide power to the lens and to provide communication between the lens and the camera body. EF-S, or *short back-focus*, lenses were introduced with the advent of the smaller image sensors in cameras such as the Rebel. Because these lenses extend farther back into the camera, they can be used only on cropped sensor cameras, and not with full-frame sensors such as are found on the EOS 5D Mark II and the 1Ds III cameras. EF-S lenses are designed for the smaller angle of view of cropped sensor cameras. With the introduction of the EF-S lenses, Canon addressed the need to provide truly wide-angle coverage for cropped-sensor cameras. The EF-S 10-22mm f/3.5-4.5 is the lens that provides wide-angle coverage for APS-C-size sensors.

Wide-angle lenses

Wide-angle lenses do what the name implies — they offer a wide view of a scene. Sometimes, the view is beyond human perspective, and depending on the focal length, this strong perspective creates a separation between the subject and the background or objects in a landscape scene. In addition, wide-angle lenses provide a greater sense of depth than normal or telephoto lenses provide.

Generally, lenses shorter than 50mm are commonly considered wide-angle on full-frame 35mm image sensors. However, on the T3/1100D, a normal lens is closer to 30-35mm. And when you use wide-angle lenses, the 1.6X focal-length multiplier works to your disadvantage. To get a truly wide-angle view on the T3/1100D, the lens must be shorter than 30-35mm. A good option for the T3/1100D is the EF-S 10-22mm f/3.5-4.5 USM lens. If you are considering an EF lens, then the wide-angle range begins at 14mm, equivalent to 22mm on the T3/1100D. The wide-angle lens category provides angles of view ranging from 114 to 63 degrees. (Fisheye lens such as the EF 8-15mm f/4L Fisheye USM are included in the wide-angle lens category, and they offer a 180-degree diagonal angle of view.)

Wide-angle lenses are ideal for capturing scenes ranging from sweeping landscapes and architecture to large groups of people, and for taking pictures in places where space is cramped.

Here are wide-angle lens characteristics to keep in mind:

▶ **Extensive depth of field.** Particularly at small apertures from f/11 to f/32, the entire scene, front to back, appears in acceptably sharp focus. This characteristic gives you slightly more latitude for less-than-perfectly focused pictures.

 The lens's aperture range is one factor that affects the depth of field. The depth of field is also affected by the focal length and the camera-to-subject distance.

▶ **Fast apertures.** Wide-angle lenses tend to be faster (meaning they have wider maximum apertures) than telephoto lenses. For example, the EF 24mm and 35mm lenses sport a very fast f/1.4 aperture whereas the more economical EF 35mm offers a fast f/2 maximum aperture. As a result, wide-angle lenses are good choices for shooting when the lighting conditions are not optimal.

▶ **Distortion.** Wide-angle lenses can create perspective distortion, especially if you tilt the camera up or down when shooting. For example, if you tilt the camera up to photograph a group of skyscrapers, the lines of the buildings tend to converge and the buildings appear to fall backward (also called *keystoning*), as shown in Figure 8.5. You can minimize the distortion by keeping the camera level and parallel to the main subject. The wider the focal length, the more pronounced the distortion. For architectural subjects, a 28mm lens offers low distortion along with an ample focal range, and on a cropped sensor camera, that translates to an 18mm lens in the EF lens line.

▶ **Perspective.** Wide-angle lenses have a *foreshortening effect* that makes objects close to the camera appear disproportionately large, while subjects farther away quickly decrease in size. The wider the lens, the stronger the foreshortening effect. You can use this characteristic to move the closest object farther forward in the image, or you can move back from the closest object to reduce the effect. Wide-angle lenses are popular for portraits, but if you use a wide-angle lens for close-up portraiture, keep in mind that the lens exaggerates the size of facial features closest to the lens, which is unflattering.

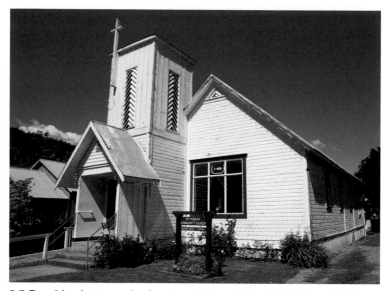

8.5 For this photograph of a church, I used the EF 24-70mm f/2.8L USM lens at 24mm. This image shows wide-angle distortion where the lines of the church converge inward. Exposure: ISO 100, f/8, 1/500 second.

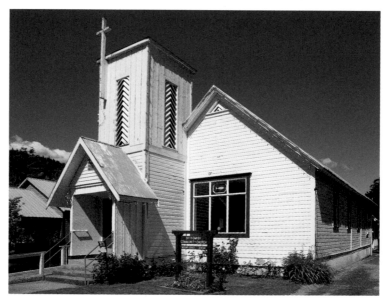

8.6 This is the same image with the keystoning effect corrected during image editing.

Telephoto lenses

When you need to make a portrait or bring a distant scene closer, reach for a good telephoto lens. Telephoto lenses offer a narrow angle of view, as well as a compressed perspective that brings the subject and background closer together while at the same time isolating the subject and bringing it visually forward in the image. Short telephoto lenses such as the EF 85mm lenses (136mm on the T3/1100D) are ideal for portraits while telephoto lenses, including the EF 300mm (480mm on the T3/1100D) and 400mm (640mm on the T3/1100D), are the ticket for wildlife and sports shooting. When photographing wildlife, these lenses also enable you to keep a safe distance.

On the T3/1100D, however, the focal-length multiplier works to your advantage with telephoto lenses. Factoring in the 1.6X multiplier, a 200mm lens is equivalent to 320mm, a telephoto length that is great for shooting everything from wildlife to sports. And because telephoto lenses are more expensive overall than wide-angle lenses, you get more focal length for your money when you buy telephoto lenses for the T3/1100D.

Telephoto lenses offer an inherently shallow depth of field that is heightened when you shoot at wide apertures. When you shoot with a telephoto lens, keep these lens characteristics in mind:

▶ **Shallow depth of field.** Telephoto lenses provide a limited range of sharp focus, and as the focal length increases, everything in front of and behind the focal area is thrown out of focus, even at narrow apertures. At wide apertures, you can reduce the background to a soft blur, and the longer the lens, the greater the blur. Because of the extremely shallow depth of field, it's important to get tack-sharp focus. Many Canon lenses include full-time manual focusing that you can use to fine-tune the camera's autofocus. Canon also offers an extensive lineup of Image Stabilized (IS) telephoto lenses.

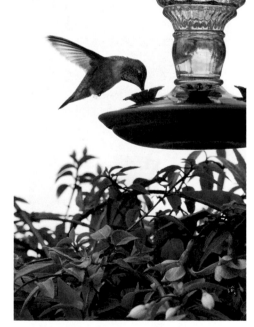

8.7 The focal length magnification factor combined with the EF 70-200mm f/2.8L IS USM lens set to 175mm allowed me to capture this hummingbird at the feeder. Exposure: ISO 200, f/5.6, 1/1250 second.

▶ **Narrow coverage of a scene.** Because the angle of view is narrow with a telephoto lens, much less of the scene is included in the image. You can use this characteristic to exclude distracting scene elements from the image.

▶ **Slow speed.** Midpriced telephoto lenses tend to be slow; the widest aperture is often f/4.5 or f/5.6, which limits your ability to get sharp images without a tripod in all but the brightest light unless they also feature IS. And because of magnification, even the slightest movement is exaggerated.

▶ **Perspective.** Telephoto lenses compress perspective, making objects in the scene appear close together. At 300mm, the compression effect goes beyond what humans naturally see. Extreme telephoto focal lengths put the subject and background next to each other, which creates visual tension in images.

Normal lenses

Normal lenses offer an angle of view and perspective that is similar to how you see the scene. Because of the normal perspective, if you are using wide apertures, you must do more in terms of balancing the subject distance, perspective, and background blur. Using your shooting position skillfully with a narrow aperture, you can make a normal lens produce images with the same impact as a wide-angle lens would. Likewise, using a wide aperture to soften the background can produce images that mimic those shot using a medium telephoto lens.

On full 35mm-frame cameras, 50-55mm lenses are considered normal lenses. However, on the T3/1100D, a normal lens is 28-35mm when you take into account the focal-length multiplier. When you shoot with a normal focal length, keep these lens characteristics in mind:

▶ **Natural angle of view.** On the T3/1100D, a 28mm or 35mm lens closely replicates the sense of distance and perspective of the human eye. This means the final image will look much as you remember seeing it when you made the picture.

▶ **Little distortion.** Given the natural angle of view, the 28-35mm lens retains a normal sense of distance, especially when you balance the subject distance, perspective, and aperture.

Charlotte's Favorite Lenses

My general approach to adding lenses to my system is to buy the highest-quality lens available in the focal length that I need. If I can't afford the highest-quality lens, then I wait and save money until I can buy it. For example, my last lens purchase was an EF 50 f/1.2L USM lens, and it took me a long time to save enough money to buy it.

But for inquiring minds, the workhorse lenses in my gear bag are the first two Canon lenses I bought, the EF 70-200mm f/2.8L IS USM and the EF 24-70mm f/2.8L USM lens. Both lenses have outstanding optics and provide superb sharpness and excellent resolution and contrast on any EOS camera body. I also frequently use the EF 100mm f/2.8L IS II Macro USM lens, the EF 85mm f/1.2L II USM, and the EF 100-400 f/4.5-5.6L IS USM.

Macro lenses

Macro lenses are designed to provide a closer lens-to-subject focusing distance than nonmacro lenses, which enables you to shoot extreme close-ups of all or part of a subject. Depending on the lens, the magnification ranges from half life-size (0.5X) to 5X magnification. Thus, objects as small as a penny or a postage stamp can fill the frame, and nature macro shots can reveal breathtaking details that are commonly overlooked. Using extension tubes can further reduce the closest focusing distance.

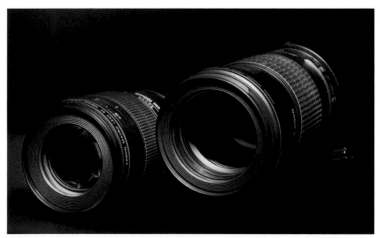

8.8 Canon offers several macro lenses, including the new Canon EF 100mm f/2.8L IS Macro USM lens (left) and the EF 180mm f/3.5L Macro USM lens (right), both of which offer 1X (life-size) magnification.

8.9 I used the EF 100mm f/2.8L IS Macro II USM lens with an extension tube to photograph this water droplet on a daisy petal. Exposure: ISO 100, f/2.8, 1/2 second with +2/3 stop of Exposure Compensation.

Some normal and telephoto lenses offer macro capability. Because these lenses can be used both at their normal focal length as well as for macro photography, they do double-duty, focusing from close-up to infinity. And with focal lengths that range from 60-180mm (96-288mm on the T3/1100D), macro lenses make good portrait lenses as well.

You can buy a macro lens based on focal length or magnification. One of the lenses I use most often is the EF 100mm f/2.8L IS Macro USM lens (equivalent to 160mm on the T3/1100D), and I use it for both macro work and for portraits.

Tilt-and-shift lenses

Tilt-and-shift lenses, referred to as *TS-E lenses*, enable you to alter the angle of the plane of focus between the lens and sensor plane to provide a broad depth of field, even at wide apertures, and to correct or alter perspective at almost any angle. This enables you to correct perspective distortion and control focusing range.

Using tilt movements, you can bring an entire scene into focus, even at maximum apertures. By tilting the lens barrel, you can adjust the lens so that the plane of focus is uniform on the focal plane, thus changing the normally perpendicular relationship between the lens's optical axis and the camera's focal plane. Alternatively, reversing the tilt has the opposite effect: It greatly reduces the range of focusing.

Shift movements avoid the trapezoidal effect that results from using wide-angle lenses pointed up; for example, when you take a picture of a building. Keeping the

camera so that the focal plane is parallel to the surface of a wall and then shifting the TS-E lens to raise the lens results in an image where the perpendicular lines of the structure are rendered perpendicular and the structure is rendered as a rectangle.

TS-E lenses have a range of plus/minus 90 degrees, making horizontal shift possible, which is useful when you are shooting a series of panoramic images. You can also use shifting to prevent reflections of the camera or yourself from appearing in images that include reflective surfaces, such as windows, car surfaces, and other similar surfaces.

All of Canon's TS-E lenses are Manual Focus only. These lenses, depending on the focal length, are excellent for architectural, interior, merchandise, nature, and food photography.

Image Stabilized (IS) lenses

Most photographers can use a bit of added steadiness when shooting. And in the Canon line of cameras, that steadiness comes in the form of Image Stabilized (IS) lenses. Image Stabilization counter-acts some or all of the motion that results in image blur from handholding the camera and lens.

Although additional stability is nice and sometimes essential, it comes at a premium price. IS lenses are pricey compared with their nonstabilized counterparts because they give you from 1 to 4 f-stops of additional stability over non-Image Stabilized lenses — and that means that you may be able to leave the monopod or tripod at home.

With an IS lens, miniature sensors and a high-speed microcomputer built into the lens analyze vibrations and apply correction via a stabilizing lens group that shifts the image parallel to the focal plane to cancel camera shake. The lens detects camera motion via two gyro sensors to detect the angle and speed of shake. Then the lens

8.10 Image Stabilization was essential for this image of a sunset sky over Mt. Rainer. I was handholding the EF 70-200mm f/2.8L IS USM set to 195mm at a slow 1/40 second shutter speed. The ISO is set at 100 and I used +2/3 stop of Exposure Compensation.

shifts the IS lens group to suit the degree of shake to steady the light rays reaching the focal plane.

Stabilization is particularly important with long lenses, where the effect of shake increases as the focal length increases. As a result, the correction needed to cancel camera shake increases proportionately.

To see how the increased stability pays off, consider that the rule of thumb for hand-holding the camera and a non-IS lens is the reciprocal of the focal length, expressed as 1/[focal length]. For example, the slowest shutter speed at which you can handhold a 200mm lens and avoid motion blur is 1/200 second. If the handholding limit is pushed, then shake from handholding the camera bends light rays coming from the subject into the lens relative to the optical axis, which results in a blurry image.

Thus, if you're shooting in low light at a music concert or a school play, the chances of getting sharp images at 200mm are low because the light is too low to allow a 1/200 second shutter speed, even at the maximum aperture of the lens. You can, of course, increase the ISO sensitivity setting and risk introducing digital noise into the images. But if you're using an IS lens, the extra stops of stability help you keep the ISO low to get better image quality, and you still have a good chance of getting sharp images by handholding the camera and lens.

But what about when you want to pan or move the camera with the motion of a subject? Predictably, IS detects panning as camera shake and the stabilization then interferes with framing the subject. To correct this, Canon offers two modes on IS lenses. Mode 1 is designed for stationary subjects. Mode 2 shuts off Image Stabilization in the direction of movement when the lens detects large movements for a preset amount of time. So when you are panning horizontally, horizontal IS stops but vertical IS continues to correct any vertical shake during the panning movement.

Correcting Lens Vignetting

Depending on the lens that you use on the T3/1100D, you may notice a bit of *light falloff* and darkening in the four corners of the frame. Light falloff describes the effect of less light reaching the corners of the frame as compared with the center of the frame. The darkening effect at the frame corners is known as *vignetting*. Vignetting is most likely to be evident in images when you shoot with wide-angle lenses, when you shoot at a lens's maximum aperture, or when an obstruction such as the lens barrel rim or a filter reduces light reaching the frame corners. On the T3/1100D, you can correct vignetting for JPEG images as you shoot. If you shoot RAW images, you can

correct vignetting in Canon's Digital Photo Professional program during RAW image conversion. Other programs such as Adobe Photoshop, Lightroom, and Camera Raw, and Apple's Aperture also offer lens correction capabilities.

8.11 The 70-200mm f/2.8L IS USM (left) and the EF 100-400mm f/4.5-5.6L IS USM (right) lenses offer Image Stabilization in two modes: one for stationary subjects and one for panning with subjects horizontally.

When you turn on Peripheral Illumination Correction, the camera detects the lens, and it applies the appropriate correction level if the lens is already registered in the camera. If the lens isn't already registered, then no correction is applied. The T3/1100D can detect 25 lenses, but you can add information for other lenses by using the EOS Utility software supplied on the EOS Solution Disk.

 In the strictest sense, vignetting is considered to be an unwanted effect in images. However, vignetting is also a creative effect that photographers sometimes intentionally add to an image during editing to guide the viewer's eye inward toward the subject.

You can test your lenses for vignetting by photographing an evenly lit white subject such as a white paper background or wall at the lens's maximum aperture as well as at a moderate aperture such as f/8, and then examine the images for dark corners. Then you can enable Peripheral Illumination Correction on the camera and shoot the images again to see how much difference it makes.

If you use Peripheral Illumination Correction for JPEG images, the amount of correction applied is just shy of the maximum amount. However, if you shoot RAW images, you can apply the maximum correction in Digital Photo Professional. Also, the amount of correction for JPEG images decreases as the ISO setting increases. If the lens has little vignetting, the difference when using Peripheral Illumination Correction may be difficult to detect. If the lens does not communicate distance information to the camera, then less correction is applied. Canon recommends that you turn off Peripheral Illumination Correction if you use a non-Canon lens.

Here's how to turn on Peripheral Illumination Correction:

1. **Set the camera to the JPEG image quality setting that you want.**

2. **On the Shooting 1 menu, highlight Peripheral illumin. correct., and then press the Set button.** The Peripheral illumin. correct. screen appears with the attached lens listed, along with text saying whether correction data is available. If correction data is unavailable, then you can exit this screen and use the Canon EOS Utility program to register the lens.

3. **Press the down cross key to select Enable if it is not already selected, and then press the Set button.**

Doing More with Lens Accessories

Even with the lenses you currently own, you can increase the focal range on some lenses while decreasing the focusing distance to add creative flexibility. Lens accessories are also relatively economical. Accessories can be as simple as a lens hood to avoid flare, a tripod mount to quickly change between vertical and horizontal positions without changing the optical axis or the geometrical center of the lens, or a drop-in or adapter-type gelatin filter holder. You can use extenders on some telephoto lenses to increase the focal range. And you can add one or more extension tubes to the lens for close focusing.

Lens extenders

For relatively little cost, you can increase the focal length of any lens by using an extender. An *extender* is a lens set in a small ring mounted between the camera body and a regular lens, as shown in Figure 8.12. Canon offers two extenders, a 1.4X III and 2X III, that are compatible only with L-series Canon lenses. Extenders can also be combined for even greater magnification.

8.12 Extenders, such as this Canon EF 1.4X II mounted between the camera body and the lens, extend the range of L-series lenses. They increase the focal length by a factor of 1.4X, in addition to the 1.6X focal-length conversion factor inherent with the T3/1100D's focal length multiplier.

However, one disadvantage to using extenders is that they reduce the light reaching the sensor. The EF 1.4X III extender decreases the light by 1 f-stop, and the EF 2X III extender decreases the light by 2 f-stops. But an obvious advantage is that in addition to being fairly lightweight, extenders can reduce the number of telephoto lenses you carry.

Thus, accounting for the extra reach of the extender, its light loss, and the focal length magnification, if you use the Canon EF 2X II or III extender with the EF 70-200mm f/2.8L IS USM lens, the lens becomes a 224-640mm f/5.6 lens.

In general, you can use extenders with fixed focal-length (prime) lenses 135mm and longer (except the 135mm f/2.8 Softfocus lens). The extender compatibility list is available at www.usa.canon.com/app/pdf/lens/EFLensChart.pdf.

Extension tubes and close-up lenses

Extension tubes are close-up accessories that provide magnification increases from approximately 0.3 to 0.7, and they can be used on many EF lenses, though there are exceptions. Extension tubes are placed between the camera body and lens and

connect to the camera via eight electronic contact points. You can combine extension tubes for greater magnification as I did to make the picture in Figure 8.14.

Canon offers two extension tubes: the EF 12 II and the EF 25 II. Magnification differs by lens, but with the EF 12 II and standard zoom lenses, it is approximately 0.3 to 0.5. With the EF 25 II, magnification is 0.7. When combining tubes, you may need to focus manually. Extension tubes are compatible with specific lenses. Be sure to check the Canon website for lenses that are compatible with extension tubes.

Additionally, you can use screw-in close-up lenses. Canon offers four lenses that provide enhanced close-up photography based on the lens size, including the 52mm Close-up Lens 250D, the 77mm Close-up Lens 500D, the 52mm Close-up Lens 500D, and the 58mm Close-up Lens 500D. The 250D/500D series uses a double-element design for enhanced optical performance. The 250/600D/500D series features a double-element achromatic design to maximize optical performance. The 500 series has a single-element construction for economy.

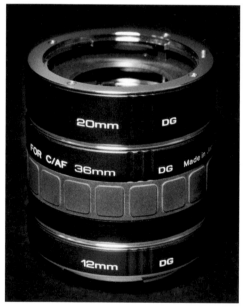

8.13 The Kenko DG Auto extension tube set allows close focusing with many lenses.

8.14 I used two Kenko extension tubes for this extreme close-up of daisy petals. Exposure: ISO 100, f/4, 1/5 second using an EF 100mm f/2.8L IS Macro USM lens.

Learning Lens Lingo and Technology

As you consider the lenses that you want to add to your system, the lens names and attributes can quickly become confusing. To help you decipher the various features offered with many lenses, here are some of the terms used to describe the advantages of various lenses:

▶ **USM.** USM indicates the lens features an ultrasonic motor. This very quiet focusing mechanism (motor) is built in and powered by the camera; however, because the lens has its own focusing motor, you get a very fast focus. USM lenses use electronic vibrations created by piezoelectric ceramic elements to provide quick and quiet focusing action with near instantaneous starts and stops.

In addition, lenses with a ring-type ultrasonic motor offer full-time manual focusing without requiring you to first switch the lens to Manual Focus. This design is offered in the large-aperture and super-telephoto lenses. A second design, the micro ultrasonic motor, provides the advantages of this technology in the less-expensive EF lenses.

▶ **L-series lenses.** Canon's L-series lenses feature a distinctive red ring on the outer barrel, or in the case of telephoto and super-telephoto lenses, are distinguished by Canon's well-known white barrel. The characteristics of the L-series lenses, apart from their sobering price tags, are technologies that provide outstanding optical performance. L-series lenses include one or more of the following technologies and features:

 • **UD/Fluorite elements.** Ultralow Dispersion (UD) glass elements help minimize color fringing or chromatic aberration. This glass also provides improved contrast and sharpness. UD elements are used, for example, in the EF 70-200mm f/2.8L IS II USM and EF 300mm lenses. Fluorite elements, which are used in super-telephoto L-series lenses, reduce chromatic aberration. Lenses with UD or fluorite elements are designated as CaF2, UD, and/or S-UD.

 • **Aspherical elements.** This technology is designed to help counteract spherical aberrations that occur when wide-angle and fast normal lenses cannot resolve light rays coming into the lens from the center with light rays coming into the lens from the edge into a sharp point of focus. The result is a blurred image. An aspherical element uses a varying curved surface to ensure that the entire image plane appears focused. These types of optics help correct curvilinear distortion in ultrawide-angle lenses as well. Lenses with aspherical elements are designated as AL.

- **Dust, water-resistant construction.** For any photographer who shoots in inclement weather, whether it's for an editorial assignment or sports event, having a lens with adequate weather sealing is critical. The L-series EF lenses have rubber seals at the switch panels, exterior seams, drop-in filter compartments, and lens mounts to make them both dust and water resistant. Moving parts, including the focusing ring and switches, are also designed to keep out environmental contaminants.

▶ **Full-time manual focusing.** An advantage of many Canon lenses is the ability to use autofocus, and then tweak focus manually using the lens's focusing ring without switching out of Autofocus (AF) mode or changing the switch on the lens from the AF to MF setting. Full-time Manual Focus comes in handy, for example, with macro shots and when using extension tubes.

▶ **Inner and rear focusing.** Lenses' focusing groups can be located in front or behind the diaphragm, both of which allow for compact optical systems with fast autofocusing. Lenses with rear optical focusing, such as the EF 85mm f/1.8 USM, focus faster than lenses that move their entire optical system, such as the EF 85mm f/1.2L II USM.

▶ **Floating system.** Canon lenses use a floating system that dynamically varies the gap between key lens elements based on the focusing distance. As a result, optical aberrations are reduced or suppressed through the entire focusing range. In comparison, optical aberrations in nonfloating-system lenses are corrected only at commonly used focusing distances. At other focusing distances, particularly at close focusing distances, the aberrations appear and reduce image quality.

▶ **Focus preset.** This feature lets you program a focusing distance into the camera's memory. For example, if you shoot a bicycle race near the finish line, you can preset focus on the finish line and then shoot normally as riders approach. When the racers near the finish line, you can turn a ring on the lens to instantly return to the preset focusing distance, which is on the finish line.

▶ **Diffractive optics.** Diffractive optics (DO) are made by bonding diffractive coatings to the surfaces of two or more lens elements. The elements are then combined to form a single multilayer DO element designed to cancel chromatic aberrations at various wavelengths when combined with conventional glass optics. Diffractive optics result in smaller and shorter telephoto lenses without compromising image quality. For example, the EF 70-300mm f/4.5-5.6 DO IS USM lens is 28 percent shorter than the EF 70-300mm f/4.5-5.6 IS USM lens.

The Elements of Exposure and Composition

I f you haven't used a digital SLR before, then the options for controlling exposure on the T3/1100D may seem confusing to you, and knowing when to use them to get specific results may seem mystifying and overwhelming. But after you know how the elements of exposure work together, the camera will make much more sense. In this chapter, you learn how aperture (f-stop), shutter speed, and ISO affect your images, as well as how they work together. And if you are returning to photography after time away, the information in this chapter serves as a refresher on the elements of exposure. In addition to introducing photographic exposure elements, this chapter includes an overview of composition guidelines and tips.

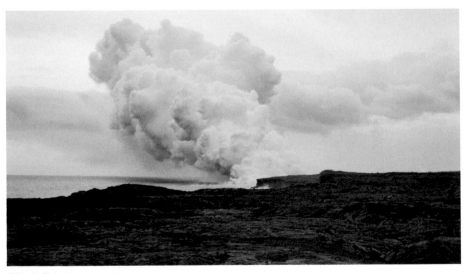

©Sandy Rippel

The line of smoke from this volcano on Kona, Hawaii, forms a strong diagonal line that contrasts with the horizontal lines of the lava field, ocean, and clouds. Exposure: ISO 1250, f/7.1, 1/8 second.

The Four Elements of Exposure

Making a picture begins with your creative eye and personal expression. The unique way that you see a subject or scene is the first step in making engaging and unique pictures. Then you use the camera to help you express how you see the scene or subject. Although creativity is first and foremost in making images, there is also an essential technical aspect that enables you to use the camera effectively to express your vision.

Although the technical aspects may not seem as exciting as the creative aspects of picture making, the more you understand what goes into making a photographic exposure, the more creative control you have. And creative control moves you out of the realm of getting a few happy-but-accidental images and into the realm of building a portfolio of beautiful-and-intentional images. A solid understanding of exposure also prepares you when you need to find creative workarounds for challenging lighting, scenes, and subjects, or limitations of the camera itself.

Photographic exposure is a precise combination of four elements:

▶ **Light.** The starting point of exposure is the amount of light that is in the scene. Before making any image, the Rebel T3/1100D first measures, or meters, the amount of light in the scene, and only then can it calculate suggested exposure settings. Your range of creative control with the Rebel T3/1100D is often determined by the amount of light you have to work with or the amount of light that you can add using a flash or other lights.

▶ **Sensitivity.** Sensitivity refers to the amount of light that the camera's image sensor needs to make an exposure or to the sensor's sensitivity to light. Sensitivity is controlled by the ISO setting. At high ISO settings, the camera needs less light to make an image than it does at low ISO settings.

▶ **Intensity.** Intensity refers to the strength or amount of light that reaches the image sensor. Intensity is controlled by the aperture, or f-stop. The aperture controls the lens diaphragm, an adjustable opening within the lens that opens or closes to allow more or less light into the camera.

▶ **Time.** Time refers to the length of time that light is allowed to reach the sensor. Time is controlled by setting the shutter speed, which determines how long the camera's shutter stays open to let light reach the sensor.

This language may sound unfamiliar, so it may be easier to think of exposure as filling the image sensor with light just as you would fill a glass with water. The goal is to fill the glass with the perfect amount of water, just as you want to fill the image sensor with just the right amount of light to get a good exposure.

In photography, you start with the amount of light that's in the scene and use that amount to determine the correct exposure. In the water glass analogy, that equates to the level to which you want to fill the glass with water. Then you have several choices. You can use a strong or weak stream of water, analogous to a large or a small aperture or f-stop. Then you can choose how long the water flows into the glass, analogous to setting the shutter speed. Finally, you can choose the size of the glass to fill. The size of the glass represents the ISO, or the sensitivity of the sensor. A small glass fills faster than a large glass just as a high ISO requires less light than a low ISO.

So starting with the goal of reaching the perfect level of water (the perfect amount of light reaching the sensor), you can choose a fast or slow water flow (aperture), and you can let the water run a long or a short time (shutter speed) depending on the size of the glass (the ISO). And there are many combinations of these variables that all result in getting just the right amount of water into the size glass that you're filling.

The following sections look at each exposure element in more detail. As you read, know that every exposure element is related to the other elements. If one exposure element changes, one or all of the other elements must also change proportionally.

Light

The first element in any image is the light that is available or that you add to make the picture. And that's the first thing the camera looks at — it first measures (meters) the light in the scene using the onboard light meter. Every time that you half-press the shutter button, the camera measures the light.

The Rebel uses a reflective light meter that measures the amount of light that is reflected from the subject back to the camera.

The light meter reading is biased toward the active autofocus (AF) point. The active AF point tells the camera where the subject is so that the camera can evaluate the light on the subject relative to the rest of the light in the scene. The T3/1100D factors in the current ISO setting, and then calculates how much light (determined by the aperture) is needed and for how long (determined by the shutter speed setting) to make a good exposure. Then the camera gives you its recommended exposure.

Once the exposure settings are calculated, the T3/1100D then applies the aperture, shutter speed, and the ISO automatically in the Basic Zone modes, such as Portrait, Landscape, and Sports. But in the semiautomatic shooting modes such as Shutter-priority AE (Tv) and Aperture-priority AE (Av), you can influence the exposure by setting the shutter speed in Tv shooting mode, or the aperture (f-stop) in Av shooting

mode. When you do that, the camera takes into account the ISO you set along with the aperture you set in Av mode, and then calculates the shutter speed for you. Or it takes the shutter speed that you set in Tv shooting mode and automatically calculates the aperture.

Sensitivity: The role of ISO

In broad terms, the ISO setting determines how sensitive the image sensor is to light. ISO settings work this way: The higher the ISO number, the less light that's needed to make a picture; and the lower the ISO number, the more light that's needed to make a picture. In the analogy of filling a glass with water, the size of the glass corresponds to the ISO. If the glass is small (more sensitive to light), less water is needed, and vice versa.

In practical terms, high ISO settings such as ISO 800 to 1600 give you faster shutter speeds. That's important to know because if you're handholding the camera, slow shutter speeds in low-light scenes result in blurry pictures caused by the slight shake of your hands holding the camera. Fast shutter speeds in low light increase the chance that you can handhold the camera and get a sharp image. On the other hand, in bright to moderately bright scenes, low ISO settings from 100 to 400 provide shutter speeds that are fast enough to handhold the camera without getting blur from handshake.

When you adjust the ISO, remember that each higher ISO setting is twice as sensitive to light as the previous setting. For example, ISO 800 is twice as sensitive to light as ISO 400. As a result, the sensor needs half as much light to make an exposure at ISO 800 as it does at ISO 400 and vice versa.

In P, Tv, Av, M, and A-DEP shooting modes, the ISO sequence encompasses Auto (ISO 100 to 6400, which is set automatically by the camera, although you can set an upper limit) and ISO 100, 200, 400, 800, 1600, 3200, and 6400. In the automated Basic Zone modes, the T3/1100D automatically sets the ISO between 100 and 3200, depending on the light.

But ISO does more than affect the amount of light that's needed to make a good exposure. ISO also affects the overall image quality in several areas, including sharpness, color saturation, contrast, and digital noise or lack thereof.

The area of digital noise merits further discussion. When you increase the ISO setting on a digital camera, it amplifies the output of the sensor so that less light is needed, but it also amplifies digital noise. This amplification is much like the hiss or static in an audio system that becomes more audible as the volume increases. In images, digital noise is comprised of *luminance* and *chroma* noise. Luminance noise is similar to film grain. Chroma noise appears as mottled color variations and as colorful pixels that are more prevalent in the shadow areas of the image, as illustrated in Figures 9.1 and 9.2.

9.1 This image was taken using ISO 100, and the digital noise isn't apparent until the image is viewed at 100 percent in an image-editing program and the shadows are lightened, as shown in Figure 9.2. Long exposures such as this also contribute to the presence of digital noise, and that factored into this exposure. Exposure: ISO 100, f/8, 5 seconds.

Regardless of the type, digital noise degrades overall image quality by overpowering fine detail, reducing sharpness and color saturation, and giving the image a mottled look. The conditions that trigger digital noise include high ISO settings, long exposures, underexposure, and high ambient temperatures, such as occur from leaving the camera in a hot car or in the hot sun. In general, the hotter the sensor gets, the more digital noise appears in images.

9.2 This detail of Figure 9.1 shows the digital noise in the shadow areas that have been lightened to reveal the noise. Even at a low ISO 100 setting, digital noise is present, and at higher ISO settings, the digital noise is much worse.

The tolerance for digital noise is subjective and varies by photographer. As an exercise, shoot the same scene or subject at ISO 100 and at ISO 6400. Then view both images at 100 percent on your computer

monitor. Scroll to the same shadow area in both images and compare the two images. You can see much more visible noise in the high-ISO image. This helps you know what to expect in terms of digital noise at each ISO setting. Then you can determine how high an ISO you want to use, especially in low-light scenes.

In situations where you must use a high ISO setting, you can use C.Fn II-4: High ISO speed noise reduction to minimize digital noise. With this Custom Function, you can choose one of three levels from low to strong. The higher levels of noise reduction can reduce the fine detail in images, so you may want to test each level at high ISO settings to see which works best for your photography. But unless you are using Auto ISO or using a high ISO that you set manually, then it's best to not use this Custom Function to get the maximum level of fine detail in your images. You can also use C.Fn II-3: Long exposure noise reduction to reduce digital noise in exposures of 1 second or longer. This option slows down shooting, but it is very effective in reducing the level of noise in the image.

See Chapter 4 for details on setting Custom Functions.

Reducing Digital Noise

If you are unfamiliar with digital noise, zoom the image to 100 percent on the computer, and then look for flecks of color in the shadow and midtone areas that don't match the other pixels. Also look for an overall rough or bumpy appearance that is similar to film grain.

If you detect objectionable levels of digital noise, you can use noise-reduction programs such as Noise Ninja (www.picturecode.com), Neat Image (www.neatimage.com), or Nik Dfine (www.niksoftware.com) to reduce it. Typically, noise reduction softens fine detail in the image, but these programs minimize the softening. If you shoot RAW images, programs including Canon's Digital Photo Professional and Adobe Camera Raw offer noise reduction options that you can apply during RAW conversion.

Intensity: The role of aperture

The lens aperture (the size of the lens diaphragm opening, shown in Figure 9.3) determines the intensity of light — either a lot or a little — that reaches the image sensor. Going back to the water glass analogy, aperture represents the strength or size of the

water flow. A strong flow, or a large aperture (f-stop) fills the glass (the image sensor) faster than a weak stream of water.

Aperture is indicated as f-stop numbers, such as f/2.8, f/4.0, f/5.6, and f/8. Small aperture numbers such as f/5.6, f/4, and f/2.8 correspond to a strong water flow. Large aperture numbers such as f/8, f/11, and f/16 correspond to a weak water flow.

9.3 The left image shows the lens diaphragm at f/22, the smallest or "minimum" aperture for this lens. The right image shows the lens opened up to f/5.6. On a lens that has a maximum aperture of f/2.8, the diaphragm opens as wide as possible, letting in the maximum amount of light.

When you increase or decrease the aperture by a full f-stop, it doubles or halves the exposure, respectively. For example, f/5.6 provides twice as much light as f/8 provides, while f/5.6 provides half as much light as f/4.0.

NOTE The apertures that you can choose depend on the lens that you're using. And with a variable aperture lens such as the Canon EF-S 18-55mm f/4.5-5.6 lens, the maximum aperture of f/4.5 can be used when the lens is zoomed to 18mm and f/5.6 can be used when the lens is zoomed to 55mm.

Wide aperture

Smaller f-stop numbers, such as f/5.6, f/4, f/3.5, and f/2.8, set the lens diaphragm to a large opening that lets more light reach the sensor. A large lens opening is referred to as a wide aperture. Based on the ISO and in moderate light, a wide aperture (a large diaphragm opening) such as f/5.6 delivers sufficient light to the sensor so that the amount of time that the shutter has to stay open to make the exposure decreases. Thus you get a faster shutter speed than you would by using a narrow aperture of f/8

or f/11. In very general terms, this means that wide apertures of f/5.6 to f/1.2 enable you to shoot in lower-light scenes with a reasonably fast shutter speed (depending on the existing light and the ISO setting). And that combination helps you get sharp hand-held images in lower light. I used a wide aperture to make Figure 9.4.

9.4 In this image, a wide f/2.8 aperture combined with a close shooting distance blurred the background, and rendered only a few of the mum petal tips in sharp focus. Exposure: ISO 100, f/2.8, 1/8 second using −1/3-stop of Exposure Compensation.

Narrow aperture

Larger f-stop numbers, such as f/8, f/11, f/16, and narrower, set the lens diaphragm to a small opening that allows less light to reach the sensor. A small lens opening is referred to as a narrow aperture. Based on the ISO and in moderate light, a small diaphragm opening such as f/11 delivers less light to the sensor — or fills the glass slower — so the amount of time that the shutter has to stay open increases, resulting in a slower shutter speed. Because narrow apertures of f/8 to f/32 require longer shutter speeds, you need a lot of light to shoot with narrow apertures, or you need to use a tripod and have a scene or subject that remains stock still (see Figure 9.5).

Choosing an aperture

In everyday shooting, photographers most often select an aperture based on how they want background and foreground to look — either showing acceptably sharp detail or with blurred detail. This is called controlling the depth of field, discussed next. But you may also need to choose a specific aperture for practical or creative reasons. For example, if the light is low and you want to avoid blur from camera shake, then

choose a wide aperture (smaller f-number) to get a faster shutter speed. Or if you want to use selective focus, where only a small part of the image is in sharp focus, then choose a wide aperture. But if you're shooting a group of people or a landscape, then choose a narrow aperture to render sharper detail throughout the entire frame.

You can control the aperture by switching to Av or M shooting mode. In Av shooting mode, you set the aperture, and the camera automatically sets the correct shutter speed based on the selected ISO. In M shooting mode, you set both the aperture and the shutter speed based on the reading from the camera's light meter. The Exposure level indicator is displayed in the viewfinder as a scale and it indicates over-, under-, and correct exposure based on the aperture, shutter speed, and ISO.

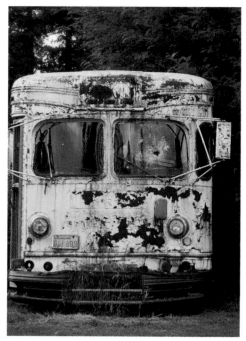

9.5 In this image, a narrow f/8 aperture maintains good sharpness throughout the old bus. I used a narrow aperture because I wanted all the details to be sharp. Exposure: ISO 200, f/8, 1/400 second using –1-stop of Exposure Compensation. (Exposure Compensation is detailed in Chapter 2.)

You can use P mode to make one-time changes to the aperture and shutter speed from the camera's recommended exposure. Unlike Av mode where the aperture you choose remains in effect until you change it, in P mode, changing the aperture is temporary. After you take the picture, the camera reverts to its suggested aperture and shutter speed.

You can learn more about shooting modes in Chapter 2.

What is depth of field?

Depth of field is the zone of acceptably sharp focus in front of and behind a subject. In simple terms, depth of field determines if the foreground and background are rendered as a soft blur or with distinct detail. Depth of field generally extends one-third in front of

the plane of sharp focus and two-thirds behind it. Aperture is the main factor that controls depth of field, although camera-to-subject distance and focal length affect it as well.

Depth of field is both a practical matter — based on the light that's available in the scene to make the picture — and a creative choice to control the rendering of background and foreground elements in the image. For example, if you are shooting at a music concert and you've set the ISO where you want it, you might creatively prefer to shoot using f/8 so that the midstage props are in acceptably sharp focus. But on the practical level, you might glance at the shutter speed at f/8 and quickly decide that you need to use a wide aperture to get as fast a shutter speed as possible. A good number of scenes involve practical and creative trade-offs, and the more you know about exposure, the better prepared you are to make judicious decisions.

Shallow depth of field

Images where the background is a soft blur and the subject is in sharp focus have a shallow depth of field. As a creative tool, shallow depth of field is typically preferred for portraits, some still-life images, and food photography. As a practical tool, choosing a wide aperture that creates a shallow depth of field is necessary when shooting in low light. To create a shallow depth of field, choose a wide aperture ranging from f/5.6 to f/1.2 depending on the lens. The subject will be sharp, while the background and foreground will be soft and nondistracting. Lenses also factor into depth of field, with a telephoto lens offering a shallower depth of field than a normal or wide-angle lens. Figure 9.4 is an example of shallow depth of field.

Extensive depth of field

Extensive depth of field maintains acceptably sharp focus in front of and behind the plane of sharpest focus. Extensive depth of field is preferred for images of landscapes, large groups of people, architecture, and interiors. When you want an image with extensive depth of field, choose a narrow aperture, such as f/8, f/11, f/16, f/22, or smaller. Figure 9.5 demonstrates extensive depth of field.

Once again, you may have to make creative and practical trade-offs when your goal is to create an extensive depth of field. Narrow apertures require a lot of light because the lens diaphragm opening is very small. This is analogous to using a weak water stream to fill the water glass. And in photography, narrow apertures require longer shutter speeds than wide apertures at the same ISO.

Other factors affecting depth of field

While aperture is a key factor in determining the depth of field — the range of acceptably sharp focus in a picture — other factors also affect depth of field:

▶ **Camera-to-subject distance.** At any aperture, the farther the camera is from the subject, the greater the depth of field is and vice versa.

▶ **Focal length.** Focal length, or *angle of view*, is how much of a scene the lens "sees." From the same shooting position, a wide-angle lens produces more extensive depth of field than a telephoto lens.

 For more information on lenses, see Chapter 8.

Time: The role of shutter speed

Shutter speed controls how long the shutter stays open to let light from the lens strike the image sensor. The longer the shutter, or curtain, stays open, the more light reaches the sensor (at the aperture and ISO that you've set). In the water glass example, the amount of time that you let the water flow into the glass is analogous to shutter speed.

When you increase or decrease the shutter speed by one full setting, it doubles or halves the exposure. For example, twice as much light reaches the image sensor at 1/30 second as at 1/60 second. Shutter speed is also related to the following:

▶ **The ability to handhold the camera and get sharp images, particularly in low light.** The general rule for handholding a non-Image Stabilized lens is that you need a minimum shutter speed that is the reciprocal of the focal length, or 1 over the focal length. For example, if you're shooting at 200mm, then the slowest shutter speed at which you can handhold the lens and get a sharp image is 1/200 second.

▶ **The ability to freeze motion or show it as blurred in a picture.** For example, you can set a fast shutter speed to show a skater's jump in midair with no blur, as shown in Figure 9.6. As a general rule, set the shutter speed to 1/125 second or faster to stop motion. Or set a slow shutter speed to show the motion of

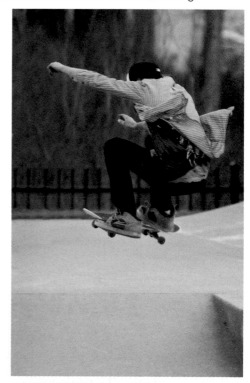

9.6 A fast 1/320 second shutter speed stopped the motion of the skate boarder in midair. Exposure: ISO 200, f/3.2.

water cascading over a waterfall as a silky blur. To show motion as a blur, use a 1/30 second or slower shutter speed and use a tripod.

You can control the shutter speed in Tv or M shooting mode. In Tv shooting mode, you set the shutter speed, and the camera automatically sets the correct aperture. In M shooting mode, you set both the shutter speed and the aperture based on the reading from the camera's light meter and the ISO. The light meter is displayed in the viewfinder as a scale — the Exposure level indicator — and it shows over-, under-, and correct exposure based on the shutter speed, aperture, and ISO.

Equivalent Exposures

As you have seen, after the camera meters the light and factors in the selected ISO, the two remaining factors determine the exposure: the aperture and the shutter speed. And just as with filling the glass with water, you can fill it slowly over a longer time, quickly, or any variation between.

Likewise, many combinations of aperture (f-stop) and shutter speed produce exactly the same exposure given the same ISO setting. For example, f/22 at 1/4 second is equivalent to f/16 at 1/8 second, as is f/11 at 1/15, f/8 at 1/30, and so on. And this is based on the doubling and halving effect discussed earlier. For example, if you are shooting at f/8 and 1/30 second, and you change the aperture (f-stop) to f/5.6, then you have doubled the amount of light reaching the image sensor, so the time that the shutter stays open must be halved to 1/60 second.

Although these exposures are equivalent, the way the image looks and your shooting options change noticeably. An exposure of f/22 at 1/4 second produces extensive depth of field in the image, but the shutter speed is slow, so your ability to handhold the camera and get a sharp image is dubious and a tripod becomes a necessity. If you switch to an equivalent exposure of f/5.6 at 1/60 second, you are more likely to be able to handhold the camera, but the depth of field will be shallow.

As with all aspects of photography, evaluate the trade-offs as you make changes to the exposure. And again, it all comes back to light. Your creative options for changing the exposure setting are ultimately limited by the amount of light in the scene.

Putting It All Together

ISO, aperture, shutter speed, and the amount of light in a scene are the essential elements of photographic exposure. On a bright, sunny day, you can select from many

different f-stops and still get fast shutter speeds to prevent image blur. You have little need to switch to a high ISO for fast shutter speeds at small apertures.

As it begins to get dark, your choice of f-stops becomes limited at ISO 100 or 200. You need to use wide apertures, such as f/4 or wider, to get a fast shutter speed. Otherwise, your images will show some blur from camera shake or subject movement. Switch to ISO 400 or higher, however, and your options increase and you can select narrow apertures, such as f/8 or f/11, for greater depth of field. The higher ISO enables you to shoot at faster shutter speeds to reduce the risk of blurred images, but it also increases the chances of digital noise.

Approaches to Composition

The technical aspects of photography are unquestionably important, and until now, that's been the primary concentration of this book. But technical competence alone doesn't create memorable images. Among the qualities that make images memorable are artful composition and compelling content. I will leave the content of images to your imagination, but I will discuss some widely used approaches to composition.

Whereas composition guidelines help you design an image, the challenge and the joy of photography is combining your visual, intellectual, and emotional perceptions of a scene from the objective point of view of the camera. Composition guidelines are helpful, but your personal aesthetic is the final judge. After all, for every rule of composition, there are galleries filled with pictures that break the rules and succeed famously.

 As you think about composition, remember that if you're in doubt about how to compose an image, keep it simple. Simple compositions clearly and unambiguously identify the subject, and they are visually easy to read.

Subdividing the photographic frame

One of the first tasks in making a picture is to decide how to divide the photographic frame. Because antiquity, artists, builders, and engineers have looked to nature and mathematics to find ways to portion spaces that create a harmonious balance of the parts to the whole space.

From the fifth century BCE, builders, sculptors, and mathematicians applied what is now known as the Divine Proportion. Euclid, the Greek mathematician, was the first to express the Divine Proportion in mathematical language. The Divine Proportion is expressed as the Greek symbol Phi where Phi is equal to 1/2(1 + square root of 5) = 1.618033989. This

proportion divides a line in such a way that the ratio of the whole to the larger part of the line is the same as the larger part is to the smaller part. This proportion produced such pleasing balance and symmetry that it was applied in building the pyramids of Egypt; the Parthenon in Athens, Greece; and Europe's Gothic cathedrals. The proportion also made its way into art. Over time, harmonious balance was expressed as the Golden Section, or the Golden Rectangle. The 35mm photographic frame, although being slightly deeper and having a ratio of 3:2, is very similar to the Golden Rectangle. The Golden Rectangle provided a map for artists to balance color, movement, and content within the confines of a canvas.

However, unlike painters, photographers don't begin with a blank canvas but with a scene that often presents itself ready-made. Even with a ready-made scene, photographers have a variety of creative guidelines at their disposal to structure the photographic frame. A popular device is the Rule of Thirds. This rule divides the photographic frame into thirds, much like superimposing a tic-tac-toe grid on the frame, as shown in Figure 9.7. To create visually dynamic compositions, place the subject or the point of interest on one of the points of intersection, or along one of the lines on the grid.

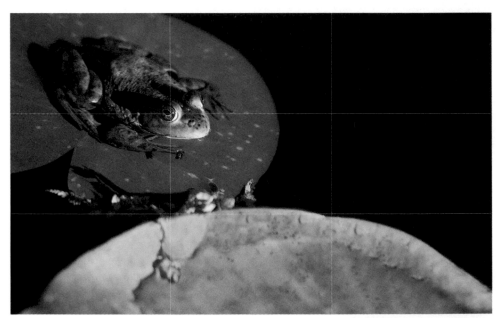

9.7 This image, with a Rule of Thirds grid superimposed, places the frog's eye roughly at the top-left intersection of the grid. Exposure: ISO 100, f/2.8, 1/500 second using −1/3-stop of Exposure Compensation.

The rule is, of course, approximate because not all scenes conform to the grid placement. But the Rule of Thirds provides a good starting point for subdividing the frame and for placing the subject within the subdivisions. For example, if you're taking a portrait, you might place a subject's eyes at the upper-left intersection point of the grid. In a landscape scene, you can place the horizon along the top or bottom line of the grid depending on what you want to emphasize.

Balance and symmetry

Balance is a sense of "rightness" or harmony in a photo. A balanced photo appears to be neither too heavy (lopsided) nor too off-center. To create balance in a scene, evaluate the visual "weight" of colors and tones (dark is heavier than light), the shape of objects (larger objects appear heavier than smaller objects), and their placement (objects placed toward an edge appear heavier than objects placed at the center of the frame).

The eye seeks balance in an image. Whether it is in tones, colors, or objects, the human eye seeks equal parts, equal weight, and resolved tension. Static balance begins with a single subject in the center of the frame with other elements emanating from the center point to create equal visual weight. Variations on this balance include two identical subjects at equal distances from each other, or several subjects arranged at the center of the frame. Conversely, dynamic balance is created when tones, colors, or weights are asymmetrical, or unequally balanced, creating visual tension.

Because the human eye seeks balance and symmetry, should compositions be perfectly balanced? Perfectly symmetrical compositions create a sense of balance and stability. And whereas symmetry is a defining characteristic in nature, if all images were perfectly balanced and symmetrical, they would tend to become boring. Although the human eye seeks symmetry and balance, after it finds it, the interest in the image quickly diminishes.

In real-world shooting, the choice of creating perfect balance or leaving tension in the composition is your decision. If you choose perfect symmetry, then it must be perfect, for the eye will immediately scan the image and light on any deviation in symmetry. In dynamic balance, the viewer must work to find balance, and that work can be part of the satisfaction in viewing the image.

Tone and color

At the most fundamental level, contrast is the difference between light and dark tones in an image. But in a larger context, contrast includes differences in colors, forms, and

shapes, and it is at the heart of composition. In photography, contrast not only defines the subject but also renders the shape, depth, and form of the subject and establishes the mood and the subject's relationship to other elements in the image. See Figure 9.8 for an example.

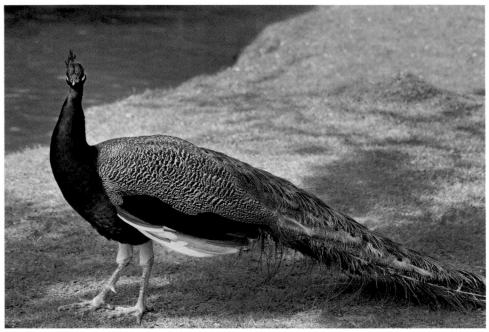

9.8 In this image, the contrast of the bird's dark colors against the background defines the subject sharply. Also the green and brown colors in the peacock echo the colors of the grass and water. Exposure: ISO 200, f/5.6, 1/400 second using –1-stop of Exposure Compensation.

Related to tones are colors used in composition. Depending on how colors are used in a photo, they can create a sense of harmony, or visual contrasts. In very basic terms, colors are either complementary or harmonizing. *Complementary* colors are opposite each other on the color wheel — for example, green and red, and blue and yellow. *Harmonizing* colors are adjacent to each other on the color wheel, such as green and yellow, yellow and orange, and so on, and offer no visual conflict.

If you want a picture with strong visual punch, use complementary colors of approximately equal intensity in the composition. If you want a picture that conveys peace and tranquility, use harmonizing colors.

The more that the color of an object contrasts with its surroundings, the more likely it is that the object will become the main point of interest. Conversely, the more uniform the overall color of the image, the more likely that the color will dictate the overall mood of the image.

The type and intensity of light also strongly affect the intensity of colors, and, consequently, the composition. Overcast weather conditions, such as haze, mist, and fog, reduce the vibrancy of colors. These conditions are ideal for creating pictures with harmonizing, subtle colors. Conversely, on a bright, sunny day, color is intensified and is ideal for composing pictures with bold, strong color statements.

Although a full discussion of tone and color is beyond the scope of this book, knowing some of the following characteristics of tone and color will help you make decisions about photographic compositions:

▶ **The viewer's eye is drawn to the lightest part of an image.** If highlights in an image fall somewhere other than on the subject, the highlights will draw the viewer's eye away from the subject.

▶ **Overall image brightness sets the mood of the image.** In addition, the predominance of tones determines the key. Images with primarily bright tones are said to be *high key*, whereas images with predominately dark tones are *low key*.

▶ **Colors, like tones, advance and recede; they have symbolic, cultural meanings; and they elicit emotional responses from viewers.** For example, red advances and is associated with energy, vitality, and strength as well as with passion and danger. Conversely, blue recedes and tends to be dark. It is widely associated with nature and water.

When speaking of color and when working with images in editing programs, keep these definitions in mind. *Hue* is the color, or the name of the color. For example, blue is a hue. *Saturation* is the intensity or purity of a hue. *Brightness* determines if the hue is light or dark.

Lines and direction

Because lines have symbolic significance, you can use them to bolster communication, to direct focus, and to organize visual elements. For example, you can place a subject's arms in ways that direct attention to the face. In an outdoor scene, you can use a gently winding river to guide the viewer's eye through the scene. You can use a strong diagonal beam in an architecture shot to bolster the sense of the building's strength. When planning the composition, keep in mind that images have both real

and implied lines. Examples of implied lines include the bend of a leaf or a person's hand. Ideally, lines will also lead the viewer's eye toward the subject, rather than away from it or out of the frame.

Lines traditionally convey these meanings:

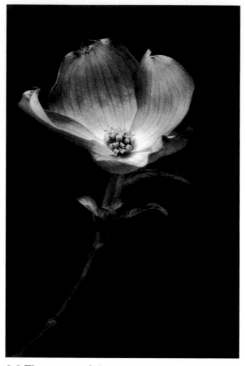

9.9 The curve of the stem emphasizes the grace of this dogwood blossom. The spot of light at the center of the blossom draws the viewer's eye to the center of the flower. Exposure: ISO 200, f/8, 1/25 second using −1/3-stop of Exposure Compensation.

► Horizontal lines imply stability and peacefulness.

► Diagonal lines create strength and dynamic tension.

► Vertical lines imply motion and strength.

► Curved lines symbolize grace (see Figure 9.9).

► Zigzag lines convey a sense of action.

► Wavy lines indicate peaceful movement.

► Jagged lines create tension.

Filling the frame

Just as an artist would not leave part of a canvas blank or filled with extraneous details, you should try to fill the full image frame with the subject and elements that support the subject and the message of the image. See Figure 9.10 for an example. Try to include elements that reveal more about the subject.

Keeping the background clean

In any picture, the elements behind and around the subject become as much a part of the photograph as the subject, and occasionally more so because the lens tends to compress visual elements. As you compose the picture, check all areas in the viewfinder or LCD for background and surrounding objects that will, in the final image, seem to merge with the subject, or that compete with or distract from the subject.

A classic example of failing to use this technique is the picture of a person who appears to have a telephone pole or tree growing out of the back of his or her head. To avoid this type of background distraction, you can change your shooting position or, in some cases, move the subject.

9.10 In this shot, I filled the frame with the beaded pillow. I used a wide aperture to isolate the subject of the image to one bead and the soft fabric of the pillow. Window light coming above and behind the pillow provided soft light. Exposure: ISO 100, f/2.8, 1 second.

Framing the subject

Photographers often borrow techniques from painters — and putting a subject within a naturally occurring frame, such as a window or an archway, is one such technique. The frame may or may not be in focus, but to be most effective, it should add context and visual interest to the image.

Controlling the focus and depth of field

Sharp focus establishes the relative importance of the elements within the image. And because the human eye is drawn first to the sharpest point in the photo, be sure that the point of sharpest focus is on the part of the subject that you want to emphasize; for example, in a portrait, the point of sharpest focus should be on the subject's eyes.

Differential focusing controls the depth of field, or the zone (or area) of the image that is acceptably sharp. In a nutshell, differential focusing works like this: The longer the focal length (in other words, a telephoto lens or zoom setting) and the wider the aperture (the smaller the f-stop number), the shallower the depth of field is (or the softer the background). Conversely, the shorter the focal length and the narrower the aperture, the greater the depth of field.

You can use this principle to control what the viewer focuses on in a picture. For example, in a picture with a shallow depth of field, the subject stands in sharp focus against a blurred background. The viewer's eyes take in the blurred background, but they return quickly to the much sharper area of the subject. To control depth of field, you can use the techniques in Table 9.1 separately or in combination with each other.

Table 9.1 Depth of Field

To Decrease the Depth of Field (Soften the Background Details)	To Increase the Depth of Field (Sharpen the Background Details)
Choose a telephoto lens or zoom setting	Choose a wide-angle lens or zoom setting
Choose a wide aperture from f/1.4 to f/5.6	Choose a narrow aperture from f/8 to f/22
Move closer to the subject and move the subject farther from the background	Move farther away from the subject

Defining space and perspective

Some ways to control the perception of space in pictures include changing the distance from the camera to the subject, selecting a telephoto or wide-angle lens or zoom setting, changing the position of the light in a studio or changing the subject's position in an outdoor setting, and changing the camera position. For example, camera-to-subject distance creates a sense of perspective and dimension so that when the camera is close to a foreground object, background elements in the image appear smaller and farther apart. A wide-angle lens also makes foreground objects seem proportionally larger than midground and background objects.

Although knowing the rules provides a good grounding for well-composed pictures, Henri Cartier-Bresson summed it up best when he said, "Composition must be one of our constant preoccupations, but at the moment of shooting it can stem only from our intuition, for we are out to capture the fugitive moment, and all the interrelationships involved are on the move. In applying the Golden Rule, the only pair of compasses at the photographer's disposal is his own pair of eyes." (From *The Mind's Eye: Writings on Photography and Photographers* by Henri Cartier-Bresson.)

As you can see from this chapter, technical exposure considerations combined with your creative vision and composition form the foundation for all the images you make.

9.11 Although the background is certainly clean, it provides a very graphic look for the single glass heart that is a vivid red. Exposure: ISO 100, f/16, 1/125 second.

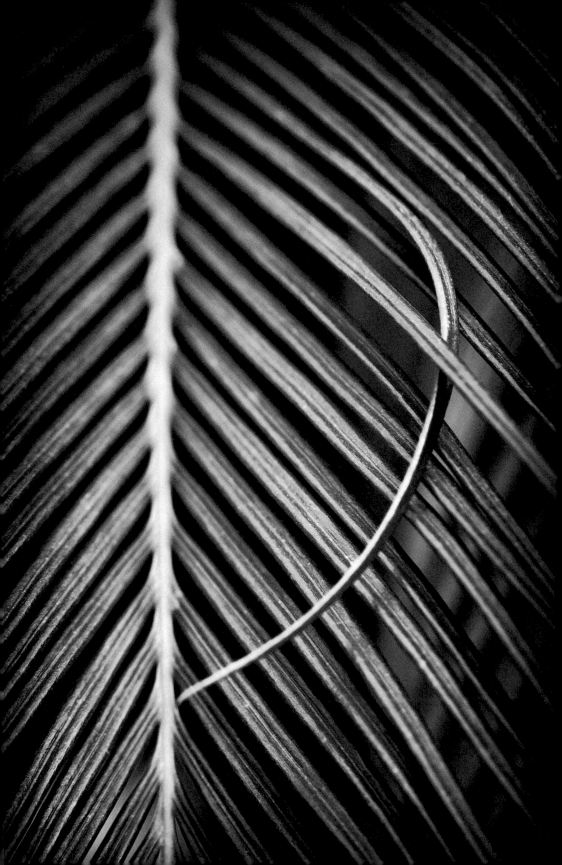

Exploring RAW Capture

To get the highest quality images from the EOS T3/1100D, it's best to capture them as RAW images. During RAW conversion on the computer, you have the opportunity to determine how the image data from the camera is interpreted. However, while RAW capture offers significant advantages, it isn't for everyone. If you prefer images that are ready to print straight out of the camera, JPEG capture is the best option. Alternatively, if you enjoy working with images on the computer and having creative control over the quality and appearance of the image, RAW is the best option.

This appendix provides an overview of RAW capture, as well as a brief walk-through of converting RAW image data into a final image.

Learning about RAW Capture

One way to understand RAW capture is by comparing it to JPEG capture, which most photographers are familiar with already. When you shoot JPEG images, the camera edits or processes the images before storing them on the media card. This processing includes converting images from 14-bit files to 8-bit files; setting the color, saturation, and contrast; and generally giving you a finished file. The same is true if you shoot RAW and have it converted to JPEG format in the camera. JPEG images can be printed with no editing. But in other cases, you may encounter images where you want more control over how the image is rendered — for example, you may want to recover blown highlights, tone down high-contrast images, or correct the color of an image.

Of course, you can edit JPEG images in an editing program and make some corrections, but the amount of latitude for editing is limited. With JPEG images, large amounts of image data are discarded when the images are converted to 8-bit mode in the camera, and then the image data is further reduced when JPEG algorithms compress image files to reduce the size. As a result, the image leaves little, if any, wiggle room to correct the tonal range, white balance, contrast, and saturation during image editing. Ultimately, this means that if the highlights in an image are overexposed, or blown, they're blown for good. Another way to look at the difference between RAW and JPEG files is that with JPEG files, you have 256 levels of information per pixel, while with RAW files you have 16,384 levels of information.

If the shadows are *blocked up* (meaning they lack detail), then they will likely stay blocked up. It is possible to make improvements in Photoshop or Photoshop Elements, but the edits make the final image susceptible to *posterization*, or banding, that occurs when the tonal range is stretched and gaps appear between tonal levels. This stretching makes the tonal range on the histogram look like a comb. And digital noise is revealed as the shadows are lightened during editing.

By contrast, RAW capture enables you to work with the data that comes off the image sensor with virtually no internal camera processing. The only camera settings that the camera applies to a RAW image are ISO, shutter speed, and aperture. And because many of the key camera settings have been noted but not applied in the camera, you have the opportunity to make changes to settings, including image brightness, white balance, contrast, and saturation, when you convert the RAW image data into a final image using a conversion program such as Canon's Digital Photo Professional (DPP), Adobe Camera Raw, Adobe Lightroom, or Apple Aperture. I used DPP to convert the image shown in Figure A.1.

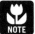 In addition to the RAW image data, both RAW and JPEG files also include information, called *metadata*, about how the image was shot, the camera and lens used, and other description fields.

An important characteristic of RAW capture is that you have more latitude and stability when editing converted RAW files than you do with JPEG files. RAW images have rich data depth and provide significantly more image data to work with during conversion and subsequent image editing. In addition, RAW files are more forgiving if you need to recover overexposed highlight detail during conversion of the RAW file. These differences in data richness translate directly to editing leeway. And maximum editing leeway is important because after the image is converted all the edits you make in an editing program are destructive. Another advantage of RAW conversion is that as conversion programs improve, you can go back to older RAW image files and convert them again using the improved features and capabilities of the conversion program.

Proper exposure is important with any image, and it is very important with RAW images. With RAW images, proper exposure provides a file that captures rich tonal data that withstands conversion and editing. For example, during conversion, you must map image brightness levels so that the levels look more like what we see with our eyes — a process called *gamma encoding*. In addition, you will also likely adjust the contrast and midtones and move the endpoints on the histogram. For an image to withstand these conversions and changes, a correctly exposed and data-rich file is critical.

A.1 This image shown after conversion was overexposed by about 1/2-stop, and that overexposure is indicated by the histogram on the left. Notice that the shadows are also blocked up. The histogram on the right shows the image histogram after converting the image in DPP to recover both highlight and shadow detail. Exposure: ISO 200, f/14, 1/200 second using –1/3-stop of Exposure Compensation.

Proper exposure is also critical, considering that digital capture devotes the lion's share of tonal levels to highlights while devoting far fewer levels to shadows. In fact, half of all the tonal levels in the image are assigned to the first f-stop of brightness. Half of the rest of the tonal levels account for the second f-stop, and half into the next f-stop, and so on.

With digital cameras, dynamic range depends on the image sensor. The brightest f-stop is a function of the brightest highlight in the scene that the sensor can capture, or the point at which the sensor element is saturated with photons. The darkest tone is determined by the point at which the noise in the system is greater than the comparatively weak signal generated by the photons hitting the sensor element.

Clearly, capturing the first f-stop of image data is critical because half of the image data is devoted to that f-stop. In Figure A.2, I biased the exposure to the right to ensure that I captured the first f-stop of image data. If an image is underexposed, not only is important image data sacrificed, but also the file is more likely to have more digital noise in the shadow areas.

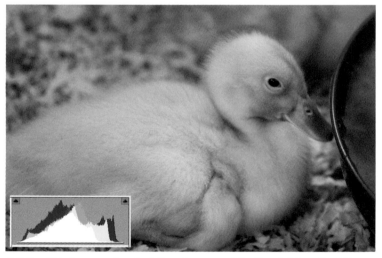

A.2 For this image of a duckling, I exposed to the right so that the highlight pixels just touch the right side of the histogram. Exposure: ISO 800, f/2.8, 1/100 second.

Underexposure also means that during image conversion, the fewer captured levels must be stretched across the entire tonal range. Stretching tonal levels creates gaps between levels that reduce the continuous gradation between levels.

The general guideline when shooting RAW capture is to expose with a bias to the right so that the highlight pixels just touch the right side of the histogram, as done in Figure A.2. Thus, when tonal mapping is applied during conversion, the file has significantly more bits that can be redistributed to the midtones and darker tones, where the human eye is most sensitive to changes.

If you've always shot JPEG capture, the exposing-to-the-right approach may seem wrong. When you're shooting JPEG images, the guideline is to expose so that the highlights are not blown out because if detail is not captured in the highlights, it's gone for good. This guideline is good for JPEG images where the tonal levels are encoded and the image is essentially pre-edited inside the camera. However, with RAW capture, adjustments are made during conversion with a good bit of latitude. And if highlights are overexposed, conversion programs such as Adobe Camera Raw or Digital Photo Professional (DPP) can recover varying amounts of highlight detail.

In summary, RAW capture produces files with the most image data that the camera can deliver, and you have a great deal of creative control over how the RAW data is converted into a final image. Most important, you get strong, data and color-rich files that withstand image editing and can be used to create lovely prints.

However, if you decide to shoot RAW images, you also sign on for another step in the process from capturing images to getting finished images: RAW conversion. With RAW capture, the overall workflow sequence is to capture the images, convert the RAW data in a RAW-conversion program, edit images in an image-editing program, and then print them. You may decide that you want to shoot in RAW+JPEG so that you have JPEGs that require no conversion, but you have the option to convert exceptional or problem images from the RAW files with more creative control and latitude.

Canon's RAW Conversion Program

Unlike JPEG images, RAW images are stored in proprietary format, and they cannot be viewed on some computers or opened in some image-editing programs without first converting the files to a more universal file format, such as TIFF, PSD, or JPEG. Canon includes a free program, Digital Photo Professional (DPP), on the EOS Digital Solution Disk that you can use to convert T3/1100D RAW files, and then save them as TIFF or JPEG files.

Images captured in RAW mode have a .CR2 file extension.

DPP is noticeably different from traditional image-editing programs. It focuses on image conversion tasks, including correcting, tweaking, or adjusting white balance, brightness, shadow areas, contrast, saturation, sharpness, and noise reduction. It doesn't include some familiar image-editing tools, nor does it offer the ability to work with layers.

Sample RAW Image Conversion

Although RAW image conversion adds a step to image processing, this important step is well worth the time. To illustrate the overall process, here is a high-level workflow for converting an EOS T3/1100D RAW image using Canon's DPP.

Be sure to install the DPP application provided on the EOS Digital Solution Disk before following this task sequence.

1. **Start DPP.** The program opens. If no images are displayed, you can select a directory and folder from the Folder panel.

2. **Double-click the RAW (.CR2) image you want to process.** The image preview opens with the RAW image tool palette displayed with the RAW tab selected. If the Tool palette isn't displayed, choose View → Tool palette. In the editing mode, you can do the following:

 • **Drag the Brightness adjustment slider to the left to darken the image or to the right to lighten it.** To return quickly to the original brightness setting, click the curved arrow above and to the right of the slider. In Figure A.3, I brightened an image slightly.

 • **Use the White Balance adjustment control to adjust color.** You can click the Eyedropper tool, and then click an area that is white or gray in the image to quickly set White Balance, choose one of the preset White Balance settings from the Shot Settings drop-down menu, or click Tune to adjust the White Balance using a color wheel. After you correct the color, you can click Register to save the setting, and then use it to correct other images.

 • **Change the Picture Style by clicking the down arrow next to the currently listed Picture Style and selecting a different Picture Style from the list.** The Picture Styles offered in DPP are the same as those offered on the menu on the T3/1100D. When you change the Picture Style in DPP, the image preview updates to show the change. If you don't like the results, you can click the curved arrow to the right of Picture Style to switch back to the original Picture Style.

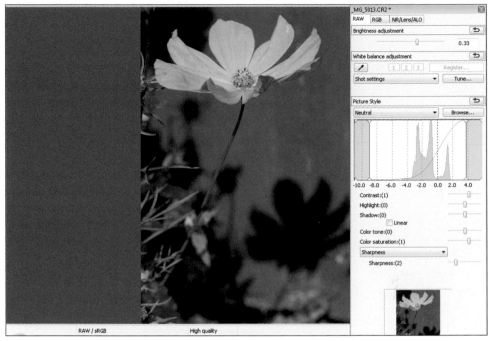

A.3 The Edit window of Digital Professional Pro

- **Adjust the tonal curve by adjusting the Contrast, Highlight, and Shadow sliders.** To see the image without a tonal curve applied, select the Linear check box. Deselect it to reset the tonal curve. Then you can also adjust the color tone, saturation, and sharpness.

- **Adjust the Color tone, Color saturation, and Sharpness by dragging the sliders.** Dragging the Color tone slider to the right increases the green tone, and dragging it to the left increases the magenta tone. Dragging the Color saturation slider to the right increases the saturation, and vice versa. Dragging the Sharpness slider to the right increases the sharpness, and vice versa. You can further refine the sharpness level with the Strength, Fineness, and Threshold sliders.

3. **Click the RGB tab, shown in Figure A.4.** Here you can apply an RGB curve and also apply separate curves in each of the three color channels: Red, Green, and Blue. You can also:

 - **Click one of the tonal curve options to the right of Tone curve assist to set a classic S-curve without changing the black and white points.** If you want to increase the curve, click the Tone curve assist button marked

with a plus (+) sign one or more times to increase the curve. Or you can click the linear line on the histogram, and then drag the line to set a custom tonal adjustment curve. If you want to undo the curve changes, click the curved arrow to the right of Tone curve adjustment, or the curved arrow to the right of Tone curve assist.

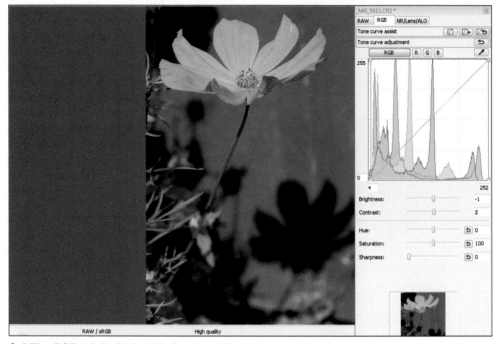

A.4 The RGB tab in Digital Professional Pro

- **Click the R, G, or B buttons next to RGB to make changes to a single color channel.** Working with an individual color channel is helpful when you need to reduce an overall colorcast in an image, but this is an advanced technique, so if you are just starting out with RAW conversion, I do not recommend making adjustments to the R, G, or B channel boxes.

- **Drag the Brightness slider to the left to darken the image or to the right to brighten the image.** The changes you make appear on the RGB histogram as you make them.

- **Drag the Contrast slider to the left to decrease contrast or to the right to increase contrast.**

- **Drag the Hue, Saturation, and Sharpness sliders until the image looks good to your eye.**

4. **Click the NR/Lens/ALO tab, shown in Figure A.5.** Controls on this tab enable you to do the following:

- **Set Auto Lighting Optimizer.** Auto Lighting Optimizer automatically corrects overexposed images and images with flat contrast. This option can be applied automatically to JPEG images in the camera, but the only way to apply it to RAW images is in DPP. You can choose Low, Standard, or Strong settings, or turn off Auto Lighting Optimizer by selecting the check box. I personally prefer to make the adjustments that Auto Lighting Optimizer makes manually on the RAW and RGB tabs.

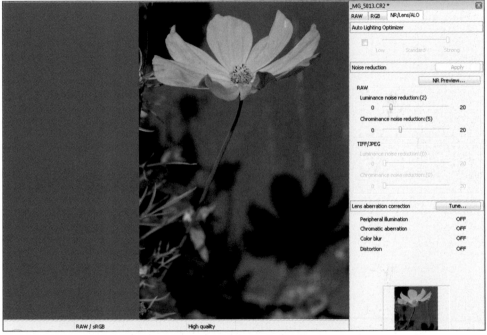

A.5 The NR/Lens/ALO tab in Digital Professional Pro

- **Control digital noise if it is problematic in the image.** There are controls for both RAW and TIFF/JPEG images. Be sure to enlarge the preview image to 100 percent and scroll to a shadow area to set noise reduction for Luminance and/or Chrominance.

- **Correct Lens aberration.** Click the Tune button to display another dialog box where you can view and adjust the Shooting distance information, and correct vignetting using Peripheral illumination, Distortion, Chromatic aberration, and Color blur.

5. **In the image preview window, choose File → Convert and save.** The Convert and save dialog box appears. In the dialog box, you can specify the file type and bit depth at which you want to save the image. Just click the down arrow next to Kind of file and choose one of the options, such as TIFF 16-bit. Then you can set the Image Quality setting if you are saving in JPEG or TIFF+JPEG format, set the Output resolution, choose to embed the color profile, or resize the image. In addition, you can specify the width and height.

The Edit menu also enables you to save or copy the current image's conversion settings, and then you can apply it to other images in the folder.

6. **Click Save.** DPP displays the Digital Photo Professional dialog box until the file is converted. DPP saves the image in the location and format that you choose.

How to Use the Gray Card and Color Checker

Have you ever wondered how some photographers are able to consistently produce photos with such accurate color and exposure? It's often because they use gray cards and color checkers. Knowing how to use these tools helps you take some of the guesswork out of capturing photos with great color and correct exposures every time.

The Gray Card

Because the color of light changes depending on the light source, what you might decide is neutral in your photograph, isn't neutral at all. This is where a gray card comes in very handy. A gray card is designed to reflect the color spectrum neutrally in all sorts of lighting conditions, providing a standard from which to measure for later color corrections or to set a custom white balance.

By taking a test shot that includes the gray card, you guarantee that you have a neutral item to adjust colors against later if you need to. Make sure that the card is placed in the same light that the subject is for the first photo, and then remove the gray card and continue shooting.

 When taking a photo of a gray card, de-focus your lens a little; this ensures that you capture a more even color.

Because many software programs enable you to address color correction issues by choosing something that should be white or neutral in an image, having the gray card in the first of a series of photos allows you to select the gray card as the neutral point. Your software resets red, green, and blue to be the same value, creating a neutral midtone. Depending on the capabilities of your software, you might be able to save the adjustment you've made and apply it to all other photos shot in the same series.

If you'd prefer to make adjustments on the spot, for example, and if the lighting conditions will remain mostly consistent while you shoot a large number of images, it is

advisable to use the gray card to set a custom white balance in your camera. You can do this by taking a photo of the gray card filling as much of the frame as possible. Then, use that photo to set the custom white balance.

The Color Checker

A color checker contains 24 swatches which represent colors found in everyday scenes, including skin tones, sky, foliage, etc. It also contains red, green, blue, cyan, magenta, and yellow, which are used in all printing devices. Finally, and perhaps most importantly, it has six shades of gray.

Using a color checker is a very similar process to using a gray card. You place it in the scene so that it is illuminated in the same way as the subject. Photograph the scene once with the reference in place, then remove it and continue shooting. You should create a reference photo each time you shoot in a new lighting environment.

Later on in software, open the image containing the color checker. Measure the values of the gray, black, and white swatches. The red, green, and blue values in the gray swatch should each measure around 128, in the black swatch around 10, and in the white swatch around 245. If your camera's white balance was set correctly for the scene, your measurements should fall into the range (and deviate by no more than 7 either way) and you can rest easy knowing your colors are true.

If your readings are more than 7 points out of range either way, use software to correct it. But now you also have black and white reference points to help. Use the levels adjustment tool to bring the known values back to where they should be measuring (gray around 128, black around 10, and white around 245).

If your camera offers any kind of custom styles, you can also use the color checker to set or adjust any of the custom styles by taking a sample photo and evaluating it using the on-screen histogram, preferably the RGB histogram if your camera offers one. You can then choose that custom style for your shoot, perhaps even adjusting that custom style to better match your expectations for color.

Glossary

720p/1080i/1080p High-definition video recording standards that refer to the vertical resolution, or the number of horizontal lines on the screen — either 720 or 1080 lines. Seven-hundred twenty horizontal lines translate to a width of 1280 pixels. The *p* stands for progressive scan, which displays the video frame all at once. The *i* stands for interlaced, an analog compression scheme that allows 60 frames per second (fps) to be transmitted in the same bandwidth as 30 fps by displaying 50 percent of the video frame at a time.

Adobe RGB A color space that encompasses most of the gamut of colors achievable on commercial printers, or approximately 50 percent of the visible colors specified by the International Commission on Illumination (CIE).

AE Used with shooting mode names such as Program AE, Shutter-priority AE, and Aperture-priority AE to indicate that part of the exposure is set automatically. See also *automatic exposure (AE)*.

AE Lock (Automatic Exposure Lock) A camera control that enables the photographer to lock the exposure at a point in the scene other than where the focus is set. AE Lock enables the photographer to set the exposure for a critical area in the scene.

angle of view The amount or area seen by a lens or viewfinder measured in degrees. Shorter or wide-angle lenses and zoom settings have a wider angle of view. Longer or telephoto lenses and zoom settings have a narrower angle of view.

aperture The lens opening that adjusts the diameter of the group of light rays passing through the lens to the image sensor. The mechanism is an iris diaphragm of several blades that can be continuously adjusted to vary the diameter of the opening. Aperture is expressed in f-numbers such as f/8 and f/5.6.

artifact An unwanted element in an image caused by an imaging device, or resulting as a byproduct of image processing such as compression.

artificial light The light from an electric light or flash unit.

autofocus A function where the camera focuses on the subject using the selected

autofocus point or points. Pressing the shutter button halfway down sets the focus using the selected autofocus point.

automatic exposure (AE) A function where the camera sets all or some of the exposure elements automatically. In automatic shooting modes, the camera sets all exposure settings. In semiautomatic shooting modes, the photographer sets the ISO and either the Aperture-priority AE (Av) mode or the Shutter-priority AE (Tv) mode, and the camera automatically sets the shutter speed or aperture, respectively.

available light The natural or artificial light within a scene. This is also called existing light.

AVCHD Advanced Video Codec High Definition refers to video compression and decompression standards.

axial chromatic aberration A lens phenomenon that bends different-colored light rays at different angles, thereby focusing them on different planes, which results in color blur or flare.

barrel distortion A lens aberration resulting in a bowing of straight lines outward from the center.

bit depth The number of bits used to represent the color information in each pixel in an image. Higher bit depths translate to more accurate color representation and more colors available for displaying or printing images. In monochrome images, it defines the number of unique shades of gray that are available.

blocked up A description of shadow areas that lack detail.

blooming Bright edges or halos in digital images around light sources, and bright reflections caused by an oversaturation of image sensor photosites.

bokeh The shape and illumination characteristics of the out-of-focus area in an image.

bounce light Light that is directed toward an object, such as a wall or ceiling, so that it reflects (or bounces) light back onto the subject.

brightness The perception of the light reflected or emitted by a source; the lightness of an object or image. See also *luminance.*

buffer Temporary storage for data in a camera or computer.

Bulb A shutter speed setting that keeps the shutter open as long as the shutter button is fully depressed.

cable release An accessory that connects to the camera and allows you to trip the shutter by using the cable instead of pressing the shutter button. The T3/1100D is compatible with the Remote Switch RS60E3.

chroma noise Extraneous, unwanted color artifacts in an image.

chromatic aberration A lens phenomenon that bends different-colored light rays at different angles, thereby focusing

them on different planes. Two types of chromatic aberration exist: axial and chromatic difference of magnification. The effect of chromatic aberration increases at longer focal lengths. See also *axial chromatic aberration* and *chromatic difference of magnification*.

chromatic difference of magnification A lens phenomenon that bends different-colored light rays at different angles, thereby focusing them on different planes; this appears as color fringing where high-contrast edges show a line of color along their borders.

CMOS (complementary metal-oxide semiconductor) The type of imaging sensor used in the T3/1100D to record images. CMOS sensors are chips that use power more efficiently than other types of recording media.

color balance The color reproduction fidelity of a digital camera's image sensor and of the lens. In a digital camera, color balance is achieved by setting the White Balance to match the scene's primary light source or by setting a Custom White Balance. You can also adjust color balance in RAW conversions and image-editing programs.

color/light temperature A numerical description of the color of light measured in Kelvin. Warm, late-day light has a lower color temperature. Cool, early-day light has a higher temperature. Midday light is often considered to be white light (5200K). Flash units are often calibrated to 5000K.

color space In the spectrum of colors, a subset of colors that is encompassed by a particular space. Different color spaces include more or fewer colors. See also *RGB* and *sRGB*.

compression A means of reducing file size. Lossy compression permanently discards information from the original file. Lossless compression does not discard information from the original file and allows you to re-create an exact copy of the original file without any data loss. See also *lossless* and *lossy*.

contrast The range of tones from light to dark in an image or scene.

contrasty A term used to describe a scene or image with great differences in brightness between light and dark areas.

crop To trim or discard one or more edges of an image. You can crop when taking a picture by moving closer to the subject to exclude parts of a scene, by zooming in with a zoom lens, or by using an image-editing program.

daylight balance A general term used to describe the color of light at approximately 5500K, such as midday sunlight. A White Balance setting on the camera calibrated to give accurate colors in daylight.

depth of field The zone of acceptable sharpness in a photo that extends in front of and behind a focused subject. Depth of field varies by the lens's focal length, aperture, and shooting distance. The depth of field in front of the focused subject is shallower than the depth of field behind the focused subject.

diaphragm An iris mechanism consisting of blades that open and close to adjust the diameter of the light rays passing through the lens to the image sensor. Setting the f-number or aperture controls the diaphragm diameter. In full increments, each successive diaphragm setting increases or decreases the amount of light passing through the lens by half.

diffuser Material such as fabric or paper that is placed over the light source to soften the light.

dpi (dots per inch) A measure of printing resolution.

dynamic range The difference between the lightest and darkest values in an scene as measured by f-stops. A camera that can hold detail in both highlight and shadow areas over a broad range of f-stops is said to have a high dynamic range.

exposure The amount of light reaching the image sensor. At a given ISO, exposure is the result of the intensity of light multiplied by the length of time the light strikes the sensor.

exposure meter A general term referring to the built-in light meter that measures the light reflected from the subject back to the camera. EOS cameras use reflective meters. The exposure is shown in the viewfinder and on the LCD panel as a scale, with a tick mark under the scale that indicates ideal exposure, overexposure, and underexposure.

extender An attachment that fits between the camera body and the lens to increase the focal length of the lens.

extension tube A hollow ring attached between the camera lens mount and the lens that increases the distance between the optical center of the lens and the sensor, and decreases minimum focusing distance.

fast A term that refers to film, ISO settings, and photographic paper that have high sensitivity to light. This also refers to lenses that offer a wide aperture, such as f/2.8 or f/1.4, and to a short shutter speed.

filter A piece of glass or plastic that is usually attached to the front of the lens to alter the color, intensity, or quality of the light. Filters are also used to alter the rendition of tones, reduce haze and glare, and create special effects such as soft focus and star effects.

flare Unwanted light reflecting and scattering inside the lens, causing a loss of contrast and sharpness, and/or artifacts in the image.

flat A term that describes a scene, light, photograph, or negative that displays little difference between dark and light tones. This is the opposite of contrasty.

f-number A number representing the maximum light-gathering ability of a lens, or the aperture setting at which a photo is taken. It is calculated by dividing the focal length of the lens by its diameter. Wide

apertures are designated with small numbers, such as f/2.8. Narrow apertures are designated with large numbers, such as f/22. See also *aperture*.

fps (frames per second) In still shooting, fps refers to the number of frames either in One-shot or Continuous drive modes that the camera can capture in one second. In video film recording, the digital standard is 30 fps.

focal length The distance from the optical center of the lens to the focal plane when the lens is focused on infinity. The longer the focal length is, the greater the magnification.

focal point The point in an image where rays of light intersect after reflecting from a single point on a subject.

focus The point at which light rays from the lens converge to form a sharp image. This is also the sharpest point in an image.

frame A term used to indicate a single exposure or image. This also refers to the edges around the image.

f-stop See *f-number* and *aperture*.

ghosting A type of flare that causes a clearly defined reflection to appear in the image symmetrically opposite to the light source, creating a ghostlike appearance. Ghosting is caused when the sun or a strong light source is included in the scene, and a complex series of reflections occur among the lens surfaces.

gigabyte The usual measure of the capacity of digital mass storage devices; a gigabyte is slightly more than 1 billion bytes.

grain See *noise*.

gray-balanced The property of a color model or color profile where equal values of red, green, and blue correspond to a neutral gray value.

gray card A card that reflects a known percentage of the light that falls on it. Typical gray cards reflect 18 percent of the light. Gray cards are standard for taking accurate exposure-meter readings and for providing a consistent target for color balancing during the color-correction process using an image-editing program.

grayscale A scale that shows the progression from black to white using tones of gray. This also refers to rendering a digital image in black, white, and tones of gray. It is also known as monochrome.

HDV High Definition Video refers to video compression and decompression standards.

highlight A term describing a light or bright area in a scene, or the lightest area in a scene.

histogram A graph that shows the distribution of tones or colors in an image.

hue The color of an object. When you describe a color using the words green, yellow, or red, you're describing its hue.

infinity The distance marked on the lens between the imaging sensor or film and the optical center of the lens when the lens is focused on the farthest position on the distance scale of a lens (approximately 50 feet and beyond).

ISO (International Organization for Standardization) A rating that describes the sensitivity to light of film or an image sensor. ISO in digital cameras refers to the amplification of the signal at the photosites. ISO is expressed in numbers such as ISO 100. The ISO rating doubles as the sensitivity to light doubles. For example, ISO 200 is twice as sensitive to light as ISO 100.

JPEG (Joint Photographic Experts Group) A lossy file format that compresses data by discarding information from the original file to create small image file sizes.

Kelvin A scale for measuring temperature based around absolute zero. The scale is used in photography to quantify the color temperature of light.

LCD (liquid crystal display) The image screen on digital cameras that displays menus and images during playback and Live View shooting.

lightness A measure of the amount of light reflected or emitted. See also *brightness* and *luminance*.

linear A relationship where doubling the intensity of light produces double the response, as in digital images. The human eye does not respond to light in a linear fashion. See also *nonlinear*.

lossless A term that refers to file compression that discards no image data. TIFF is a lossless file format. See also *compression*.

lossy A term that refers to compression algorithms that discard image data in the process of compressing image data to a smaller size. The higher the compression rate, the more data that is discarded and the lower the image quality. JPEG is a lossy file format. See also *compression*.

luminance The light reflected or produced by an area of the subject in a specific direction and measurable by a reflective light meter. See also *brightness*.

megabyte Slightly more than 1 million bytes.

megapixel One million pixels. It is used as a measurement of the capacity of a digital image sensor.

memory card In digital photography, removable media that stores digital images, such as the SD/SDHC media used to store T3/1100D images.

metadata Data about data, or more specifically, information about a file. This information, which is embedded in image files by the camera, includes aperture, shutter speed, ISO, focal length, date of capture, and other technical information. Photographers can add additional metadata, including copyright information on the T3/1100D.

middle gray A shade of gray that has 18 percent reflectance.

midtone An area of medium, or average, brightness; a medium-gray tone in a photographic print.

neutral density filter A filter attached to the lens to reduce the required exposure.

noise Extraneous visible artifacts that degrade digital image quality. In digital images, noise appears as unwanted multicolored flecks and as grain that is similar to grain seen in film. Both types of noise are most visible in high-speed digital images captured at high ISO settings.

nonlinear A relationship where a change in stimulus does not always produce a corresponding change in response. For example, if the light in a room is doubled, the human eye does not perceive the room as being twice as bright. See also *linear*.

normal lens or zoom setting A lens or zoom setting whose focal length is approximately the same as the diagonal measurement of the film or image sensor used. In full-frame 35mm format, a 50-60mm lens is considered to be a normal lens. On the T3/1100D, normal is about 28mm. A normal lens more closely represents the perspective of normal human vision.

open up To switch to a larger f-stop, such as f/5.6, f/4, or f/2.8, to increase the size of the lens diaphragm opening.

overexposure Giving an image sensor more light than is required to make an acceptable exposure. The resulting picture is too light.

panning A technique of moving the camera horizontally to follow a moving subject, which keeps the subject sharp but blurs and/or streaks background details.

photosite The place on the image sensor that captures and stores the brightness value for one pixel in the image.

pincushion distortion A lens aberration causing straight lines to bow inward toward the center of the image.

pixel The smallest unit of information in a digital image. Pixels contain tone and color that can be modified. The human eye merges very small pixels so that they appear as continuous tones.

plane of critical focus The most sharply focused part of a scene. This is also referred to as the point or plane of sharpest focus.

polarizing filter A filter that reduces glare from reflective surfaces such as glass or water at certain angles.

ppi (pixels per inch) The number of pixels per linear inch on a monitor or image file that are used to describe overall display quality or resolution. See also *resolution*.

RAW A proprietary image file in which the image has little or no in-camera processing. Because image data has not been processed, you can change key camera settings, including brightness and white balance, in a conversion program (such as Canon Digital Photo Professional, Adobe Camera Raw, or Adobe Lightroom) after the picture is taken.

reflective light meter A device — usually a built-in camera meter — that measures light emitted by a photographic subject back to the camera.

reflector A silver, white, or gold surface used to redirect light into shadow areas of a scene or subject.

resolution The number of pixels in a linear inch. Resolution is the amount of data used to represent detail in a digital image. Also, the resolution of a lens indicates the capacity of reproduction. Lens resolution is expressed as a numerical value such as 50 or 100 lines, which indicates the number of lines per millimeter of the smallest black-and-white line pattern that can be clearly recorded.

RGB (Red, Green, Blue) A color model based on additive primary colors of red, green, and blue. This model is used to represent colors based on how much of red, green, and blue is required to produce a given color.

saturation As it pertains to color, a dominant, pure hue undiluted by the presence of white, black, or other colors. The higher the color purity is, the more vibrant the color.

sharp The point in an image at which fine detail is clear and well defined.

shutter A mechanism that regulates the amount of time during which light is let into the camera to make an exposure. Shutter time or shutter speed is expressed in seconds and fractions of seconds, such as 1/30 second.

slave A flash unit that is synchronized to and controlled by another flash unit.

slow A reference to film, digital camera settings, and photographic paper that have low sensitivity to light, requiring relatively more light to achieve accurate exposure. This also refers to lenses that have a relatively wide aperture, such as f/3.5 or f/5.6, and to a long shutter speed.

speed The relative sensitivity to light of photographic materials such as digital camera sensors, film, and photographic paper. This also refers to the ISO setting and the ability of a lens to let in more light by opening to a wider aperture. See also *fast* and *slow*.

sRGB A color space that approximates the gamut of colors of the most common computer displays. sRGB encompasses approximately 35 percent of the visible colors specified by the International Commission on Illumination (CIE).

stop See *aperture*.

stop down To switch to a smaller f-stop, such as f/8, f/11, and narrower, thereby reducing the size of the lens diaphragm opening.

telephoto A lens or zoom setting with a focal length longer than 50-60mm in full-frame 35mm format. On cropped sensor cameras, telephoto is a focal length longer than approximately 28mm.

TIFF (Tagged Image File Format) A universal file format that most operating systems and image-editing applications can

read. Commonly used for images, TIFF supports 16.8 million colors and offers lossless compression to preserve all the original file information.

tonal range The range from the lightest to the darkest tones in an image.

TTL (Through the Lens) A system that reads the light passing through a lens that strikes an image sensor.

tungsten lighting Common household lighting that uses tungsten filaments. Without filtering or adjusting the correct White Balance settings, pictures taken under tungsten light display a yellow-orange colorcast.

underexposure The effect of exposing an image sensor to less light than is required to make an accurate exposure. The resulting picture is too dark.

viewfinder A viewing system that allows the photographer to see all or part of the scene that will be included in the final picture.

vignetting Darkening of edges on an image that can be caused by lens distortion, using a filter, or using a lens hood. This is also used creatively in image editing to draw the viewer's eye toward the center of the image.

white balance The relative intensity of red, green, and blue in a light source. On a digital camera, white balance compensates for light that is different from daylight to create correct color balance.

wide angle A lens with a focal length shorter than 50-60mm in full-frame 35mm format. On cropped sensor cameras, wide angle is a focal length wider than approximately 24mm.

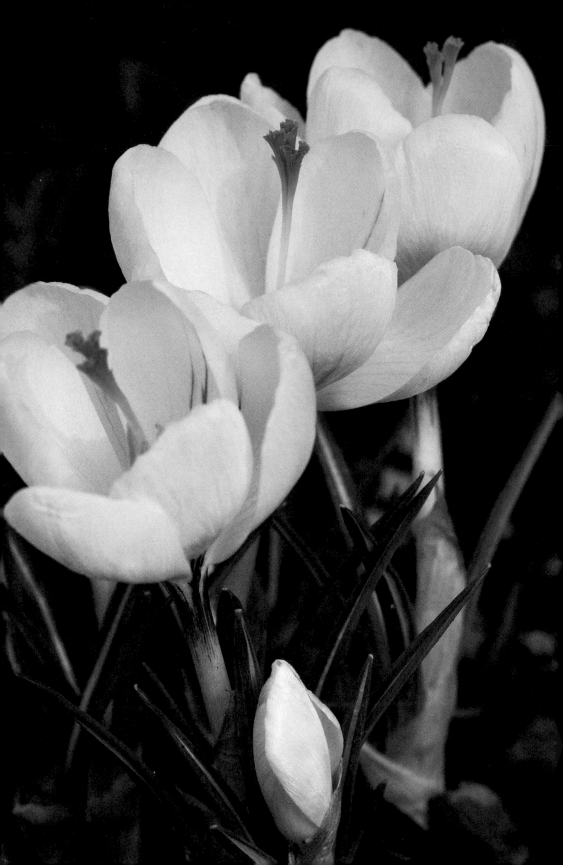

Index